peripheries

a journal of word, image, and
sound

CENTER
FOR THE
STUDY
OF WORLD
RELIGIONS

FACULTY ADVISOR Charles M. Stang

EDITOR-IN-CHIEF Sherah Bloor

MANAGING EDITOR Sam Bailey

DESIGNER Gabby Woo

COMMUNICATIONS COORDINATOR Izzy Cho

ASSOCIATE EDITOR Emma De Lisle

SENIOR EDITOR (WORD) Eden Werring

SENIOR EDITOR (IMAGE) Joel Werring

SENIOR EDITORS (SOUND) Rebecca Lane

POETRY EDITORS Darius Atefat-Peckham, Benjamin Bellet, Alex Braslavsky, Joanna Burdzel, Yongyu Chen, Shao Wei Chew Chia, Olivia Cowley, Edith Enright, James Fraser, Josh Gregory, Amanda Gunn, Joshua Kurtz, Timothy Leo, Tawanda Mulalu, Madeleine Scott, Ethan Seeley, Eliza Tewson, Martine Thomas, Walter Smelt III

PROSE EDITORS Scott Aumont, Rebecca Doverspike, Edwin Alanís García, Marta Jordana, Harry Hall, Veronica Martin, Kim Mereine, Leah Muddle, Maria Pinto

SOUND EDITORS Nomi Epstein, Rebecca Lane, Andrew Schulman

VISUAL ART EDITORS Isabel Bailey, Olivia De Lisle, Joey Hou (aka Delilah Lyses-sApo), Maria Matulewicz, Becca Voelcker

Cover image: Seal, Dickinson family artifacts, Houghton Library, Harvard University

Editors' Foreword

This, our sixth issue burgeons and bristles. Proudly capacious, *Peripheries* is capable of publishing lengthier pieces, lingering with a single poet over many intimate, meditative pages. We are especially honored to open and close this collection with longer sequences from Geoffrey Nutter and Joanna Klink. We get to trace Stacy Szymaszek's 'Essays' back through Stephanie Young's poem of the same title to Bernadette Mayer's original 'Essay', watching the process by which, again and again, poems grow out of each other. Because, as Mayer asks, teasing but with bite, "Why not a poet who was also a farmer"

 Steadfast as any farmer and fixed as the stars
 Tenants of a vision we rent out endlessly

Tenants, whether steadfast or otherwise, we begin by entering the "Great Hall of the People—" and wander through the visionary world of Nutter's *Emissaries* before emerging again from the revealing dark, blinking. We find a succession of self-contained and crystalline lyric poems from Victoria Chang, Alice Oswald, Rowan Ricardo Phillips, and Tracy K. Smith. We travel into the thicketed dreamscapes of Jackie Wang's experimental prose, to the tune of Laura Steenberge's scores, and through the time-travelling twists of Jessica L. Wilkinson's non-fiction poetry:

 You must never leave a memory. You must
 not lose a truth.

The journal sprouts with seedlings_ to the algorithms of Qianxun Chen and Marina Roa Oliva; it burrows, following the bark beetle tracks of Jessie Hobeck's tracing. Ian Ganassi asks:

Does anybody really know what time it is?
Was your salad all right? Is anything all right? Are you all right?

The collection continues, extravagantly: now, stills from Sam Messer's animation of Denis Johnson's 'Red Darkness'; now, Sam Weinberg's collage and saxophone improvisations; now, Abigail Levine's year choreographed in dances… until, expertly considered by our designer, Gabby Woo, the journal becomes itself a composite: one piece grafting onto the next, and the next. Like an exquisite corpse, perhaps, or like Margaux Crump's grafts. With the help of our editorial team—thank you—everything blossoms into this, our annual anthology.

Finally, the journal brims over its own edge to generate another journal. To close *Peripheries'* pages with pieces from Angie Estes, Jennifer Grotz, Bin Ramke, and Joanna Klink is to open another collection: a book behind a book: this year's folio. With exquisite care, *Peripheries'* own Sam Bailey and Emma De Lisle have curated a collection of 'Anti-Letters.' Inspired by Emily Dickinson's three mysterious letters to 'Master', these are pieces that grew out of exercises at first peripheral to poets' main work—journal entries, marginalia, *l'esprit de l'escalier*, lecture notes, notes on TikTok, notes on farming, therapeutic practices, unexpected dialogues—only to ripen and evolve into works of art in their own right.

Thank you to all our contributors for their incredible pieces; we gift in return this 'anthology,' etymologically 'flower-gathering.' If this is a strange bouquet, then perhaps we should ask with Cole Swenson: what is a fake flower but "A real fake flower"? What is "unnatural about artifice"? If artifice, then perhaps this can be the poets' farm, for a time.

Thank you to those who make us a home: the Center for the Study of World Religions and the Harvard Divinity School. And to our neighbors and friends: Grolier Poetry Book Shop, the Woodberry Poetry Room at Lamont Library, the Harvard English department, and as always especially Jorie Graham. We are grateful to Houghton Library for images of Emily Dickinson's seals; and to Amherst College Archives for permission to reprint the letters in Emily's own hand. We are excited to be working with Harvard University Press, our new distributors, thanks to whom this journal now lies open in your hands.

Sherah Bloor, Editor-in-Chief
Emma De Lisle, Associate Editor

Table of Contents

Folio: Anti-letters

From *Emissaries*

Geoffrey Nutter

Equinox/The Seasons Pass

The Great Hall of the People—
It could be anything from a bubble
Of titanium to a duck egg
To a sandpiper. The dome
was the reflective egg of the people,
where the outsider could lay claim
to his originary, and they could
Put ladders up along side it, brush it
With seedpods, wandering in the garden
with self-abandon, with inadvertence,
Women hiding there in giant flowers,
Rain falling on the carbonized red stones
Everybody could be themselves completely
Once they asked themselves what that was,
what they were, leafy outcasts among beehives,
And rain slid off ivy toward beautiful earth
Where the air we breathe has been breathed by all others
And for that is the purer; no one coerced
Into anything, no one trying to be anything,
A falconer or sandman, diplomat,
In full bloom like a desert succulent,
O person, for that is what you are—

As the well-arranged kite is able to glide
gracefully up—the house kite or the Malay kite,
the box, the dragon, or the one called Lilac
of Persia—up to its steady position
owing to its symmetry, its leaves turned up
like a hat brim, the variable stars
fluctuate in brightness.
On Linden Terrace people are sharing the ritual.
It's name? Still to come. Fall begins,
The sun crosses the equator, the hours
Of day and night are approximately equal lengths
all over the earth. On the last Sunday
In October, we fall back. The nights are longer now,
We have passed the month of sapphire and lapis
Lazuli—the months of resolve—and we are in
The tourmaline and Opal month, ashine
With hope, and truth. Topaz November lies
Ahead. But so does the Amethyst month,
Then thirty-one days of Jasper, Bloodstone,
Quartzite webbed with rain. Then,
The Diamond Month, April, when we are faceted,
There is a gentle acceleration. But for now,
The constellations of autumn appear,
We are fixated on all the questions
That are implied but seem to demand
Unequivocal answers, until, to our relief,
The scattering of leaves seems to be a response
That is sufficient, and we are released
From obligation that made us shrink
With withering apprehension. The tide turns,
And just as things were looking bad for all,
The unexpected guests arrive, we are amidst
Food and wine, friendship, and as you allow them in,

Through the open door you can see the emergence
Of a 19th century crystal palace, emerging
From behind the cliffs. The children
Are coaxed to sleep by the mother
who tells them, "Dolls need a rest too,
need peace to grow into grownups.
And don't you worry, children,
For all sleeping dolls come back from the dead."

Confluence

The truth is, you are a listener—a secret listener.
While beclouded and dark, the ball of crystal
Tells the times by clearing for just a moment,
Gleaming with brilliance, then darkening yet again,
Returning to its normal state. All your present
And future, all that you are now, is hidden
From easy perception, like piles of hay
They have moved out of reach of the destructive wind.
It is just the beginning, as always. And
As always, we search for it in divination:
In divination by flight of birds, in divination
By grass covering letters traced upon the ground;
By winds, by a balanced hatchet, by arrows,
By herbs, by the rising of smoke, by the floating
Egg pointing north; to tell the future by the hand,
By dice, by a balanced sieve, by a spirit seen
In a magical lens; to tell it…to tell it by the laugh,
By the position of the stars at birth; by dots
Made on paper at random; by walking in a circle
Or by fish, by precious stones, by meteors,
By letters forming your secret name; by dreams;
By nails reflected in the sun's rays; tell it

By fountains, by pebbles, by pebbles drawn
From a heap, by ghosts and sacrificial fire,
By the sea and the seashell, by passages
In a book, or by departed spirits; by the departed
Spirits of those you loved.

It is for you that dawn breaks over the blue hills
With their terraced fields, to nearly touch the dark green
Water of the canal. It is to interpret the writing
On the walls of a room that you awaken
And leave off dreaming. Where the raindrops
grow more beautiful
With your dawning awareness of the sounds
They make; and like them, you are planning
To disappear, to vanish completely, to lose
Identity, irrevocably, and then be part
Of a great dispersion, just one tile in the mosaic.
And there is no message on the mildewed wall,
It's just how light falls on it, the green rain-light.
Did you choose this place, this path, during
Those moments when you were half awake?
And this split in time, momentary, you tenaciously
Held to, even adopted as a code of living.
And now, the thunder is telepathic, and seems
To read—or feel—your deepest thoughts,
And responds in the only way it can, and you
Receive its gift through the mind and the mind alone.
You feel the cold freshness of the room
In which this work—your work—is done.
There are no outside distractions. The heavy
Ticking of the grandfather clock, covered
In a layer of green moss, is ticking.

But the earth, so near to man, so varied
And manifold, is not understood; it is barely
Apprehended as an entity. But from her
Come the life-giving streams that wander the land,
Dear as a storage of opals, flux-grown like rubies;
One gathers that a destination lies somewhere
In the distance, past rank grass and cooling towers,
Mountains under red skies, and a flowering
Of curiosity flowers in you, and you can come
As you are, or as you always have been,
As you will be much later at some unforeseeable
hour. There was always the danger, felt
Or apprehended by your heart, that what
Awaits you is a slow petrification, a turning
Of your body slowly to an ancient green stone—
But could it be that what lies on the other side
Of that mountain is a group of emissaries sent to greet you,
And they are bringing gifts, they are the "possible
People", the ones in a shadow life lived adjacent
To yours, others on the margins? It is a delegation
Welcoming you.

A guy was walking down the street
Past Hennepin on Facet and stumbled
Over something: it was one of those big
Diamonds that people drop and just leave
Lying in the street. This was a big one:
About the size of a very large cat
Or an anvil or an air conditioning unit
For an apartment complex. So you just
Keep walking into the hills where it seems
That all might be well if left the way
You found it. And you could see

Your favorite star shining like a greeting.

To the lapidary, Rigel is very beautiful,
And man and star are equally diligent.
People are coming out of a building
Like a stream of ants. One stops
To pick up a twig with a single dry leaf
Of eucalyptus hanging from it. Others
Just hurry onward with perfect equanimity.
What are they doing? Ask the man
Who's in the insect business…he'll tell you.
But you might need to sit on a tree stump
And smoke a cigar with him as he tells you
The story of how he fell in love—it's clear
He's talking about a girl now, not fire-ants.
He claims he needs to "start from the beginning":
Always a bad sign. So you leave him there,
Looking a little puzzled, then forlorn, shaking
His head, and walk from the enchanted wood
Into the town, where some kind of procession
Is being planned.

And who am I? The rains are falling now
And a time of rest has come. Time is passed
In feasting and enjoyment; wine is brought out;
One steps out into the courtyard to smoke
A cigarette, clouds still streak the sky,
And all seems just fine. Slowly the stars
Come out, one by one, in their usual order.
There are barely any lights on in the town
And in the surrounding hills and valleys,
The night market has not opened yet,
So the Milky Way can be seen, and it is

Wonderful. When he goes back inside,
The men and women are pairing up and going off
To bed: Damien and Irene; Orange and Ignacio; Sky
And someone whose name means "summer;"
Jia and that other girl named Jia; and then,
Finally, Dorothea and the girl known only
As "Thirty-Nine." It's time for love,
Or games, or whatever, or sleep, or whatever,
"You do you," as they say, "you only live once,"
Say others, which is true, but what one does
With that information is still to be seen....
And the shadow pyramids stand on the outskirts
Of a shadow city, on a shadow planet.
And its government does its dark work
With a sullen diligence.

...

I want to tell you something that seems true...
But in truth, I don't know yet.
But I will end by divulging the secrets
Of another kind—the secrets
Of magic, of the ten kinds
Practiced by the prestidigitator:
He asks you for some object,
Some thing of value to you.
And takes it from you: and then—
Vanishing—he makes the thing disappear.
Transposition—he makes the thing
you love change places with another;
Penetration: he passes something through
The object, but it is not harmed;
Transformation: the object you love is changed

into something else, a diamond, or
a bird's egg, or a shadow; or something
you do not recognize as yours;
Production: the object you love appears instantly
from thin air;
Escape: the object of your love breaks free
from your grasp;
Prediction: the magician predicts
what will someday become of the beloved,
for all things must pass;
Transportation: your beloved travels
from one place to another, far away;
Restoration: she who you love is destroyed
and somehow made whole again;
Levitation: your beloved defies gravity;
she displays impossible lightness;
she is borne aloft.

This was expressed very neatly
By Dr. Harlow Shapely
In his book *Of Stars and Men*,
In which he tells us much that is wise
About the city and the dream,
The explosion, the explosion of color,
The mixture of nitrogen, star shine,
And water which, with other atoms,
In the right conditions, will everywhere
Produce animals just like ours
As in Precambrian times, when Insect X
Or Green Lizard Y or Star Fish B
Or a profusion of flowering plants
All had queens like bee-swarms,
And when Rosa was given a green book

Which was placed under a bright red light,
Rosa said the book was blue…
And as she rested her hands on the book,
The light was suddenly switched off,
And she cried, "The book has changed
From blue to green!"

We walked to the pier, all of us in a group.
The children followed close behind, then would
At times rush ahead.
Then we would all feel ourselves in the sun.
The cat waited there at the door,
Its eyes boring into it
As if it would magically swing open.
The sun was at the other end of the earth
And the darkness was frank and simple.
It just revealed everything but itself.

(Make Of Yourself) An Instrument Of Day

Tracy K. Smith

A dove's known song—
those five warm notes and two
Measures of silence—

sounds then ceases,
over and again
in pattern. Finally

the bird flies off
into a clean
patch of sky, but

something now rings
in the bell of my body,
clapped awake

by what the bird
kept saying. *So much
is over,* I think it was.

Or *Nothing
is finished.* Some

of what the bird sang

were questions:
*Why did you
Worry? What*

Were you hoping?
As if there is only
a single tune any

will need. *Look past
your longing*, I heard.
Morning is dawning.

Wind. Leaves. Human
flurry. The long song
we make and ride—

the one everything alive
sings with us.

Spider

Alice Oswald

I found this copper spider in my shoe
and when I praised her gracefulness, she grew
more graceful, she began to lift as if
inflated by my gracious adjective.
Oh spider full of order, made of air
and horse-hair, like an inside-out guitar,
I want to praise your instrument of praise
and so increase its tentative and sideways
workings, that when you fasten to my door
four pairs of compasses whose pencils draw
the surface area of time in eight
successive circles like a sketch of fate
with one line lengthening to the sun... I know
if I keep still, the whole design will grow....

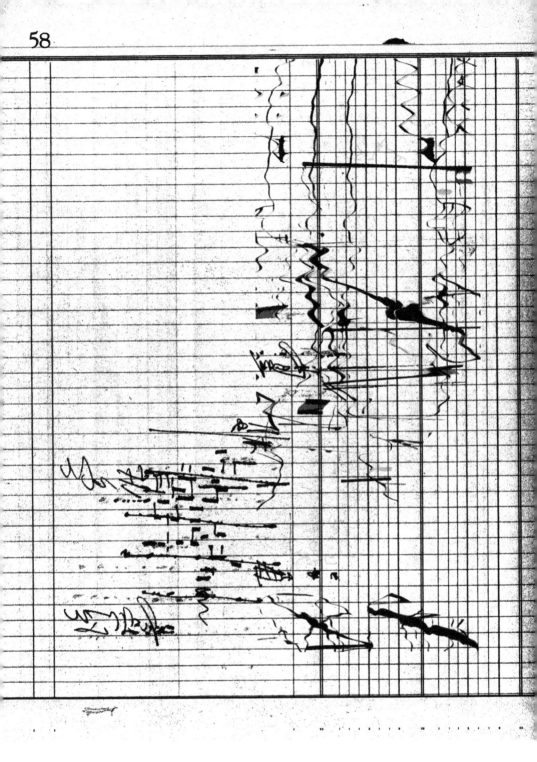

Rosaire Appel, *Chart Account 58*, 2022, ink on vintage ledge paper, 13.5" x 17"

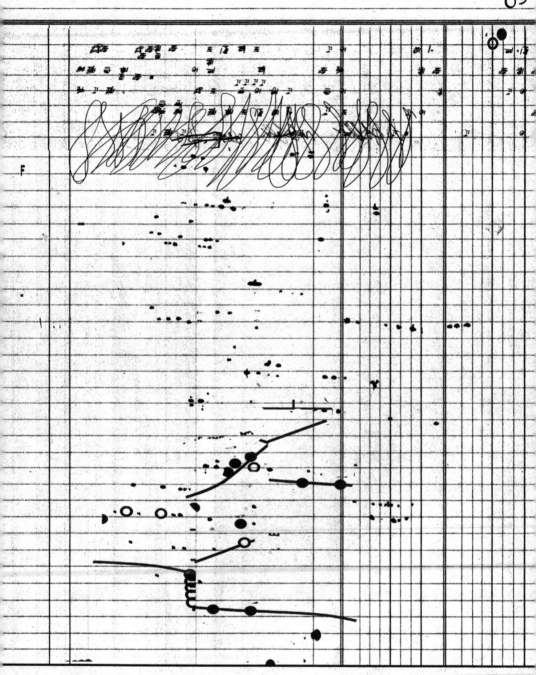

Rosaire Appel, *Chart Account 69*, 2022, ink on vintage ledge paper, 13.5" x 17"

Reclining Woman

Victoria Chang

The woman's head, the size of a small peach.
Three more small peaches between her legs. I

wouldn't have put three between her legs,
separating desire into thirds, or making it round.

I wouldn't have painted desire on its side. The
women are always reclining on couches. Lately, a

rope pokes out of my skin. The only way I've ever
known how to use a rope is for hanging. Lately,

I've been feeling that there could be another use for the
rope. Others might name that *hope*. But

I think of it as efficiency. Once, I used the rope to
hold back my hand's desire to touch someone so

many times, that my biceps doubled in size.
Sensitive people's fingers are always pointing at

the lilies outside of the frame. What if the tingling
was never an inner life, but the trees using our

veins to send earth's classified information.
Maybe the hands were spies all along, wrapped

in a borrowed coat. Maybe desire is really
vertical. It is a tree rushing messages to another

tree. Sometimes there are so many messages
because of our killing that our hands swell.

Blue Territory

In Alaska, I was no longer outside of time but riding
on it. It turns out that I get motion sick from time. I

collected hag stones on the beach to weigh myself
down, but they had holes in the middle so I kept

losing time. My pockets became so heavy, I sunk
back into my own suffering. I was afraid of everyone

there. Eventually, I realized only the moose could kill
me. The two babies I saw hardly knew each

other. Maybe didn't even like each other, would only
live ten to twelve years. Meaning I would never

see these moose again. By next year, the mother will
reject them until they don't return. We keep our

children so long, they eventually reject us. No one is
born using punctuation. Because the goal is to grow

up as fast as possible. Now, there are dry eucalyptus
leaves in the middle of the room. Each day, I sweep

them out the door. Today, I pick one up with my
hands, but the tips have already become ghost

hands. The leaf is a dead person's comma, asking me
to pause, to reconsider my whole life. I insert the

leaf between the blue and myself. I pick up another
leaf and insert it between myself and the present.

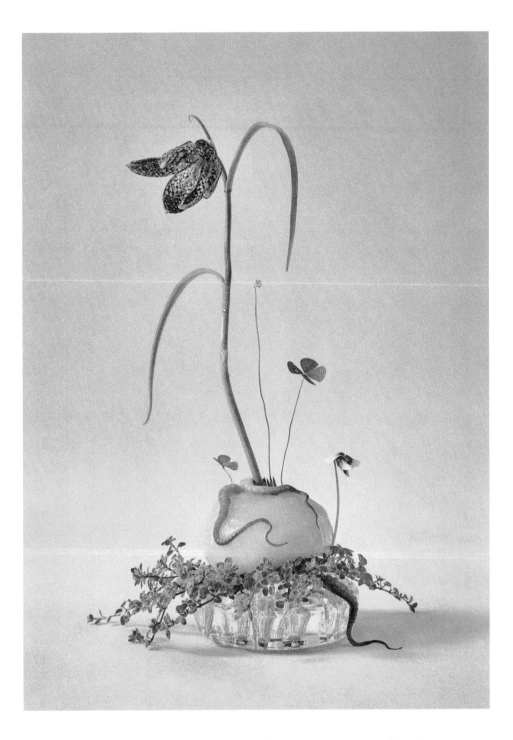

Margaux Crump, *Grafts II*, 2020, digital pigment print, 24" x 17"

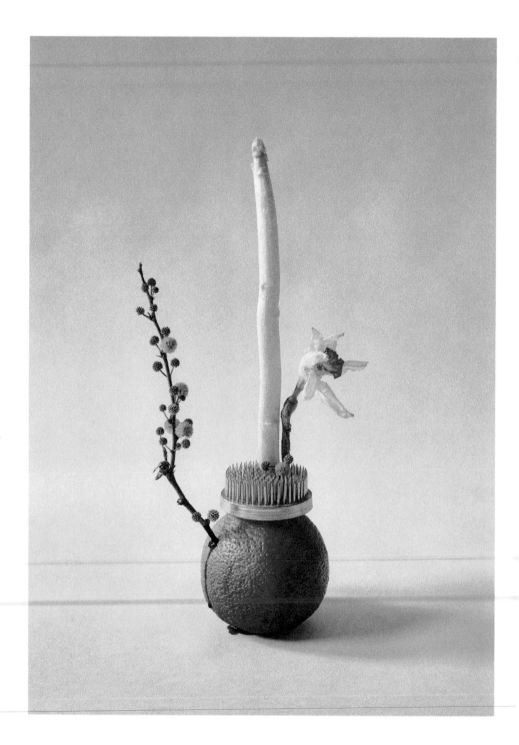

Margaux Crump, *Grafts III*, 2020, digital pigment print, 24" x 17"

Margaux Crump, *Grafts IV*, 2020, digital pigment print, 16″ x 24″

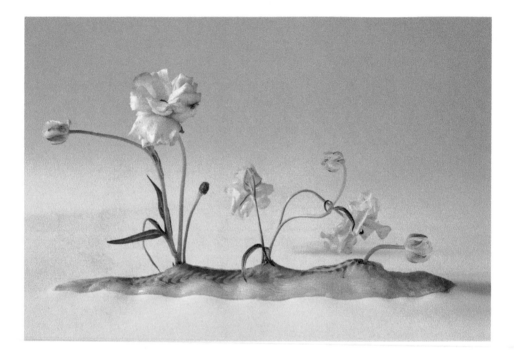

Margaux Crump, *Grafts I*, 2020, digital pigment print, 20 1/4" x 36"

[notes for a dance w/jug]

Aracelis Girmay

She tells us—we are many, so she lifts her voice a little, she goes, *Go and gather your cups and get them ready.* So we run home. And back. She goes, *Put your cup ever beside your sisters' cups.* Then out of her head she pours the water, comes the calcium night, song of the smaller sticks. Into one sister's cup falls a fraction. Of a shell. Into another's falls a little bit of silt so little it is like a murmur, and on and on beyond any single person's knowing. Then we drink and there's this shift of energy which changes what we can perceive in the water—like we are touched by what is still inside the river's mind.

The jug woman. She points this way, she points that way: *Go and make yourself a mountain. Go and make yourself a little book.*

I thought she said "teeth" but "leaves" was the word. *And the leaves that come through,* she said, *give them to the children*

Seeing Double

Jackie Wang

The shock of familiarity, of recognition even as what is in front of you is not what you have seen before, a paramnesiac fugue, for the past and its phantoms are playing a trick on you. Thus, the Greek teacher traveling alone in Switzerland in Han Kang's novel *Greek Lessons* gets off a boat in a small city called Brunnen, drawn by a memory of the Suyuri neighborhood (now Suyu-dong) of Seoul, the neighborhood flanked by two mountain peaks: Baekundae to the left and Insubong to the right. Brunnen had conjured a childhood landscape in the mind of the weary wanderer. When he disembarked at the quay, a pale blond-haired man sitting at a café catches his eye. "He didn't resemble you in the slightest, and yet he made me think of you."

Leaving, he must lose his object all over again—it doesn't matter that the German and the Swiss man have been transposed, so powerful is the mind's capacity to pin all the unrealized hopes associated with lost objects onto ill-founded doppelgängers, all the like-you-but-not-really-s who step into our field of vision, oblivious to the idiosyncratic characteristics they possess that bind them to others—to strangers—circulating in the world. It could be a birthmark, a verbal tic, their eyes, their gait, their style of thinking or

sartorial preferences—something as deep as "they both had mothers who died when they were thirteen" or as superficial as "they both wore red pants." Whatever the detail that binds the object and its double, the nervous system responds as though they were one and the same, returning the perceiver of the echo to the same physiological state induced by the originary object.

I pause writing in my journal to read Deleuze's *Bergsonism*, get lost for an hour trying to understand Bergson's theory of memory and duration, of the coexistence of the past and present, rather than the linear view of time. Deleuze: "The past and the present do not denote two successive moments, but two elements which coexist: One is the present, which does not cease to pass, and the other is the past, which does not cease to be but through which all presents pass."

There are people who live this split-screen existence more intensely than others, who experience the-past-in-the-present perhaps even more vividly than the scene that is in front of them. Is that the quality possessed by the characters in Han Kang's novels and Theo Angelopoulos's films that hypnotizes me, the elegiac atmosphere, the way the haunted melancholics walk around, out of sync with the world? In Angelopoulos's *Eternity and a Day*, Alexandros, a middle-aged, terminally ill poet with a beard, is driving his car at night. He stops at a stoplight. When the light turns green, he does not move. *Oh no—is he dead?* I thought while watching the scene. He sits there, stock-still, like a protruding stone in a river, while the cars flow around his unmoving vehicle—a metaphor for the way our tempo sometimes comes unstitched from the tempo of the world. For the entire night he sits frozen, stares out the windshield until sunrise, then drives away.

His daughter informs him—she has sold his old house. He returns to the old seaside house in Thessaloniki. As

he paces the derelict building, he hears the voice of his late wife Anna reading a passionate letter she had written to him while sitting by the sea. The letter concludes with the words: "Give me this day." As the last line rings out, the shutters swing open, revealing a stunning vista of the sea of memory, a vision of the past: to the right, Alexandros's mother sits on the balcony rocking his newborn baby, while below, his dead wife Anna and their friends sing on the shore. In the distance, all are facing away from him, toward the sea, until she and she alone turns to face him, her beautiful white dress blowing in the sea breeze. Then he's down there, inside the memory as she implores him to join them in dance. The other people fade, until she too disappears.

On the shore he delivers a soliloquy on the split-screen life: "With words, I brought you back. You are there. And all is true and waiting…for the truth. For the truth."

<center>*</center>

I remember, last fall, walking around the Kreuzberg neighborhood of Berlin with Al Burian, killing time before heading over to Sylvia Schedelbauer's dinner party. Under the crepuscular sky, we were indecisive about where to go and eventually wandered into a graveyard, where we walked among the dead until it was fully dark. Al said that he knew it was time to leave Chicago when every inch of the city had a memory attached to it—he could no longer simply walk around without feeling held captive to the past, to the mental stream of associations summoned by particular places. Berlin was becoming that to him now: every location came with customized emotional baggage. As he was saying this to me, I knew he was thinking about a memory he had associated with the graveyard we were in—I dared not ask what the

memory was.

We walked all the way to the other side of the graveyard. Did he go off to find a place to piss in the dark? We were talking about dreams. I was telling him about the monomanias implanted by my dreams, how they possess my soul, how I cannot stop until the oneiric prophecy has been realized. "Which is a liability because, as technicians of the sacred know, not all dreams are true. Penelope knew this. In Homer's *Odyssey*, she spoke of the difference between dreams that pass through the gate of horn (true ones) and dreams that pass through the gate of ivory (false ones)—the Greek for horn being similar to the word *fulfill*, while ivory was similar to deceive. But what method did Penelope use to sort the true dreams from the false ones?? If only I knew! Perhaps your father could help me." (His father being an emeritus professor of Classics and scholar of ancient Greek literature.)

He told me about how he had found the collected works of Freud discarded on a street, how he regretted not taking the volumes. I told him about a dream I had as a teenager: "You appeared in a retro living room with Björk, standing in front of a switched off TV, in a Lynchian set that exuded a surrealist Americana vibe. I thought to myself—my two favorite people! How happy I was in the dream." (That was two decades ago. Then I was just a fan of his writing. His worked had ignited, in me, a desire to write—to become a writer.)

When we walked back to the entrance of the cemetery, the gate was locked. We panicked for a moment, until we found a tree stump that we climbed onto to hoist ourselves over the fence. While walking up the staircase to Sylvia's top-floor apartment, I said, "And what would have happened if we got trapped in the graveyard all night?"

"We'd probably talk about our childhoods until

sunrise," he joked.

I was wearing my t-shirt emblazoned with the opening page of Virginia Woolf's *The Waves*, which I bought when I was teaching the novel in my "Water and the Imagination" class. ("Why not rep the most epic opening in all of literature?" I joked to my students, pointing to my shirt.) Later, as I was reading the ending of Woolf's *Orlando*, I came across a passage that made me want to email Al to ask what memory he was thinking about as we perambulated through the cemetery in the diminishing light. I remember the dread in his voice as he spoke softly about the days getting shorter, the darkness that was the coming of winter—would it be the first winter without his mother?

I grab my copy of *Orlando* to look for the quote that made me think of that night.

Orlando bemoans: "'Time has passed over me,' she thought, trying to collect herself; 'this is the oncome of middle age. How strange it is! Nothing is any longer one thing. I take up a handbag and I think of an old bumboat woman frozen in the ice. Someone lights a pink candle and I see a girl in Russian trousers. When I step out of doors—as I do now,' here she stepped on to the pavement of Oxford Street, 'what is it that I taste? Little herbs. I hear goat bells. I see mountains. Turkey? India? Persia?' Her eyes filled with tears."

How much heavier the weight of memory must have been for Orlando, who had accumulated three centuries of experience! Woolf reminds us: "For if there are (at a venture) seventy-six different times all ticking in the mind at once, how many different people are there not—Heaven help us—all having lodgment at one time or another in the human spirit?"

In the margin of the book, near the passages I had marked, I had jotted down a note about the exchange in the

graveyard: *Every place had a memory associated with it, so that as he moved through the city, he experienced time non-linearly. That's when he knew it was time to go.* "You don't like that feeling?" I asked, thinking about how beautiful my memories appear to me at sunset.

(And isn't reading so much like walking through the memory-conjuring cemetery? That's why my marginalia so often consists of memories triggered by the text I'm reading, the way Woolf's description of all the times ticking inside us made me think of Al.)

*

A couple of months later, I accompany Molly to a piano performance of Hans Otte's *Book of Sounds*. One by one the phantoms bubbled to the surface of my thoughts as I sat quietly in the dark, toward the back of the theatre, listening to the austere piano music. It's often when I'm disconnected from my phone—unable to blot out my inner monologue with a perpetual stream of podcasts—when I'm passively watching a concert or a film, that the phantoms slide sidelong into my thoughts.

"He didn't resemble you in the slightest, and yet he made me think of you." I saw in the pianist, Conor Hanick, an echo of M, a Russian mathematician and pianist I had dated in grad school. The way Hanick played reminded me of the way M would play the piano, slowly rocking to and fro, possessed by the music. Even the way Hanick would, between songs, push up his glasses with his pointer finger reminded me of M. Perhaps I would have had this response to any bespectacled pianist, I don't know.

M did not have access to a piano, so I would use my student ID to book a piano practice room for him at Harvard.

He would practice while I sat on a metal folding chair reading or pecking at homework, periodically pausing to watch him, entranced by his playing and incredible posture, that amazing discipline of body and mind that I had associated with the rigorous pedagogy of the Soviet Union, with its classical music conservatories in every town and specialized mathematics high schools. How I envied the intense conditioning the Russians I knew had undergone as youth, fearing my loosey-goosey American upbringing would condemn me to a life of underachievement, for the "do what you love" ethos of the US had denied me a lesson in doing what's difficult because it builds character.

I thought about what Amina Cain wrote in her book *A Horse at Night,* about how we're always projecting onto what's in front of us, living in a kind of split-screen reality, where the screen of the imagination is laid over the scene before us—that was the phenomenon that Al loathed. But why do I find it pleasurable, even when my associations bring me pain, when I feel no fondness or affection for the people remembered, people like M? Yet there is still affection for the memory-as-memory. Yes, it is possible: to no longer love a person while still loving your memory of them. Is it *amor fati*—this love—this avowal—of everything lived simply because it is proof of existence—and more than that—of *awareness* of existence? All my memories are filigreed—they appear to me, haloed and luminous.

open/close

Catherine Lamb

open — close — open —close — open — close —open—open—close—
open — close — open—open —close — open —open — close —open—
close —open — close — open—open — close —open—open —close—
open — open—open—close— open—open —close —open—open—open—
close — open — open —close —open —open—close —open—open—open —
close —open—open—open —close — open —open —open — close—
open—open—open—open—open —close — open —open —open—open—
open— close — open —open—open—open —open —open —open—close —
open — open—open —open— open—open— open—open —open

fill.

collapse.

The Stolen Note

Rowan Ricardo Phillips

On the most westerly Blasket
In a dry-stone hut
He got this air out of the night.

-Seamus Heaney, *The Given Note*

Ocean-exposed like the smallest Blasket:
Luanda's isthmus, a northernmost hut,
And a sail staring out at it through the night.

They knew that was no crescent moon, had heard
Of others dragged into the white, their tune
Silver as shark and sword and loud weather,

As much a bleak code as a melody.
There was no preparing for it, an ear
Either knew it or not, nothing easy,

A continent turned into an island,
An island turned into pain. Take this thing,
They heard, this is your first violin.

So whether they called it sacred music
Or not, I don't know if I care. Here it
Was: the ancient-modern mid-Atlantic

Song of a somewhere turned into nowhere.
And nowhere to hide they listened gravely,
As an iron note inched closer on air.

Fake Flowers

Cole Swensen

A clutch of white silk roses is standing on the shore in a
clear glass vase and shifting in the wind against a
background of silver-green reeds, which are rocking in the
same breeze. We in the boat ship the oars for a moment
to watch and note the counterpoint—roses and reeds
responding so differently to the same currents of air—
and wonder if here is not a perfect demonstration of the
difference between the natural and the artificial, but then,
what's unnatural about artifice?

Or, put another way, a silk flower must be placed exactly, no
matter where it's put, which is to say, it's not the place that
matters, but the precision, she thinks, with the flower in one
hand, which she detests—not the hand, but the flower, for
its flagrant disregard for the real—she sighs and refuses to
consider it further—but nonetheless, she can't help asking
herself why she should detest a silk flower—of course, it's a
fake trying to pass itself off as real, and yet, she thinks, it is,
after all, a real fake flower.

Blue-Collar Beauty

Denise Duhamel

He called me a blue-collar beauty,
meaning, I guess, my parents
couldn't afford an orthodontist
for me when I was a kid. I wore
Maybelline makeup and Sally Hanson
nail polish, my sundress from Sears.
It was a compliment, he insisted,
but I felt the sting of being
not a true beauty, the kind
he was used to. I was a less-than
beauty, if a beauty at all,
with my Claire's earrings
and $2 jelly shoes. When he
took me for an expensive steak, I was
self-conscious when I chewed.

Father's Day

My sister was born on Father's Day
and was closer to him than I was,
physically too since I moved
out of the house as soon as I could—
Boston, Wales, New York, Pennsylvania,
Florida. I loved my father. I love him still
though it was my sister by his side
when he died, his insides outside
after a failed surgery. I once misread
surgery as sugary. O, my father's
sweet tooth which I share. He'd put jam
on Pop Tarts, gooey toppings on ice cream,
and bring Grammy small buckets
of frosting from the bakery. I have
his tin General Foods recipe box
which still holds the faint smell
of flour, delicious dust. I have his childhood
copy of *Ali Baba* (in French)
and his cufflinks. Every year he feels
farther away. Father, farther. But I really mean
further as the distance is figurative. Oh Father
Figure, Figurative Father. And further. Furthermore

my father may have loved my sister more
but I never felt it. He and I both loved long walks
and we would take them, despite the weather,
whenever I was home. My mom was at work
at the hospital or, after she retired, in the living
room with her tea. Today my sister puts flowers
on his grave. Flower, flour, my first homonym.
Father, farther, further, how I miss him.

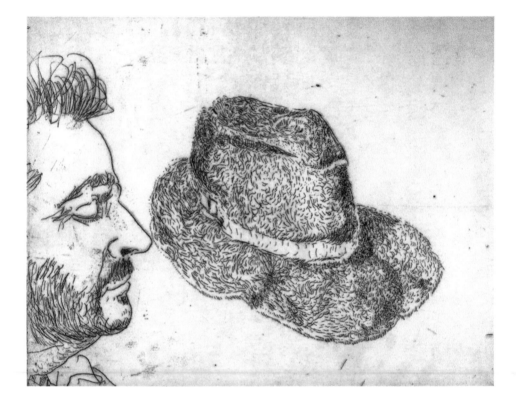

Sam Messer, *DJ and his hat*, etching; edition of 17, 2004

An Interview with Sam Messer

Sam Bailey

SB: You met Denis Johnson during the winter of 1981?

SM: Denis and I were fellows in Provincetown at the Fine Arts Work Center from September of 1981 to May of 1982. We quickly became friends. We used to joke that Denis was the first living poet I'd ever met, and I was the first living artist he'd ever met, because everyone else we'd ever admired was dead. I loved dead Spanish poets when I met him. When you're a fellow there, the artists do a show and the writers do a reading. So the two of us decided to make a collaboration and Denis wrote the poem "Red Darkness" in response to my paintings, and then we had my show. We put up some of my painting drawings, and we had a slide projector that was showing some others. At this opening, Denis read his poem. But the funny part of "Red Darkness" is this. Denis said, "You know when I did 'Red Darkness,' I put all the lines in a hat and then I went to an AA meeting, and however the lines were pulled out of the hat was the order of the poem." I was like "You took 30 years to tell me that?" The poem came out in the book *The Veil*, which my painting is on the cover of. When the book came out, a review from the *New York Times* said that they loved the book, but they specifically pointed out that "Red Darkness" was a bad poem.

SB: And what do you think?

SM: It is. It makes no sense. When you read that poem, the lines are amazing, but from line to line it is not like other poems. Compare that to the poem, "The Veil." I didn't realize it but the part of the weakness of "Red Darkness" was that Denis let people pick lines out of a hat. But this poem was, oddly, a collaboration too.

SB: "Meeting a Stranger" is a collaborative piece you did with Sharon Olds which *Peripheries* is publishing in this issue. I read an interview in which you said that you had chosen to work with Sharon's poem, "Meeting a Stranger," because there was less imagery in that particular poem than in some of her other work. Because it was more abstract, you felt like you could work with it a little better. Was this selection process also true for *Reflecting on Red Darkness*?

SM: Yes, in some ways. I really wanted to find a poem of Sharon's where I didn't feel hampered by a narrative. I actually found one of the early maps of the Americas and based my work on that. In *Reflecting on Red Darkness*, I was trying to channel into the drug ideas of the poem. Another image in the animation is of a guy standing in darkness on some rocks looking into the distance. That image is actually based on a photograph of Denis by the rocks in California right before he died which Cindy, Denis's wife, sent me.

SB: And the line that accompanies that image is "Night like a thing."

SM: Yes. I love that line in the poem as well as the line, "the geography and pornography of your face."

SM: *Reflecting on Red Darkness* does not follow a narrative so much, but I did want to go back to the language of it. Reiterating Denis's language was a way of honoring it. Language was so important to Denis and he was so precise with his words, extremely precise. Most people think he was casual because they think, *Oh, he was a drug addict for so long he would just write.* But he wrote an essay for a catalogue for a show of mine in 1991. I remember I gave it to my dealer in New York and my dealer said "This is great. I'll just correct the grammar and we'll print it." I mentioned it to Denis and Denis said "Fuck him. My grammar is perfect. I was taught by the Jesuits." Cindy told me that when he read at literature conferences, he would attend seminars on grammar just to listen in. He was always reading grammar books. Everything appears off the cuff in his work, but it's not.

SB: That makes me think of the introduction Denis did for your book *One Man By Himself: Portraits of Jon Serl.* In it, Denis quotes from Walt Whitman's preface to *Leaves of Grass*: "This is what you shall do: Love the earth and the sun and the animals, despise riches, give alms to everyone that asks, stand up for the stupid and crazy, devote your income and labor to others, hate tyrants, argue not concerning God, have patience and indulgence toward the people, take off your hat to nothing known or unknown or to any man or number of men, go freely with powerful uneducated persons and with the young and with the mothers of families, read these leaves in the open air every season of every year of your life, re-examine all you have been told at school or church or in any book, dismiss whatever insults your soul, and your very flesh shall be a great poem and have the richest fluency not only in its words but in the silent lines of

its lips and face and between the lashes of your eyes and in every motion and joint of your body." Denis throws in this text to describe you, Sam, as an artist. But I think he is also describing himself.

SM: Yes. There are different ways to be educated and that's why he has that Whitman quote in there. Don't just trust your teachers, trust the person on the street, the "uneducated" person. That is the way Denis was and that is the way that Sharon is too. They are both totally engaged in education and teaching, and yet they both appear to be ignorant. People think they don't know anything, but they're both very concerned with the structures and histories of their craft so that when they break the rules, they *know* that they are breaking them.

SB: I'm thinking of the precision in Denis's books such as *Incognito Lounge or Jesus's Son*. On the one hand you have this narrator named "Fuckhead" who doesn't know anything, who is totally drifting. On the other hand, the voice in those books is totally prophetic. It takes careful editing to get that kind of ignorance. But this is everywhere in Denis's work. You mentioned Denis's poem, "The Veil," earlier. Why are you drawn to that poem?

SM: Well it starts with ["…of an afternoon and gave them back to themselves / oilier a little and filled with anonymous boats"]. This poem is all about light. And it ends with somebody putting down "a blazing credit card on a plastic tray / and you'd know. You would know god damnit. And never be able to say." That line was what I would use to teach. This idea that you know it, but how do you speak about it? I learned so much from Denis that year because we went to

the bars every night. He loved going to the bars, as he said, to get his "contact high." He just loved being around people who were high. Denis said another great line to me. We were at my studio and he said, "Anything is possible and it could be extraordinary." I laughed and said "Yeah, it could also be totally shit."

SB: More generally, what about illustrating poems makes you a better reader?

SM: This is more about the way I am as a person. I draw to understand the world. Some years ago I remember looking at something and I said "I love that." And I said "What does that mean? Why do I love that compared to that." And I sat there and drew the thing I loved. So for me, by drawing, I pay more attention. It's the same when I look at a poem. By drawing a poem it makes me think, *Okay, what's happening in the language?* In painting of "The Veil" on the cover of Denis's book with that same title, the guy is at the table and there is a diagonal shaft of light. All of that was me thinking about that idea of "where light passed through." Do you have those lines from the poem?

SB: "…where light passed through the liquid in the glasses / and threw itself on the white drapes / of the tables, resting there like clarity / itself, you might think, / right where you could put a hand to it."

SM: Right, that's the line that I love, "like clarity itself." Those shafts, the yellow and those things coming through, and the red, and the drawing would go through that into another part of the painting, maybe through the red or the yellow, just a line, like the part where the guy is at the table, that

way of seeing things differently.

SB: I don't usually hear "Sharon Olds" and "Denis Johnson" in the same sentence. What are the similarities and differences between working with these two writers?

SM: They are both very similar as people in that they are both 120 percent nonjudgmental of anyone. I always thought Denis was the most nonjudgmental person I'd ever met until I met Sharon. They're both also just channeling. They see everything. You could walk down the street with Denis and he'd say, "Did you see the way that guy was smiling?" But also they are remarkable in the way that they can find something in one word. Both of them seem so loose, but they're both also so indebted to their craft that they can jump off of one thing and end up a million miles away. It takes a long time for someone else to figure out how the things are tied together. I was with Sharon Thursday night when she got this inaugural poetry prize [Joan Margarit International Poetry Prize]. The King of Spain came to give it to her, and she started by saying, "You know, I was really afraid there was going to be a lot of bowing involved. And I remember as a girl all these Japanese families had their homes taken away and they bowed all the time." And she went go on, "And that taught me how it meant that I am here for you." It's taking one experience and filtering it and all of a sudden you are somewhere else. Sharon meets the King of Spain, and then talks about bowing, and then talks about Japanese internment camps, and then brings it back to the present moment. Denis was like that too.

SB: I've heard you lecture before on Jimi Hendrix's rendition of "The Star-Spangled Banner." What you're describing here

sounds similar, a thread that the artist generally follows through, all the while leaping in and out of an explicit recognition of that thread.

SM: I mentioned that to Denis specifically about The Laughing Monsters. I said, "You know DJ, this novel really makes me think of Hendrix's "The Star-Spangled Banner." You know where you are and then you're just lost, like where the hell am I, and then you come back and you know the song again." And he was like "That's exactly what I was trying to do! That's the best compliment." Denis loved Jimi Hendrix. We talked about how you can be on a riff that is so known to everyone, and then slowly it's just gone, and then you're totally without it. And how do you find your way back? That's a standard jazz motif.

SB: But it's nice to have it transferred to other mediums.

SM: Right. For Denis, that was because he was really always a poet. He became a novelist when Tama [Janowitz] got $10,000 for American Dad and he got $1,000 for Incognito Lounge. He said "Fuck that, I'm going to start writing a novel." And then he wrote Angels.

SB: I've always felt that Jesus's Son, for instance, is more a collection of poems than stories.

SM: Yes. When you look at his books, traditional narrative structure is not really the thing he cared about. Compared to other novels, Denis's work is much more poetic. Look at Tree of Smoke. I gave that book to a Vietnam veteran at Yale and the guy said "I read this and it brought back the smell of Vietnam." I told Denis and Denis said, "Oh, thank God,

I only went to Vietnam for two weeks, and I went because I wanted to know what it smelled like."

SB: That's great.

SM: And I'll leave you with one last thing. Have you read *Largesse of the Sea Maiden*? Read "Triumph Over the Grave." That story is really about a friend of Denis's. Denis took care of him when the friend was in hospice. That guy is also one of the characters from *Jesus's Son*. When Denis met him at an AA meeting his friend had just gotten out of prison. One morning that guy got up to go to work and he realized there was a dead person on the grill of his car from the night before. That's the guy from the story, the character who is losing his memory. And that story is as good as anything that Denis has ever written.

SB: That *is* a good thing to leave me with.

SM: And the other thing to know is that Denis finished *Largesse of the Sea Maiden* before he realized he was sick again. So the final line of "Triumph Over the Grave" says, "The world keeps turning. It's plain to you that at the time I write this, I'm not dead. But maybe by the time you read it." He didn't know at that point that he was sick again. Only a couple weeks after he turned in the book, he got the diagnosis again. Then he was dead fifty days later.

Sam Messer, still from *Red Darkness,* hand-colored etching, 2017

Sam Messer, still from *Red Darkness,* hand-colored etching, 2017

Sam Messer, still from *Red Darkness,* hand-colored etching, 2017

Sam Messer, still from *Red Darkness,* hand-colored etching, 2017

Meeting a Stranger

When I meet you, it's not just the two of us meeting.
Your mother is there, and your father is there,
and my mother and father. And our people -- back from our
folks, back -- are there, and what they
might have had to do with each other;
if one of yours and one of mine
had met, what might have happened is there
in the room with us. They are shadowy,
compared to us, they are quivers of reflected
light on a wall. And if I were
a German, and you a Jew, or I a
Jew and you a Palestinian,
or, as this morning, when you are an African-
American woman, and I am a WASP,
one of your family might have been taken
from their home, and brought through murder to murder
by one of my family. It is there in the air
with us. And if you're a woman in the city
where you live, and I am staying at
the hotel where you work, and if you have brought me
my breakfast on a tray -- though you and I have not
met, before, we are breathing in
our lineages, together. And whether
there is guilt in the room, or not, or blame,
there is the history of human evil,
and the shame, in me, that someone I could be
related to, could have committed,
against someone you are related to, some
horror. And in the room, there is
a question, alive -- would I have risked harm
to try to protect you, as I hope I would risk it
for a cousin, a niece, or would I have stood
aside, in the ordinary cowardice and self-
interest of my flesh now sharing your breath,
your flesh my breath.

 Sharon Olds

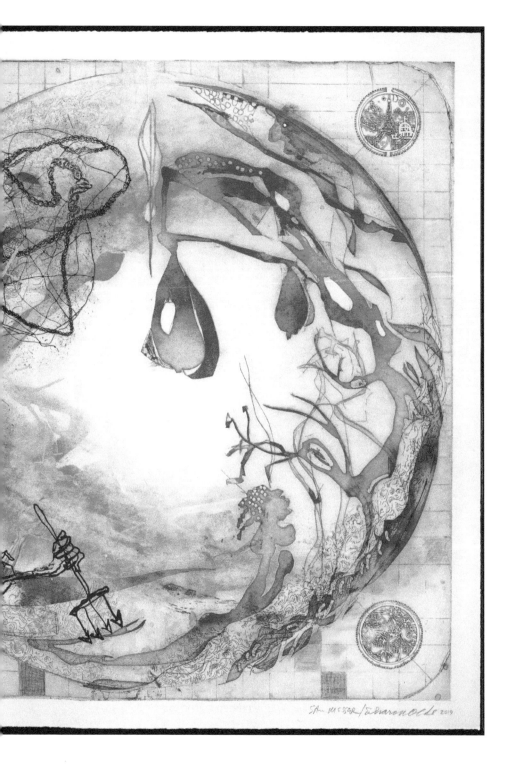

Sam Messer, *Meeting a Stranger,* etching, silkscreen, and letterpress, 2019

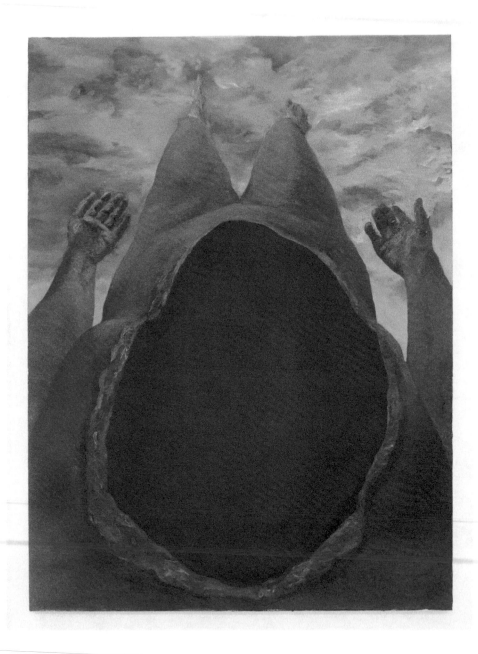

Maisie Luo, *Inside Blue*, 2022, acrylic and oil on canvas, 36" x 48"

Letter to My Future Self as a Previously Incarcerated Writer

PM Dunne

Writer, you hold a flame in your hand,
or is it the blade of a sword or a spear—
the tree of knowledge of good and evil,
or a staff to make wondrous signs appear?

-Santob de Carrion

That some men find joy in other men's pain is a truth
we're still, and always will be, contending with. The Word,

the great doggerel of tyrants, offers nil on the subject,
while giving poets a reason to be more than poets.

Growing up in the schoolyard, our cruelty was clichéd.
Now it's innovative—toothbrush daggers, locks in a sock,
boiled baby oil, arroz con crushed glass—paid in kind.

Cell full of books, an old timer lit himself on fire to protest
his tenth parole denial. Immolation's always done pro se.

In here a little verse goes a long way, filling our lungs
with sky until gray clouds expel the unknowable.

Par avion. Life's a sentence in The Book of the Dead:
each breath, each tear, takes as much as it gives.

II.
Years ago we wielded our pen for others,
against others, and learned firsthand

the nature of ink and blood. Before that, we wrote
ourselves into being as the local papers wrote us off.

There isn't much my verse can tell you about mercy.
Like all convicted artists, we had to survive on our own—

in a cold cage with a pocket-sized Gideons, a bag
of skunk, a matchbook, and our private revelations—

but we did so out of fear, animalistic purpose;

to be honest, we were just a child playing an adult,
more afraid of death than we were in love with life.

Whenever the cherry flickered, smoke whirling
in our face, we'd close our eyes, hold our breath,
like them older kids at Elm Park once taught us

and wait for earth to stop spinning on its axis.
Nobody ever told us, then or now, that it doesn't,
that living blind and breathless in a fleeting world
wouldn't change the past or future. Absolution's

a privilege of the ignorant, a burden of the wise.

More than anything, excluding women,
you'll want to feel the weight of our crimes, letting
gravity turn our pen into a planchette.

III.
Lately you've grown tired of doing things you can't undo,
but, tell me, what good are these lonely scribblings?

Too few of us trust ourselves enough to know another,
to brave the offer of an empty hand, fearing we'll be bitten,
so we clench our fists and watch time descend upon us

like a coffin lid. Prison gates close with a deft finality,
yet it's easy to think otherwise—except during lights-out,
when grown boys play manhunt with their shadows,

and poets, lost in the din of time, recompose themselves
via moonray—swallows crooning O glorious morning!

Everybody's got a release date, even lifers. Some return
to family; others, to potter's field. Unrest assured, friend,

there's no guarantee we'll leave this place in one piece,
or that there's anything after but epigrams and weeds:

Our dreams of freedom are the same
as a free person's dreams of heaven

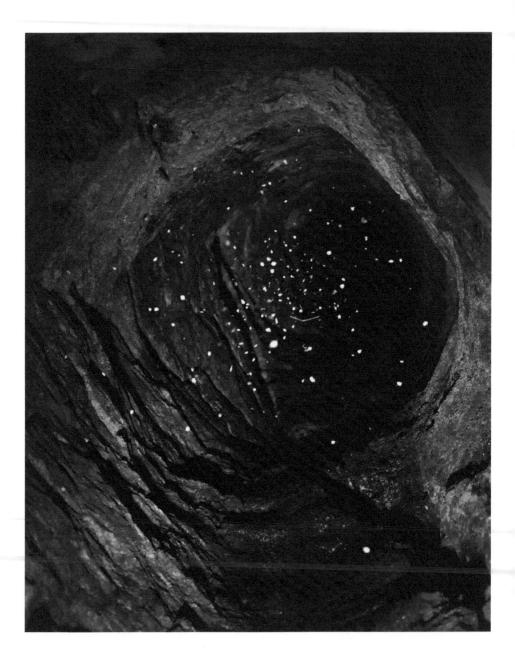

Chloé Milos Azzopardi, from *Les formes qu'illes habitent en temps de crise*, 2020

Sacramento Adoptionis

PM Dunne

The windshield is a blank monitor, night pulling
them face-first into dusk—father and son, strangers
to long vowels and stars (one will forgive nothing
as one tries to forget) staring at old maples
and brownstones as the son crashes toward his future
then whiplashes inside—blinded in gun flashes
of scarred fists until space falls to a day breaking.
When glass shatters the son bursts into red pixels,

although eons have passed through undefiled quotients.
He drinks like an adumbration of his father
as light pours in the gray casket and night smiles.
The bar claims what it earns, carnage of youth's tender:
a rerun on the boob tube of a householder
with two wives and a kid, fido and fluffy on
the couch, flames in the hearth billowing moonflowers

of smoke. Nothing is left but the unraveling,
 the brocade of a leaf-strewn boulevard lining
the son's path on his long trip out of perdition

The Silence of Those Who Cannot Speak

Never cherished life
until I took one.
Watched a soul
leave a body
through wide eyes.
It was quiet
peaceful even.
Between night & day
the scene
like a negative
superimposed
on the moment.
Burned into my retinas
for an eon.

* *

Although I won't be
here forever
I feel as if the blood
on that knife will.
Crying with Abel

in the clouds
& dew covered fields
the crushed glass
of the deserts
& plasma of earth
black as this period.
I can try to
put into words
the silence
of those who cannot speak
for themselves.
But only because
I am *here*.

On the Limits of Empathy, Which May in Themselves Be Transcendent

Daniel Kraft

There still exists a garden, and its trees
bear hollow fruit. Inside the fruit,

absences which are divinity.
They're like the sky tonight,

they hold no words.
The emptiness within the fruit

is letters lovers wrote, the ink washed clean,
colored like torn scraps of a bedsheet in

a Polish field. Your mother picks
the fabric up. It's damp with snowmelt,

and she ties the bedsheet as a blindfold on her face.
Light spills through its frayed fabric.

She inhales beads of mildewed water,
not thinking yet of anything like you.

I don't know what she sees that day
in Poland, with a ruined bedsheet

on her child's skin, why she stands
alone in that empty field,

what this all means to her,
or why it's brought her here,

into this poem. I've never heard her voice,
and I don't even know her name.

The Wages of Mysticism

This mistake lingers from the Renaissance,
to think the cherubim are beautiful.
They are incarnate terror
and Ezekiel was not (as no one who sees them can be)
a happy man again.

A sanctuary
of my own and no one else's making
is this desert home I visit, crawling
like a hurt dog
through its empty rooms. Burn
the incense. Squeal and bray,

thank God I have
a house in which to make inhuman noises.

An Aching of Earth

Vincent Katz

I will see this through
I didn't get very far
But I got all the way

You look at it in your photograph
And it doesn't look as good as it does in real life

Be still, the tall white tulips are fantastic
And everyone is full of life

For John

People create lives
Families occur as lives grow
Together and with separation

Drums in the park at night
And another music people congregate to
The musics mix, and the people, walking across in the dark

Rhythm comes out of the dark, bonding
People, blending them
Back in the streets, people are walking

There is a slowdown, is there no mystery, or is there?
Something different from what appears
A tendency toward life that is not darkness

The Salesman

Louis Harnett O'Meara

The cottage was white, stark against the greens and greys that spanned around it: the dark edges of the forest, the garage, the dry-stone walls bordering the garden, neatly mown. His fingers pressed against the edges of the frame. In it, an aerial photograph of her house, a metre by a metre. When it was taken, it was sunny. Now it was dark, and he was standing in the rain.

"Hear me out now, I'll take two minutes of your time, just two minutes," he said. "I promise you that."

She peered over her glasses: a salesman. "Well," she said. "You'd better come in."

*

A widow in her eighties with two children who she was deeply proud of but rarely saw, Mrs McMahon had become accustomed to spending time alone. Her husband had passed when she was fifty and had done so slowly: first from sanity, then from life. She worked another ten years, retired, then left Dublin for the west coast on a teacher's pension. Purchasing a home in a fishing village where his family had lived and he was buried, she hoped she might find peace.

But sometimes the stillness was too much. A life in city classrooms did not prepare her for the endless fields of turf and gorse, the iron sea and the empty greyness of the sky. The pubs were lively, but the townsfolk had looked at her suspiciously when she first arrived. Over time they warmed to her, but still she was a blow-in, even now. She made friends where she could: with tourists, second cousins, with those who came to mass from out of town. Blow-ins stick to blow-ins, after all.

"Sugar?" she asked, laying the tray on the dark wood of the coffee table. A white cube followed tea and milk. The china tinkled as she stirred.

"Nice place," he said, leaning back in his chair. Reaching his feet toward the fire, he ran his eyes along the mantelpiece: a polished brass carriage clock, a wicker bowl of potpourri, a Madonna in miniature and two wooden icons, saints Christopher and Anthony. There was a photograph of two women, daughters, by the looks of them, and a black-and-white one of a man.

"Your fella?" he asked, nodding toward it. He received his cup and saucer with both hands, and she settled opposite on the settee.

"Well go on then," she said, ignoring his question. "Sell it to me."

He sipped his tea and the peat crackled in the grate. The aerial photo in its frame stood propped against his chair.

"I come from Strabane," he said. "It is, I know, a way from here. When I left, I was looking for privacy—something I had never found at home. There are a great many of those busy-body types in Strabane, a great many indeed. People all too often keen to know your business. And though I am not an un-forthcoming man, I do not, by most accounts, seek to share a great deal of my life. I respect the discretion of others

and expect my own to be respected. I trust you feel much the same?"

She nodded.

"And so I come to you with an apology. This photograph is, by all rights, already yours. It is not proper that it has fallen into my hands. It does not respect your privacy. I know this. However, I can't help that it's with me now. Nor can I help but know its value. I'll offer it to you for a fair price: three hundred euro, the frame included. Now you can take it, or you can leave it. It won't bother me either way."

Returning her teacup to the table, she sighed. "Strabane," she said. "I once knew a fellow up that way. Not an altogether pretty place, from what I gather."

She pushed a plate of biscuits out toward him, gesturing he take one, and he did. The firelight caught his hair, slicked back. He wore black trousers that needed pressing and his skin was chalky white. Black shoe-polish, thickly applied, sparkled cheaply on his toecaps. He ate the bourbon in a single bite.

"I dare say you'll take two-fifty and save an old lady a trip to the bank?" she said.

He looked surprised, then nodded.

"And the bed-and-breakfasts up in town, they're not so good. I'll put you up the night. We can settle in the morning."

*

Heard in the hallway from the lounge, her voice rang out with the unnatural loudness of the elderly on the phone. "Not your business," she said. "Not a bed you've used in months."

His case bounced against the mattress. A bedroom was a pleasure, not one the salesman had anticipated that

night. He had been on the road a long time, and a chance to hang his clothes, to lay his tobacco on a table, seemed to him a novelty.

To say he was from Strabane was not quite true, though it was not untrue either. Born along the border to a travelling family, boundaries had been porous for as long as the salesman recalled. His folks would not know if they were in the North or South, whether the fields they would stop in were public or private land. Nor would they much care. Why should a thing be one's and not another's? The copper cables that lined a railway track might just as easily wire a faulty motor. A bitch could breed a litter, instead of yapping in a stranger's yard.

The weakest of the bunch, the salesman was granted bruises by his father often. Once old enough to leave he did. He learned to make distinctions: a shopkeeper's knuckles taught him to ward his fingers; a farmer's rifle to mind where he would lay to rest. The value of agreement and transaction became clear to him, as did the dependable edges a suit would bring. He became a fair man. To give and take judiciously was key.

He finished his unpacking, stowing a map of county Galway in a drawer that he shut tight. Beneath the bed he slid his empty case. He rolled a cigarette and smoked it from the window. Its ember vanished in the night.

<p style="text-align:center">*</p>

The faded bougainvillaea that wound across the wallpaper, well known to Mrs McMahon by now, seemed to tangle up her thoughts as she sat propped up in bed.

Her eldest, Cara, offered a familiar refrain when she'd called: gently corrective, considerate—but interfering. It was

she who had stopped the fish van's daily visits after finding in the freezer too much mackerel, stacked dormant and dead eyed. She made clear often that she thought she knew what best, as if she'd forgotten who the parent and who the child. A strident tone she'd taken on the phone that night. But Mrs McMahon would not be put off. The salesman would stay.

She unfastened her white hair from its bun, letting it fall against her shoulders. Switching off her lamp, she lay and listened to the patter of the rain against the roof. The salesman, his face young, looked much as her husband did when he was just a lad. Not a rich man when they'd met, but they had danced together, he taking her hand and then her waist as he guided her about the room. He'd been wayward in his youth, and so she had guided him also. Many years were happy. But in time there came a new waywardness, ungovernable toward the end.

<p style="text-align:center">*</p>

The hammering cut through the kettle's whistle. It had been put to him with no adornment: she would pull together breakfast while he would hang the picture in the lounge.

He eased it down until he felt the cord behind it twinge. Taking three steps back, he eyed it. Spotted among the tasteless ornaments of a flea market in Letterfrack, he'd known it to have some worth, even there. A domestic scene, it reminded him of homes he'd passed, perhaps a little longingly, when he was young. The number of the house was clear and, coming close, you could make out the street name on a plaque against the garden wall.

"Good man," Mrs McMahon said, ushering him into the dining room. Two plates were laid with bacon, eggs and soda bread, thickly sliced. Sunlight illuminated steam that

gusted from the teacup as she poured.

As they ate, she spoke. Two daughters, she told him, both in the medical profession, one in Dublin and one in London, both marvels in their own ways. Of course, their visits weren't so regular, due to the distance and all. But she had her independence, as did they. They had learned to stand on their own. Their father would be proud to see them now.

Though not expecting it, the salesman enjoyed her steady chatter and his not having to speak. If he were another person, he might have known her speech for what it was: a little hospitality. But he did not seek to classify experience, and so knew it only by the warmth it brought him, a nourishment like the food he ate. He smiled and nodded, forgetting himself a little and falling into the old woman's musings and repetitions.

"He'd be proud to see them now," Mrs McMahon said again. The salesman enquired on this point.

"A good man, he passed too soon. Not all there by the end of course, but it's common enough. Perhaps not so young as that, but common enough." She looked out of the window at the greenness of the garden and smiled at the way the sun lit up the yellow flowers in bloom.

"He trained to be a plumber," she went on, half-joking that the drains had never been quite right about this house. She turned to the salesman. "I don't suppose you know a thing or two about a faulty pipe?"

He said he might, could certainly have a look. He asked, a touch embarrassed, as to when he should expect the money for the picture, and she waved her hand and said the money would come. She would wash the plates and he would take a look at the toilet nearest to her room. "Nothing major, I'm sure," she said. "Should be no bother at all."

*

Cara drove quickly. She couldn't get through to her mother when she'd phoned again last night. With no cover for her morning shift, she had fretted as she worked and left without changing from her nurse's scrubs.

The evidence was growing. Last time it was her mother's hobbling, unexplained for weeks before eventual confession: a fall along the river path when on her way to church. The priest had warned of fresh inconsistencies not so long before, of journeys to morning mass on odd days and at all hours. And the pub landlord, Pat Joe, said that often now she called him Brendan, a man unknown to him but who, Cara knew, in a bar in Dublin some twenty years ago had played a similar role in pulling pints.

These small confusions had come first with her father: reading glasses misplaced, his toolbox forgotten before he left for work. Mishaps that soon became preludes to rage. One day, then many, he would pull his cap low over his eyes, demand to know why people went about hiding his things. Correcting him would see the house turned over. He would play his disappearing act, be gone for days. He had never been an angry man before.

Cara had not handled matters with tact last night. She thought of her sister in London, who'd calmed their father in the past. Their mother's mind was not what it was. She needed that light touch now.

*

"The money first."

"I only ask if it's no bother. Such a good job you did on the pipe."

"Listen here now, I'll need the money first."

"It's clear the wall could do with it. There's a bucket of paint in the garage." She handed him a pan, pointing toward a cupboard.

"We had agreed."

"It will only take a moment, and then I'll fetch it. The money will come."

Mrs McMahon waved her hand as she spoke. Lifting two plates from the drying rack, she planted them onto the shelves before putting the last two mugs away. Turning back, she saw the salesman eyeing her. She paused, as though looking for something in his features. Then she blinked and shook her head.

"The money will come," she said. She headed away through the house.

The salesman slowly opened the cupboard and stowed the pan. To fix the toilet had not taken long. Nor hanging the picture. Nor helping to put the washing away. And it was clear that there was some parity in the tasks as they were shared about the house. Breakfast had been served, a generous one. Conversation had been granted, as had room and board. But these trade-offs were unfamiliar to the salesman. Things were not agreed, no prices set. The rule was cardinal in his trade, a maxim his father drummed into him also: always, always, the money first.

The foolishness of his actions now did not escape him. Heading to his room, he pulled his empty case from beneath the bed and began to pack his things, pulling his shirts from the wardrobe where they hung. His map he took from the bedside drawer and his tobacco from above it, stuffing both into the pockets of the jacket he pulled on. Stopping for a moment, he checked himself in the mirror: case in hand, suit complete, ready again for the road.

Passing back through the hall, resolve steadied, he entered the lounge where he would wait for Mrs McMahon, announce his departure and claim the money that was his. But there, he found her already sitting, idle on the sofa. She smiled at him.

"Good morning," she said, then glanced at the carriage clock. "Or is it afternoon already?"

"I'll take the money and then be going."

"The money?" Mrs McMahon blinked and looked about the room. She frowned. "I'm afraid I don't know what you mean."

<p style="text-align:center">*</p>

Cara's tyres crunched against the gravel drive. She didn't see the fire's glow from the living room, as was usual at this hour. Only the familiar silver Skoda was in the open garage as she parked. The salesman had been and gone. But there was no sign of her mother stepping out to greet her. With the key beneath the plant pot, Cara entered by the back.

The theft was partial. The china tea set was missing from the dining room cabinet, though the gold-lipped whiskey jug wasn't taken. A mirror in the guest room was gone, though nothing vanished from the kitchen. In her mother's bedroom she found the drawers thrown wide, clothes strewn. The mattress had been turned over. Looking into the lounge from the hall, there were gaps along the mantelpiece and the aerial photograph—an eerie thing—was newly hanging on the wall. Uneven breathing was coming from inside.

Her mother was seated, crying on the sofa, a sight once unthinkable but all too common now. Her hands clutched a photograph, black-and-white. Cara recognised her father. Then she heard words repeated, muddled at first then

unmistakable.

"He's gone," Mrs McMahon said. "He's gone again." She said she wanted to go home.

*

The dusk was soft, wipers displacing the fine rain that had begun to settle on the windscreen of the car. The salesman had stopped to gain his bearings in Galway town, intending now to head to Cork, where an antiques fair was popular among the county Mayo crowds. Turning sharply, he heard the crack of glass. Likely the mirror, too hastily packed. He resolved to drive more slowly.

His actions did not make him proud, though regret was not a sentiment that would serve him either. The mess was, of course, unfortunate. He had felt anger when he couldn't find the money, and sadness when he realised it wasn't there. Just the twenty-five euros, stashed beside her bed. Not enough, not nearly. But a deal was done and would be honoured, in one way or another. He was a fair man. He would make up the rest, or thereabouts, by selling on what he had taken.

In time the evening thickened. Lamplight on the roads between the towns was rare. On the radio country music played, the lyrics about the wild and travelling. He switched it off.

Before leaving the house, the salesman had felt something he couldn't explain: an urge to take away with him the photograph that he had sold her. The thing would go for little, if anything, if he tried to sell it on again. He had no wall on which to hang it, and its contents—the cottage, the garden, the garage—were not his. Still, the thought had tugged at him. But the impulse was just that, an impulse,

and then was gone. Scrutiny would bring nothing. He would continue on, as he had always done. The headlights revealed only the road that fell before him, and the whiteness of the rain.

Dois Poemas De Amor À Morte

Affonso Romano de Sant'Anna

1

Não me canso do estudar a morte
Como é fértil e reverbera novos ângulos
conforme a hora em que entrevejo
na minha trajetória.

Preencho-a de significado vários.
Ela cresce, me fascina, me enriquece,
me habita viva feito feira
que parece domesticada e, no entanto,
soberana
 - mansamente me devora.

2

Vou ficar de vez na porta deste cemitério.
Aqui já enterrei dez corpos num só ano,
e vejo outro esquife dobrando a esquina.

Vou ficar de vez na porta deste cemitério.

Farei aqui minha tenda como os antigos
que ali montavan feiras e quermesses
como tranqüilos inquilinos.

Vou ficar de vez na porta deste cemitério.
Assim já não serei suppreendido
quando de novo me morrer um outro amigo.

Aguardarei aqui a morte
que há algum tempo começou a a chegar. A morte
que há muito tempo começou a a cavar. A morte
repetentina, que diariamente abre sua oficina. A morte
matinal e vespertina.
 A minha morte
que há muito tempo
nasceu em mim, em Minas.

Two Mineiro Poems on the Love of Death

Affonso Romano de Sant'Anna

Translated from Portuguese by Lloyd Schwartz

1

How could I get tired of studying death?
What a ripe subject, new angles shooting out
according to which hour its blur
darts across my path.

It overflows with all kinds of meanings.
It never stops growing. It grabs me.
It makes me richer. It lives in me like a wild animal
who seems domesticated yet remains
master
 —and tenderly chews me to bits.

2

I'm not going to budge from the gate of this cemetery.
I've already buried ten corpses here in just one year,
and, look, there's another coffin coming around the corner.

I'm not going to budge from the gate of this cemetery.
I'll pitch my tent here, a peaceful tenant, like the ancients

who once mounted their fairs in the same place, their *kermesses*.

I'm not going to budge from the gate of this cemetery.
So I won't ever again be surprised
when another friend dies on me.

I'll wait for death,
who once upon a time began turning up here. Death,
who once upown a time started to dig. Death
matins and vespers. Sudden death,
who opens his office daily.
 My death,
who once upon a time was born
in me, in Minas.

Preparando A Casa

Affonso Romano de Sant'Anna

Meu amigo visita sua cova
como quem vai
à casa de campo plantar rosas.

Há algum tempo
comprou sua casa de terra.
Plantou árvores ao redor
e de quando em quando vai lá
como se vivo
pudesse fazer o que só morto fará.

De vez em quando vai ver
como seu morte floresce.
Olha, pensa, ajeita uma coisa e outra
depois volta à agitação da vida:
ama, come, faz projetos,
pois ja botou a sua morte
no lugar ela merece.

Getting Ready the House

Affonso Romano de Sant'Anna
Translated from Portuguese by Lloyd Schwartz

My friend goes to visit his grave
like someone going
to his country house to plant roses.

Some time ago
he acquired this little homestead.
Planted trees around it,
and occasionally he'll go there
as if alive
he could do what he would do only if he were dead.

From time to time he'll see
his death beginning to blossom.
He'll look around, think, straighten something or other out,
then back to the business of life:
making love, eating, inventing projects,
having already left his death
in the place it deserves.

Eles Estão Se Adiantando

Affonso Romano de Sant'Anna

Eles estão se adiantando, os meus amigos.
Sei que é útil a morte alheia
para quem constrói o seu fim.
Mas eles estao indo, apressados,
deixando filhos, obras, amores inacabados,
e revoluçöes por terminar.

Não era isto o combinado.

Alguns se despedem heróicos,
outros serenos. Alguns se rebelam.
O bom seria partir pleno.

O que faço? Ainda agora
um apressou seu desenlace.
Sigo sem pressa. A morte
exige trabalho, trabalho lento
como quem nasce.

They Are Moving Along

Affonso Romano de Sant'Anna
Translated from Portuguese by Lloyd Schwartz

They are moving along, my friends.
I know death is useful in others,
those who put our lives into perspective.
But they are racing, rushing,
leaving their children, their work, their love incomplete,
and revolutions to finish.

This wasn't part of the bargain.

Some leave heroically.
Others in peace. Some rebel.
It's best to leave full.

What am I supposed to do? Even now
there's someone trying to accelerate his own denouement.
I'm not in such a hurry. Death
demands work, work
as slow as being born.

Na casa de Elizabeth Bishop

Marina Colasanti

Sentadas nessa horta
-ou seria um jardim?-
desfolhamos lembranças.
O passado desliza
entre almeirão e dálias.
O nome de Lili resvala nas cravíneas
vai Ninita pousar-se
a salsa repicada
acolhe Elizabeth.
Chegam de dentro as vozes dos parentes
que se atardam à mesa
Descomposta do almoço.

A mureta está quente
sob as coxas.
Há um antúrio na lata
um limoeiro.
Eu esfarelo entre os dedos
flores secas
procuro no miolo
cato, assopro.
E enquanto conversamos
relembrando as amigas
vou juntando na palma
o meu carregamento
de sementes.

At Bishop's House

Marina Colasanti

Translated from Portuguese by Lloyd Schwartz

Sitting in this backyard
—or is it a garden?—
we peel away memories.
The past slips by
between chicory and dahlias.
Lilli's name glides through the carnations,
Ninita alights on the chamomile,
bitter parsley welcomes Elizabeth.
From inside come the voices of relatives
who've stayed late after lunch,
the table already in disarray.

The low stone wall is hot under my thighs.
An anthurium flourishes in one pot,
and a lemon tree.
I crumble a dried flower between my fingers
feeling for the kernel, and blow it away.
And while we talk,
remembering our old friends,
I gather in my hand
my own cargo of seeds.

The Wall Follower

Daniel John Pilkington

A blind man enters the maze. He places his left hand against the wall and walks confidently around the first corner. He is confident because he knows that if he follows the wall continuously, never lifting his hand, never turning around, he will eventually arrive at the exit, and while this confidence does allow him to enjoy the rhythm of his footsteps and the cold stone sliding beneath his fingers, he has forgotten to ask a friend to meet him at the exit, meaning, that when he gets there, he will simply travel around the outside of the maze, only to enter it again, as if there had been no exit, and as if he had never been on the other side.

Jan Hogan, *Trembling Stone*, 2023, woodcut and lithograph collage, 31.5" x 23.6"

Jan Hogan, *River Attachments*, 2023, woodcut and lithograph collage, 31.5" x 23.6"

Jessie Hobeck, *Tracing Place I*, 2023,
charcoal, watercolour, collage, and bark beetle tracks on kozo, tracing paper, and card, 11.4" x 16.5"

Pedro Barbeito, *Drawing 73*, 2022, watercolor on paper, 9"x 5"

Pedro Barbeito, *Drawing 85*, 2022, watercolor on paper, 14" x 8"

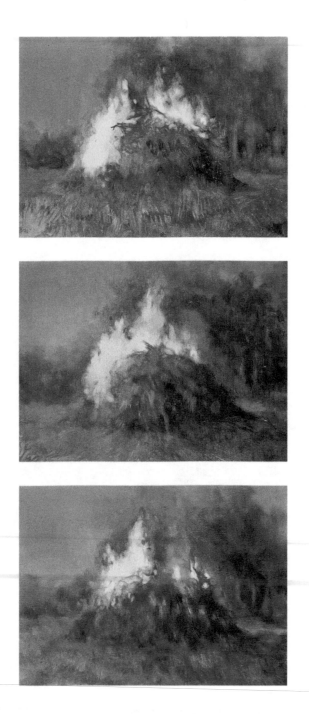

Elisha Enfield, *2301(i), 2301 (ii) & 2301 (iii)*, 2023, oil on wood panels, 5"x 7" each

Haunt, or, In the Atelier

Jo Langdon

'Thank God I don't believe
in ghosts because I would be miserable
alone in the atelier.

Only in these moments do all the tangled little women's
questions and progressions pour
out of my mind,

brushing them always, always and constantly.'

An Ice-skating Rink in the Crater of Vesuvius

Picture the ice violet—which
in a rush to sibilance I confuse
sometimes for *violence*—

there would be bodies, skaters
under paper
lanterns, synthetic

snow; Russian waltzes on cassette
& overhead
ski-lifts, lifting

frames and figures
through air. Unreal
-ised but for her

sketches, written
plans, Alina proposes
'the Peggy Fleming of the moment'

might be together
with spectators swept by lava
into a terrestrial passage—delivery

of movements mortal and pyroclastic,
morbid and preposterous, a fiasca scarcely
met by each dash across the page—

Stage left
by a complete turn
of pirouette & event

Alina's attention glides towards
the warm cavernous wet
mouth space of making

One Day Elsa These Verses

Louis Aragon

Translated from French by Peter Brown

Nightingale, that's enough of singing,
Henceforth this garden is too dark...
-Théophile, *Ode X*

What have I in me that bites me this monster this cancer
Deep within me smothered in vain by me
Now and then I feel it rise in me in fits
It's like another within who would give concerts
Another myself a terrible furious other
Who resembles me but never listens to me
Whatever the cost I must go along in time with him
I overflow with a sublime imperious song

A song concerned as little for myself
As a flame for the hearth or wind for a curtain
As drunkenness for the drunk or the bullet for a living man
A song to shake my poems by the hinges
A song to bring the night of the eagle over its prey
An incendiary song at the hour of high mass
A harvest that leaves nothing behind
A song like plague forever closing in

A thousand violin bows I haven't mastered
Quivering at the downbeat I haven't given
I am a grim conductor for a dazzling orchestra
Within me silence shatters like a windowpane
All at once a thousand quivering bows set off
Attacking all at once their piece with such bravura
And the black violins make my night their day
My secret refrains their violent voices

I am no longer anything but the echo of my avalanche
This language rolling its pebbles along
Too bad if on its way it crushes me wherever I was going
That my heart remain red and my hands be white
Nothing remains of me but a bit of melody
Gusts of wind over shards of glass
A bit of springtime green a bit of madness
One day they'll hear the rest of what I said

One day my verses Elsa will be your crown
And survive me being born by you
They'll be better understood in all their variation
By this the reflection of you the light your hair gives them
One day my verses Elsa because of your eyes
Your penetrating sweet eyes that knew to see
Tomorrow like no one else in the last lights of evening
One day Elsa they'll understand my verses better

And then beneath the drawl of my delirium they'll hear
In the blind words the cries of lunacy
That for this love of you the blossom seeps out
Of the great human rosebush promised to the future
Then they'll hear the never extinguished heart
Then they'll hear the sob beneath the stone

They'll see it bleeding where my ivy clings
They'll know my night prepared the morning

One day my verses Elsa will rise on those lips
No longer sick with these strange times
They'll awaken the trembling children
And teach them love was never just a fever
That it's untrue that age must surely conquer love
That right to the end life and love are one
There are loves bound as well as the vine in the arbor
The wine flows there as long as the vein runs blue

One day my verses Elsa what more would I say
The others who'll read them after will repeat them
My arm is strong enough to bind your knees
Do not expect a brief embrace from me
No longer is there a season for the rose you see
For those who'll one day read my verses Elsa
They cannot separate your name from the universe
With the flesh of their mouths they form your statue

Agnus Dei

Kenneth Baron

I can tell the news is grim even before my wife begins to speak. The slower-than-normal intake of air, the unusual tilt of her head, the narrowed gaze – the many nonverbal ticks and tells, inscrutable to all but a spouse.

Yet as she takes in that breath, cants her head at an atypical angle, reduces her field of vision, etc., I become strongly aware of Samuel Barber's Adagio bleating mournfully in the background of my living room, of my life. This should not surprise me. After all, I had placed the song on this evening's playlist, noting as I did an interesting though rather meaningless fact on the album's cover: This year marks the 100th anniversary of Barber's birth. That fact sparked a tangential, and to me more interesting, observation: The ability to create something – anything – worthy of a stranger's affection is quite an accomplishment. But to create something that causes the world to raise a flag in your honor a hundred years after your birth, as was done for Barber in recognition of that beautifully dour dirge of his, the one to which he remains forever conjoined? That speaks to supreme achievement, to a form of cause-and-effect that surely keeps artists and architects, novelists and poets (heaven reward the optimism of poets!) creating on long nights such as this one.

And so in this suspended moment before Christine delivers her surely bad news, I too narrow my eyes and draw in a slower-than-normal breath, not as a set-up to my own forthcoming broadcast of woe, but to more fully appreciate Barber and his music. His sorrowful tune overtakes me, and I catch myself trying to think of another of his compositions, a happier conjoinment. But I cannot. For me, Barber will remain one of American music's early one-hit wonders. And a glum one, to boot.

I look at Christine standing in front of me. If a film is a series of still images, with the brain creating fluidity by filling in (or perhaps eliding) what is missing, then a marriage is made fluid by eliding what is present. Frustration, jealousy, disappointment, boredom. None of those things are good news. And I much prefer to pretend that they don't exist than to confront them head on. Thus, I decide that the news my wife is about to impart, while bad, will not be about us. Which means that instead of turning us into adversaries, her news will unite us. And to make this alliance a strong one, I further decide that her news won't just be bad, it will horrible, that of a friend's or a relative's death – talk about a dour conjoinment – but a distant friend or relative so that, ok, it will be bad but not harrowing. Such grim news is possible. Statistically probable, in fact. Not because Christine enjoys morbid themes (she doesn't), but simply because of the inevitable decay, randomness, and entropy that governs (and eventually ungoverns) us all. Take a large enough sampling of living rooms across any given meridian and the truly startling news would not be that someone has died, but that someone hasn't.

And what of death? Yes, I am already preparing my reaction – shock? dismay? condolence? – whatever I feel will get me past the "telling" and on to the "reflecting"; that is, on to the "forgetting about it as quickly as God and conscience

will allow." Indeed, I have made yet another observation in this moment of slow air-intaking and ominous eye-narrowing: Each death – other than one's own, of course – is an opportunity to measure one's ability to feel. But more (but worse?) – those who concern themselves with such measuring, as I am doing at this moment, tend to feel the least. Examining one's feelings, after all, is not feeling.

Is there time, before Christine starts to speak, for me to move my attention from Barber to another topic? Oh yes there is. The mind can travel to far-off lands and back again with the speed of light – around the world (of worry, hope, fantasy, doubt, pride, To Do lists, etc.) seven times in a second. There is endless real estate to cover and no "Keep Out" signs for an active imagination. So off mine goes – not to some remote realm but to my own backyard where, earlier this day, my young son has built a snowman. And he's given it a name: George Robertson. An overly specific name to be sure, and one that might suggest issues of insecurity when it comes to keeping friends – permanence through elaborate nomenclature, that sort of thing.

While I am doing this brief backyard farandole with the subject of permanence, another thought arises: What does my seven-year-old son know of death? Not much, I presume. Which is to say probably a great deal more than I – or he – is willing to admit. Perhaps he'll know just that much more come the morning sun and the demise of George Robertson.

Having yoked together Christine's impending news and old carrot-nosed George, I squelch a smile. The instant persists.

Worry, hope, fantasy, doubt, pride, To Do lists. Yes, they're all there maundering around my mental theater. But they can't each occupy the mainstage. Or rather, the one belting out his lines the loudest tends to command the most

attention – and ruin the entire production for the others.

"*Each day you should list three things that you are grateful for.*" "*Do your breathing exercises.*" "*Count your blessings.*" This is a small sampling of wisdoms Christine imparts to me when she senses that one of my bad actors is ruling my inner theater. Which means that those are wisdoms she herself employs, that work for her. And whenever I reply, "Yes, I will do exactly that," she leaves me with a look that says, "No, you won't" or "These things should work for you. Why are they not working for you?" Her effort to solve whatever troubles me is noble. But as many a spouse frequently fails to remember: One doesn't want solutions; one wants empathy.

There is a photo of Christine and me on our living room mantle. A few, in fact. But there's one that my eye keeps coming back to. It was taken not long after we met, more than twenty years ago. We are standing on an empty beach. I have on a long-sleeve striped shirt with a towel draped over my shoulders. My hair is thick and windblown. My eyes are hidden behind fashionable sunglasses. I look, I think, quite good. Christine is wearing a flannel shirt and a baseball cap that displays a lighthouse. Her eyes are clear and bright, her arms are around me, and we are both smiling big, hearty smiles at whoever is taking the picture. One can instantly see why my wife likes this image, why she displays it so prominently in our home, and why she used it on the cover of a book of photographs that documents our life (so far) together. I've thumbed through that photobook more times than I can remember. And each time I pick it up, I find myself taken by the pages of smiling faces and happy moments. But I also feel, if not the presence of something counterfeit, then some artful manipulation at work. Life cannot be page after page of good moments. I know this, of course, despite what those maundering actors "fantasy" or "hope" would try to have me

believe. So what to make of all the unsunny moments, the ones that are not framed and published but that are as real as that beach, that embrace, and that forgotten photographer? The answer, Christine would say, is to embrace it all, the unsunny and sunny, the bad and good alike – to find and sustain beauty in the unedited maw. *Do your breathing exercises.*

Can one talk oneself into being happy? The better question might be: How can one be happy without such inner convincing? Such a paradox falls squarely into the realm of the philosophers. And after my thoughts return from backyard snowmen and long-ago beaches to my living room and the looming Christine, these two contradictory questions cause Socrates' old connubial saw to come to mind, the one he offered up to a groom-to-be, which, when boiled down to its bitter core, declared that the man would either have a happy marriage or he would become a philosopher. (I once had a college professor define philosophy as "the art of asking questions" – even if, he quickly added, those questions have no answers.)

Is Christine eager to tell me her horrible news? I feel that she is. Further, I feel that while the news will cause her sorrow, she will find some joy in telling it to me. Another paradox. And this one not foword hyperbolically, of course, but also as a man who returns home from each visit to her ancestral land with a stiff neck and the cowed fade, sex drives can jump the guardrail, but language holds strong. Unlike impetuous romantics, I know that love is a long haul. Clever banter and a slick turn of a phrase now and again – to say nothing of first-rate Scrabble skills – will survive the

inevitable nuclear meltdown of lost lust.

So is *that* it? Is that her bad news? Is it shining an uncomfortable, let's-take-that-next-fateful-step light on the fact that one of us is lusting while the other is working out how to earn maximum points with seven vowels and no Triple Word play in sight? I do have my suspicions that she might suddenly call it a day, just say "Enough is enough." As I know Christine has similar suspicions about me. One knows one's own bed, as Socrates might have said had he been restricted to five English monosyllables. What Christine and I find in our bed is an old story, and not a very interesting one – except for the poor duo it's about. For us, it is not a five-syllable witticism; it is a never-ending saga. Serialized. In nightly installments. A saga whose passages include verbs befitting the sport of fencing, medical clinics, and fairytales: e.g. parry and thrust, moan and groan, huff and puff, and so on.

Have I let on who the thruster is and who is doing all that nocturnal parrying? The therapist – our therapist – tells Christine and me that in the wider conjugal world it's as much a she-wants-but-doesn't-get situation as it is a he-wants-but-doesn't-get. Thus, I suspect your sympathies will lie with the thruster if you are a thruster and the parrier if you are a parrier. So I'll leave things there. Unsaid. But will Christine?

Agnus Dei! Yes, of course. How could I have forgotten? That's another Barber standout – a glorious composition, too. And remembering it suddenly, as I do on this night, means that my very limited list of one-hit wonders – The Knack, Sniff 'n' the Tears, Norman Greenbaum – can remain intact and firmly rooted in the shallow shoals of late-20th-century pop music. But wait. Isn't *Agnus Dei* simply a choral adaptation by Barber of his *Adagio for Strings*? And if so, doesn't that make him a one-hit wonder two times over? An insignificant honor

– or perhaps a significant dishonor. (I pause to admire my slick turn of phrase, even if the admiration is mine alone.) But *Agnus Dei* – reboot or otherwise – is a composition that I do love (I make a mental note to put it on tomorrow evening's playlist). In fact, I recall having admired it in the past to the point where I'd done a bit of armchair musicology. From the Latin, meaning "Lamb of God," "Agnus Dei" is the name of a prayer used in the Catholic Mass. In this case the one being petitioned is Jesus Christ.

Barber plays on. He's made it a century, so clearly he is here to stay. And me? No, I have no delusions of flags waving in the wind on my centennial. My historical footprint will be limited to a room, to an evening, to an instant. To questions with no answers. *The things that you are grateful for.* They all blend into a night, into *Agnus Dei* and the prayer one utters on bended knee:

> *Jesus, Lamb of God, have mercy on us.*
> *Jesus, redeemer of the world, grant us peace.*

And then Christine – Christine begins.

In the Borrowed Room

Jennifer Barber

I lie, naked as a clock
at the arrival of daybreak.

The serial knock of a woodpecker
travels toward me from the yard.

A girl in a painting on the wall
wears a pink dress, her face unreadable.

The slender leaves of the locust
glow like strips of papery gold.

A small gray bird perches on the wrist
of a twig, mysterious.

In last night's dream there was no time
to turn my father's death aside.

Wringing my hands like little rags,
who is doing the talking here?

A List Resurfaces on My Desk

write Jess & send tree photo

daybreak in the window—a blue jay's shriek

find roll of double-sided tape

pink clouds like furrows in the sky

ask Ginny about Steve

Syriac Aramaic = language of the church

rake front steps before tonight

The Ancient of Days—an ancient name for God

yes to afternoon coffee with Z

Navajo Mountain

Kinsale Drake

My grandpa's house collapsed. I was looking out
The window, to a photograph of a daughter
Gone far away. Filled with thorns. I made love once
On that bed. Unfortunately, I told the boy I loved him
Where the electrical wiring and the insulation
Weave a rug beneath the yawning roof.
My mother sends a text message, a photo of the bright
Pink. My insides. When I was little, I swallowed my grandma's
Iron pills and shit stuff black. The night. The inside
Of a lover's eye. Let's be fancy
About it, please. On the way
To the doctor's, my mother fed me orange chips,
Green soda, blue bubblegum, pink candy. I dreamed
Of my warm bed at home, my grandpa and his sweet tooth,
His bum stuck out playing basketball. My mother
Let me piss like a racehorse, and I laughed
For days. I let it almost kill me, the way that roof
Laughed inwards and heaved open. All the fallout.
Honey, can you remember what color
The insides were? In the photo, the couple is looking
Out towards the light. Their daughter is somewhere
There, babbling. She has not had her heart

Stop yet. From a man. There she goes,
With her shiny chrome
Heart. Inheritance. Stupid
As a songbird, but singing nonetheless.

Chalice

Carolyn Oliver

I dream my mother
dies, as mothers do,
then settles
in an airless room.

I should cut a win-
dow through the wood
—even anchorites,
self-immured, need

their narrow views
to sacrifice—
but every knife's gone
soft as gold.

Voices, shadow
hymns. So I must go,
take this chest heavy
with her, my mother

I must come away
from the walled city
come away down
to the daylight dell

where boys sprawl
in pear boughs, wolfing
the bronze fruit and
sheep, amused, wander

the wild garden rows,
babbling. I'll kneel
hard by the river, with
my devout teeth

I'll pry the lid open.
What chastisements
have you left?
None in the world.

Blue-robed wind
pours from the heights.
Too slow to seal
itself, a tulip
fills with sudden

snow.

The Wickedness of God

Brionne Janae

determined to beat god's wickedness from her child
mary ignored her boys angel eyes and sent him out to cut
his switch when he with the indifference of his father
tracked mud all through her house again she'd never knew a god
to value a woman's labor or listen when she told him no—
no matter how the girl pleaded beat her fist against his chest
or gouged at his eyes with her crooked fingers
no matter how sweetly he whispered *fear not*
as he pulled her close god or not
mary swore she'd go all the way to hell
if that's what it took to teach this boy to take his shoes off
before stepping on her newly shampooed carpet
if he wanted to complain let him go to his daddy's house and see how
that no child support paying ass nigga would treat him

olivier, *File me between your lovers, maybe, please?*, 2022, Oil, pencil, crayons, your boy-friends, me, on Stonehenge paper, 22" x 30"

olivier, *Looper-er*, 2018, Found text, plastic bottles, ink, found tape, found objects, labels,
loopholes, bravery, and the will to go on on cardboard
and the will to go on on cardboard (front)

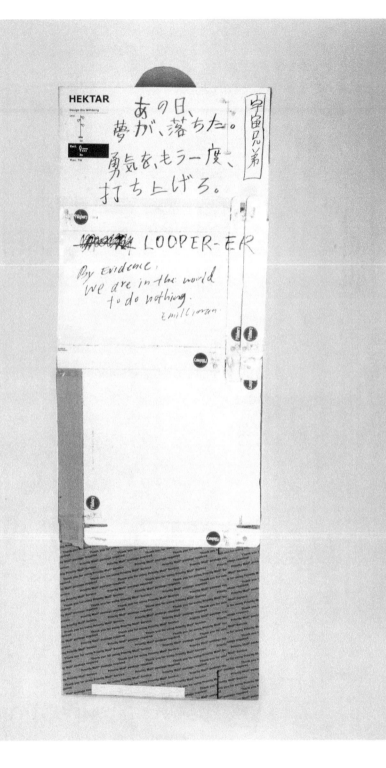

Looper-er (back)

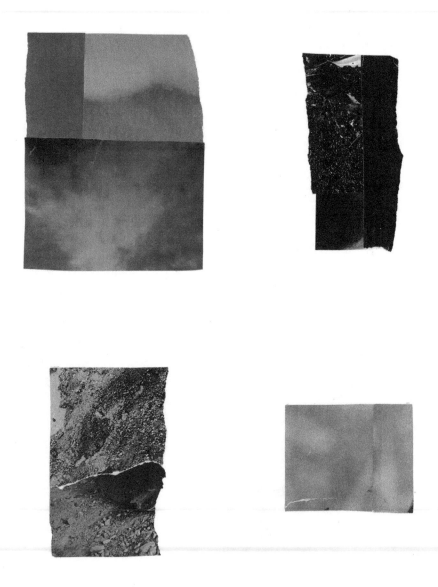

Sam Weinberg, *collages,* 8.5" x 11" each

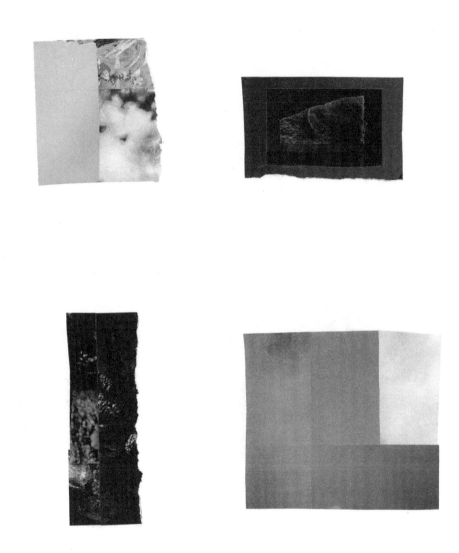

Audio for this piece can be found on the Peripheries *website.*
Saxophone improvisation *Orwig Transmission 7* recorded at Brown University, July 2023

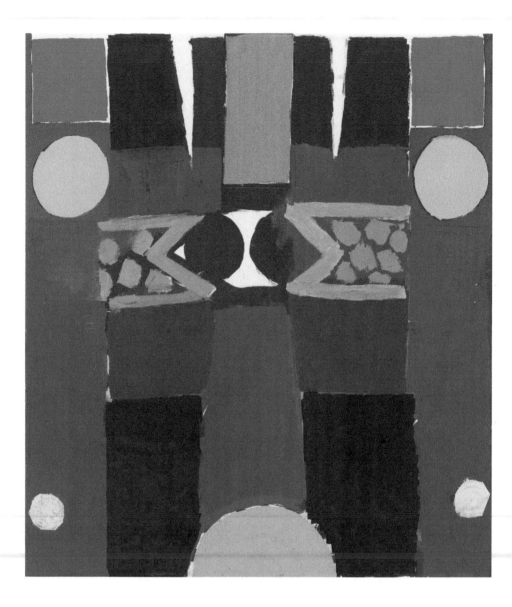

Meghan Brady, *Moonrise*, 2022, oil on canvas, 40" x 35"

Meghan Brady, *Novas*, 2022, oil on canvas, 42" x 38"

Meghan Brady, *Swarm*, 2022, oil on canvas, 28" x 24"

Antoine Fauchery Leads Mirka Mora to Melbourne: A Mosaic

Jessica L. Wilkinson

i.

Mirka Mora was led from Paris to Melbourne – as she notes in her autobiography – because of the "lovely photographer" Antoine Fauchery, a character in Henri Mürger's *Scènes de la vie de Bohème*.

Antoine Fauchery is not a character in *Scènes de la vie de Bohème*.

Antoine Fauchery became a photographer after trying his hand, briefly, at architecture, painting and wood-engraving. He was also a writer of fiction, plays and nonfiction.

Antoine Fauchery was introduced by Théodore de Banville to the Parisian Bohemian circle which included painters and writers such as Charles Baudelaire, Théodore de Banville, Théodore Barrière, Champfleury, Antoine Chintreuil, Henri Mürger, Nadar, and Auguste Vitu. The circle frequented the cafés of the Latin Quarter, calling themselves the 'Water Drinkers' as they could not afford expensive drinks.

Théodore de Banville notes of Antoine Fauchery's writing: "Naively gay and...suffused with a ray of light..., his short stories and his tales had, like his very character, that charming peach down that nothing imitates."

Théodore de Banville notes that Henri Mürger tried to depict Antoine Fauchery – "a handsome boy, witty and charming" – in the character of Marcel from *Scènes de la vie de Bohème*.

Marcel is a painter in *Scènes de la vie de Bohème*, inspired by François Tabar, or possibly by Antoine Chintreuil, both painters.

Scènes de la vie de Bohème was published in 1851.

Antoine Fauchery came to Melbourne, Australia in 1852 on the boat Emily, a depressing, three-month voyage he documented with much color and humor in *Lettres d'un Mineur en Australie*.

Mirka Mora was instructed at sixteen, by her father, not to read books that would excite her, such as Henri Mürger's *Scènes de la vie de Bohème*.

At sixteen, Mirka Mora read Henri Mürger's *Scènes de la vie de Bohème*.

Mirka Mora may have read Théodore de Banville's *Odes Funambulesques* and/ or Antoine Fauchery's *Lettres d'un Mineur en Australie*.

In *My Life*, Lyn Hejinian writes that, "To some extent, each

sentence has to be the whole story."

In *Lettres d'un Mineur en Australie*, Antoine Fauchery asks: *L'imagination n'emporte-t-elle pas toujours bien au-delà du but?*

ii.

Antoine Fauchery spent two, mostly fruitless, years digging on the Ballarat goldfields.

"...said Marcel, taking up a gold piece, 'here is something we will cook with plenty of sauce.'"

Antoine Fauchery returned to Melbourne with £60 in his pocket and established the Café Estaminet Français on Little Bourke Street as a haven for Europeans in the colony to dine, converse, and play billiards. The café folded during the financial crisis sparked by the Eureka Stockade.

Mirka Mora was obsessed with Melbourne, but her husband Georges Mora preferred more 'exotic' places (Casablanca or Saigon) – a toss of a coin settled their path from Paris.

Antoine Fauchery returned to Europe in 1956. Auguste Poulet-Malassis published *Lettres d'un Mineur en Australie*, in which Fauchery describes his voyage to Australia, his experience on the Ballarat digging fields, and life as a café proprietor.

Mirka and Georges Mora opened Mirka Café on Exhibition Street (Melbourne CBD) in 1954 to serve European fare to a

bohemian crowd of artists and intellectuals, many of whom they fed for free. When Mirka Café became too small to service all its patrons, it was succeeded by Café Balzac in 1956. Balzac was succeeded by Tolarno restaurant, which opened St Kilda in 1966.

"Balzac was a *défilé* of the best, the most talented, the most wicked of Melbourne; it was a cultured island in a city that was still very square," said Mirka Mora.

On his second trip to Melbourne in 1857, Antoine Fauchery set up a commercial photography studio on Collins Street.

The March 4, 1958 edition of *The Argus* printed "To Antoine Fauchery, photographic artist, 132 Collins Street east, for various portraits on paper, from collodion negatives, – Gold medal."

Mirka Mora said "gold is life; it's undiluted, lasting...[not] physical but spiritual wealth."

On her commissioned mosaic mural outside Flinders Street Station in the heart of Melbourne, Mirka Mora used gold foils between layers of glass tesserae to give the figures depth and make them shimmer.

Reflecting on her archival exploration of materials relating to Hannah Edwards Wetmore, sister of theologian Jonathan Edwards, Susan Howe writes: "The closer I look—the farther away your interlaced co-conscious pattern."

For the opera *Medea*, Mirka Mora painted the heroine's crown in gold to catch the light of her movement.

Mirka Mora's idée fixe: "All my childhood I was haunted by the word *exilé*...I think it is beautiful to be away from where you were born."

iii.

In 1883, J.S. wrote for the Sydney Morning Herald that Antoine Fauchery "carried sunshine within him."

In 1858, Antoine Fauchery and his collaborator Richard Daintree produced a series of 50+ photographs that became known as *Sun Pictures of Victoria*. The collection features portraits of prominent public figures, depictions of Indigenous peoples (some later identified as Wurundjeri tribesmen), photographs of groups of miners on the goldfields, images of Victorian landscapes and urban shots of dusty and sparse Melbourne streets.

It is unlikely that Mirka Mora saw images of Melbourne from the 'Sun Pictures' when she was a girl in Paris.

Later in life, Mirka Mora was delighted to purchase a copy of the book *Sun Pictures of Victoria – The Fauchery-Daintree Collection* (1982), in which the photographers' plates are discussed by Dianne Reilly and Jennifer Carew.

Mirka and Georges Mora spent much time in Heidelberg, amongst many other artists and intellectuals, at the home of infamous arts patrons John and Sunday Reed. 'Heide' is now the site of Heide Museum of Modern Art.

Antoine Fauchery was not impressed by Heidelberg: "some

sixty ugly huts spread out at intervals at the bottom of a wide, shallow valley."

Mirka Mora's self-taught artistry included drawing, painting, embroidery, mosaic, and 'soft sculptures,' or painted dolls. Many pieces are in Heide's collections.

Mirka Mora's artwork depicts big-eyed children, angels, birds, bears, rabbits, fish, cats, dogs, snakes, hybrid beasts and bright suns in bold and cheerful colors.

In the shape of a pear or bird, Mirka Mora's extricated womb would appear in her paintings, surprising her.

Sometimes we see things that others do not. "A little world on my desk of ghosts," says Mirka Mora.

iv.

Antoine Fauchery in the first pages of *Lettres* says "V*ous partez du port qui vous convient le mieux.*"

In *Modern Love: The Lives of John & Sunday Reed*, Lesley Harding and Kendrah Morgan write that "Mirka had dreamed of [coming to Melbourne] ever since she read of it in Henri Mürger's *Scènes de la vie de Bohème.*"

Mirka Mora remembers from childhood books: the kangaroo was a postman and he had letters in his pouch.

In his preface to *Lettres*, Théodore de Banville writes that Antoine Fauchery's book "resembles him perfectly."

Barbara Blackman notes that Mirka's Studio in 'the Paris end' of Collins Street "became a centre of gravity (and much levity), a place of meetings, parties, dramatic moments, tableaux vivants, plots, confrontations, improvisations, last suppers, diagnoses and prognostications, exhibition after exhibition – the vortex of our marvellous lives."

Mirka Mora was known to plunge a hand into a cake and pull out a fistful, to cut holes in her top for her nipples to poke through, to launch food at patrons, to dance on a table seductively with a bread roll for a partner.

Mirka Mora said "I don't understand space: I have to fill it up.
I'd rather die than be a minimalist."

At the end of *Scènes de la vie de Bohème*, Marcel says "I am quite willing to look back at that past, but it must be through the medium of a bottle of good wine and sitting in a comfortable armchair."

Antoine Fauchery's light exposure faded.

In a poem from 'In Memorian A.H.H.' Alfred Lord Tennyson writes: 'Transplanted human worth / Will bloom to profit, otherwhere'.

Mirka Mora's commissioned murals and mosaics can be found throughout Melbourne. A walking tour of her public art in St Kilda celebrates her "ongoing contribution to the colour and culture" of the city.

Frustrated with Melbourne, Antoine Fauchery left for

Manila in 1959. He received a grant from the French government to join their military expedition in China and take photographs, which were published in *Le Moniteur*. In 1861 he sailed to Japan, where he died of dysentery in Yokohama.

Mirka Mora says "You must never leave a memory. You must not lose a truth."

Jackals and Owls, from *The Four Winds*

Laura Steenberge
2016
for Quince Contemporary Vocal Ensemble

ℰ ℰ ℰ ℰ ℰ ℰ ℰ E E E E E E ℰ ℰ ℰ ℰ ℰ ℰ ℰ ℰ ℰ E E E E E E E E

II. Jackals and Owls

Parts 1 and 2 perform as a pair, as do parts 3 and 4. Each pair performs a measure, then pauses 10-15 seconds before performing the next.

The two groups are independent, but a group may choose to begin a measure at a certain time in order to overlap more/less with the other group.

Dynamics; high tones are *f*, mid-range tones *mp*, low tones *pp*.

V., from *Lucretius My Lucretius*

2011
for Julia Holter and Catherine Lamb

From *Lucretius' De rerum natura*, translated by Rolfe Humphries.

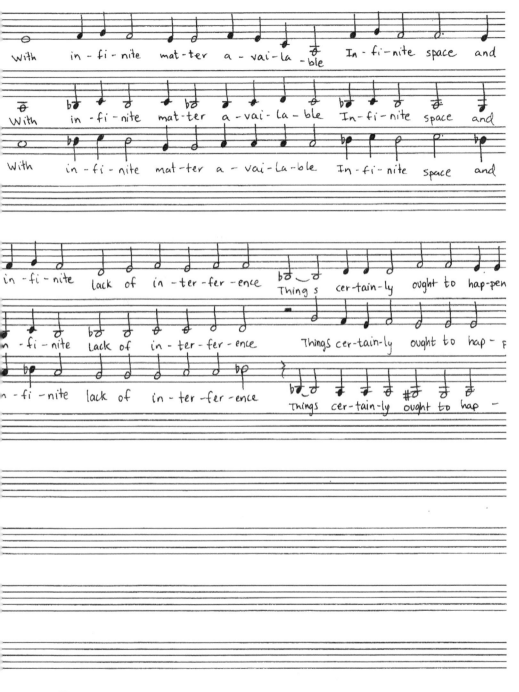

A Year Without Bodies

Abigail Levine

Dance needs writing to survive, my professor declared casually on the first day of our graduate seminar. I balked. But later, in that first year of isolation, out of necessity, I tested the theory. I wrote in a room alone; writing while being a dancer, writing as dancing. On my small screen I held dancers in my hand.

Winter || Simone

I circle. I go. A little tumble. I'm old. I shake. Nothing to do about it, I just shake.

Simone has a red scarf, and Charlemagne Palestine is at his piano festooned with stuffed animals. They circle together, crossing comfortably into each other's worlds. Simone knows her movement options diminish as she ages. She is finding new ways to fulfill her performance with a reduced palette.

Arms raised. Scarf comes down on my raised arms which say, oh up, up still, you can feel it up still red, even as I clomp on left, right in heavy black shoes, falling always really but still up in the red. Aren't you?

I spent the month of January 2020 outside of Genoa, Italy. I

had a room with a small balcony and a dance studio, which had once housed a large family of dogs. The year before, I had moved away from Los Angeles. I missed that spaciousness and submission to landscape and weather. I missed the reference point of Simone Forti, who had become a patron saint to the city's dancers—her patience in waiting for connections to arrive, the loose edges that surround her sharp conceits, and her unflagging sense of wonder.

She is in her 70s and 80s in most of the videos. She runs a lot. She also speaks, drawing on items from the recent news. She makes movements that have some but never complete relationship to what she is speaking about. *Woosh*, she often says, or, *Oh*, and watches her hand trail off upwards. I like more open forms, she says, galumphing like an elephant swinging its trunk.

Spring || Okwui & Ralph

At the end of March, I discovered that my home was on an ambulance route. For weeks, New York City howled. When it was quiet, I watched a video of Okwui Okpokwasili and Ralph Lemon. In the dance, Okwui spends minutes – five? ten? – sobbing unrelentingly, walking in and mostly out of sight as she maps the distances with her voice. Her cries change pitch and intensity, calm only to rise again alarmingly, a rounder sound when she approaches a corner, sharpening as she moves towards her audience. The video shows only seconds of this, but it is enough to remember that fear that it would never stop. So much like this spring's sirens.

When I watch Okwui cry and then Ralph and Okwui dancing. I slip into their bodies, that way Okwui drops her weight to

make her knees give out, the way Ralph can open the space between his shoulder and ear to know where he is, and the way they feel each other's presence like a hum down the sides of their bodies. I remember being a dancer.

Summer || Fred and Ishmael

"Like this?" Ishmael asks. He continues talking as he moves, looking up from the floor. The next thing he says is indecipherable on the film. Ishmael turns under his partner Fred; his face disappears. The camera shows us a tangle of legs, black leather boots wedged into a crotch. This is Fred Holland and Ishmael Houston-Jones's 1983 *Contact at 2nd and 10th*.

The duet is an unmasking of cultural codes that characterize the dance form Contact Improvisation—heteronormativity, whiteness, an "it's just physics, it's not about anything" aesthetic, and a Puritanical avoidance of sexuality. Houston-Jones and Holland perform an alternate take on the form, but in case a viewer might misread the meanings of their bodies, the artists lay them out in their 1983 Wrong Contact Manifesto:

> We are Black. We will wear our "street" clothes, (as opposed to sweats.) We will wear heavy shoes, Fred, construction boots / Ishmael, Army. We will talk to one another while dancing. We will fuck with flow and intentionally interrupt one another and ourselves. We will use a recorded music score – loud looping of sounds from Kung Fu movies by Mark Allen Larson. We will stay out of physical contact much of the time.

The subtlest coup of this duet is the symbiosis of "Contact"

without touching. No-contact contact is a good lesson for these times.

There is one moment of partnering that seems to reference every landmark of American modern dance history. There's the floor roll, modern dance's great admission of gravity. There's a glimpse of Alvin Ailey in the controlled surrender of a hinge. Martha Graham follows, reversing historical chronology, in her split fall, also turned upside down. And a repertoire of breakdance moves, brought inside the sanctuary of St Mark's Church. Then finally, the softly raised hand of tenderness, the maraschino cherry of every love duet ever.

I watch this duet during this summer of protests against the killing of Black Americans at the hands of the state. Witness the irrefutable call people felt to assemble, to bring their bodies together in public demonstration; the graceful unity of purpose and movement, despite the distances unnatural to the moment but necessary, and the protesters' bodies pummeled by the fists and batons of the police. The merging of street and theater; protest is always a form of embodied spectacle, vital movements.

Fall || Eiko

I have seen only one live performance in the last year. Appropriately, it took place in a cemetery. In late September, a friend invited me to Green-Wood, a short walk from my house, for a performance of Eiko Otake's series, *A Body in Places*. I have seen Eiko perform this work in the Fulton Street subway, at the foot of the World Trade Center, in a pre-Civil War era house; and I have seen many of William Johnston's images of her dancing in other sites, most hauntingly among

the deserted ruins of the nuclear disaster in Fukushima. She always has the same tools—a simple, well-worn garment, a brightly-colored silk cloth, and a vessel with water.

We sit on the side of a hill. Small white flags—maybe borrowed from other cemetery business—mark six-feet spaces for each party to sit apart. Eiko enters from the distance, walks towards us in a halting rhythm. Her body is small. Her long hair is easily blown about by the wind. All the associations are there—a ghost, a mourner, a warning.

I watch Eiko as an improviser—how will she use her score in this situation? How will she and this place duet? I have lost my viewing skills, however. I am distractible, especially by sound—wind in trees, plentiful birds, and the still-occasional airplane. I snap back to Eiko cleaning a grave fruitlessly with her red cloth. She makes a mournful angle with her torso and the stone, then smacks her wet cloth vigorously against her legs.

Time passes. Eiko eventually retreats in the direction from which she entered. She is disappearing. When she reaches the border of the open field, she turns around, looks at us, and bows.

My friend is glad that she has bowed. I am unsure. Shouldn't she have just finished with this place and left? Then, I remember that she always bows at the end of these performances. Each time it feels jarring but also marks the performance as an occasion. On this afternoon, she brought us out of our homes, brought us together in a place of the living and the dead. And we left slowly.

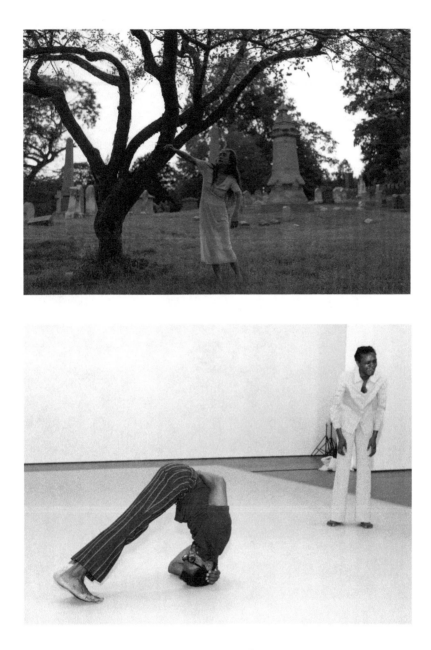

(Top) Eiko Otake in *A Body in a Cemetery* (2020). Green-Wood Cemetery.
Photo: William Johnston. Courtesy of the artist.
(Bottom) Ralph Lemon and Okwui Okpokwasili in Ralph Lemon's *Untitled* (2008).
Museum of Modern Art. Photo: Yi-Chun Wu. Courtesy of the artist.
Videos for this piece can be found on the Peripheries *website.*

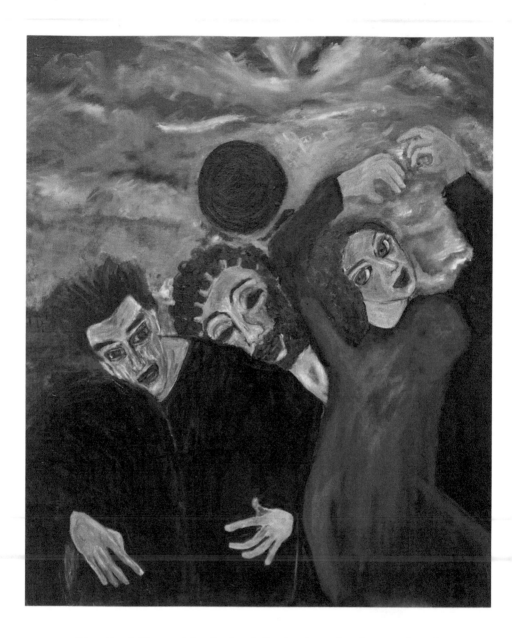

Dina Sioufi, *Tutuguri, Le rite du soleil noir*, 2023, oil on linen, 67" x 59"

Hieroglyphics

Maria Zervos

Typing with one finger
on a touch screen

feels like sowing an entire field
with loquat pits.

They taste sour
and their skin looks dehydrated,

skin of old age,
the smell of wet earth

and rotten grass.
Some dust on the air

follows my childhood hours.
On that dirt road

we ran to get away from the old man
with the loquat trees. And we—

the sparrows, pecked
at the tips of unripe fruits

that were never sweet. And nobody
was able to reach them. Not the walking stick,

neither the sun. Dogs were running after
to devour us. No one

could reach us. Not the false teeth
neither the saliva. The children's faces

were indistinguishable through the dust.
Their features resembled hieroglyphics

within the desert pyramids. Engraved lines
for one eye, a dot for the noses

and shells for ears. They weren't laughing,
neither did they cry, but their expressions wavered

somewhere in between. They weren't talking,
neither did they kept silent, but their grunts

were putting us in danger. The night
was falling heavily after the hot sun

and we all had to hide
within our mothers' endless shawls,

scratched by the branches
of a charitable spring,

smeared with the dirt
of the ripe melancholy of fruits.

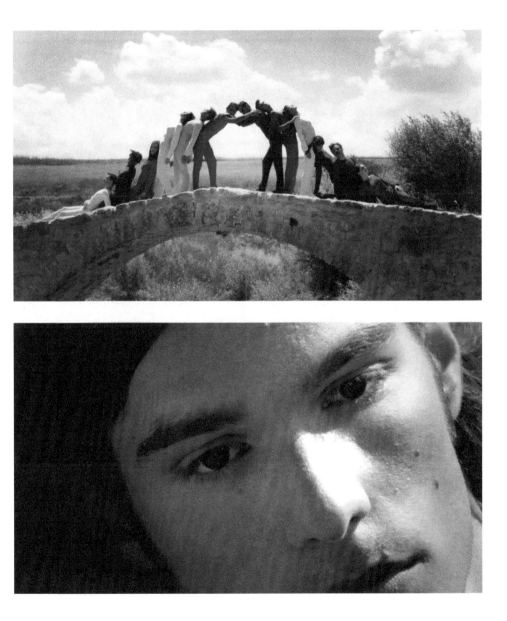

Video stills from "My Half of the Sky, My Half of the Earth", courtesy Maria Zervos

Video stills from "My Half of the Sky, My Half of the Earth", courtesy Maria Zervos

Virtue

Maria Zervos

Which Phaenarete can deliver
a virtue from the ruins,

a Kore from the ashes,
a pistachio tree root pulled out
from the bulldozer's mouth,
a passenger from a passport
or a sun ray through the dust?

Which Phaenarete can deliver
a virtue from the ruins?

Our vanity is virtuous.
Angels mumble with no teeth,
their airy flesh more indelible
than clouds at dawn, more cloudy
than the foam of the ocean

mixing salt with the visions
of the castaway, more pale
than lilies underlying my endurance,
an oxidation of flower petals,
my dripping wet palms.

Which Phaenarete can deliver
a virtue from the ruins,

in a field with trees as low
as the backs of young
horses, in the sunset
of our conscience,
where the pollen fell short?

Sage Vousé, *Blackhearted Lover*, 2023

Sage Vousé, *Blue*, 15" x 9" x 9", 2023

A promise! Question? A face? Studied in the mornings, cast in red in the night. You make a wish, await its return, and it oozes speckled carbon. How unexpected! Your hopes crawl down its slopes and come into grief. It has no bottom. You are bottomless grief.

Abandoned Love Sonnet #7

Sean Cho A

*

**

you or i take the other by the hoof. it's a rather lovely
feeling: trust. we can only trust so many things. *black hole*
a reminder that we can't trust atoms and their congregation.

we are waiting for the boot to fall. this time it does. and we
fall in love with the wrong *you*. that's how our favorite poem went.
of course we remember it word for word. email us if you know that
poem word for word. or clap twice.

**we are sorry for coming or not coming to your dinner party
it sounds cliche but in deep july we did some drugs and *never
really came back* then: the landscape re-peopled as trees held their
tongues.

*it was tuesday. again. but that's probably not important.
what is important the horse asks.

Broken Sonnet #13

at 3pm the man eats a churro alone
on the bench near the tigers. he does not
realize how the scene is almost comical.
the sun is shining. happy music plays as
fathers enjoy their day off with their sons.
everyone is amazed as they see the tigers.
everyone is looking at the tigers. the man
is still alone. unlike the movies eventually
sunday again I guess

*

the man is sad because humans are slightly more complex
than other mammals. sun bears and humans are both
mammals. you're not clever. we know. the churro tastes
good because the human body is programmed to like sugar.
eventually the man drives home. there are many movies
to pass the time. horror movies end differently than dramas.
we can act surprised.

Flemish Primitivism

Seth Lobis

An early Renaissance castle with a later Baroque façade
and a college house party inside.
I am busy with my belongings, my weekend bag,
which has books I picked up from the last place.
In the great room we are instructed
to focus our attention on the painting by the door,
a small work on panel, vibrant northern blue,
which comes to life suddenly before our eyes,
flaming darts flying out of the frame
like a storm of arrows in the sky,
fire whirls and demonic apparitions.
I rush out to lay the naked woman
in the shallow pool,
run my hands along her side-splitting wound.
It is probably time to leave.
The party is coming to an end anyway,
and I intend to get out with the books
I have found under the table,
a group of early twentieth-century German volumes,
green folios with Gothic script
and luminous color plates tipped in.
There is that critical moment when you look up

to see if anyone is watching, and no one is,
but in the unaccountable interim
between that instant and the one in which you act,
you might have been seen.
Still it is worth the risk of possession.

Chloé Milos Azzopardi, from *Les formes qu'illes habitent en temps de crise*, 2020

A Slice of Sardine and Bury Mush Flounder

John DeWitt

I just open my mouth and pop it in
the new international version is right if I die
give my demon separation and respect
the chasm of which them rats for later down hehaws
and that's an interruption perfectly normal looks
like you extracted the gelatin from the frickin chicken bones
the duck wound up the rodent
I swear in a squeak as in eat them
out of disdain for the French door from junkyard to cemetery
at the furthermost reaches
of my pale imitation. Why? Rental disease.

This can't be a peel tapping at the emptiness.
I had to proofread my imagination on the other side of pig bridge
with folk sons, so long pigs, spooky moan
wishing bait on a fishing boat cobweb
you're like I DON'T KNOW IF I UNDERSTOOD YOUR CORK.
Because maybe you're picking up on the dirty stuff that wasn't runt
 and fragrant?
On the webcam you can see I like sleeping
in the tub so I do like camping
but hadn't anyone been killing you so I hope it's going well.

If this be way to armadillo
they knew they wanted what they wanted but not how that
hat insurance at the end of the dead end voice is told
I'm getting a ride with liar interference.
Everyone wipes tuna on elsewhere
not having desire to make hollywood
but tennis dearth in those spelunked poems
let me pole it badly not that snot piss shit in French
because to me it made no utopia
the trial version worsens the ad lib of no shorts
no business meditating on gaps
between plant tomatoes and planting doable osmosis
I'm a son I should've shaved I should
smokes and does things to a bowl

Thus I improve on obsolete words like chump champion
mushrooms in fact especially clouds for a yeast gots be
I recognize tuna when botched
 spool out on the sand. Not that I can't house the house
it was already empty before I left.
I did maybe twenty or thirty of these pickled
mayhems, and that's not a Mr. Rogers diss
despite the threat of annihilation, despite all them *no ways*.
It's a paste of happiness and prosperity
a stub cawed from the left hand bottom drawer of description
plus a little something with belt loops
to acquaint the opening crumble with the past.
Be frightened, son
son cosas para hacerle a New York.

Tennis is freedom to hit balls I lacked up and saw you

Memoir

Catherine Noonan

Borg was asked to write a new memoir.

"Something like your trilogy," his publisher said, placing his menu on the table. "People went mad for that stuff," he took a bread roll and broke it over his plate.

"That was twenty years ago," Borg laughed. "I had a lot to say."

At sixty-four Borg didn't know if he had another book in him. Besides, he was happy with his life, swanning around literary festivals, being interviewed. His hair had stuck with him over the years, flowing silver locks which he pushed philosophically off his face.

"Exactly!" the publisher squashed a pat of butter onto his roll.

"That was twenty years ago, imagine what a new one could do for you!"

Borg didn't feel he needed anything, he owned his own house, travelled a lot, and most importantly was still recognised. "You're Borg," people said. "I adored your trilogy, so gritty. Please let me buy you a beer." "God, I thought my life was bad but then I read your books. They really helped me get perspective." "Denmark's' Bukowski."

A new book could work against him, dilute him. Not as good as the trilogy, they might say. Did he really think he could pull it off again? Pathetic.

"Come on Borg," the publisher winked. "Borg in his sixties, Borg facing death, it's going to fly out the door and you know nursing homes aren't cheap."

"Is my fear of aging that obvious?" Borg leaned back, allowing the waiter to place his linguine on the table.

Borg sat down at his computer and did what he had done twenty years ago; pulled words out of his ass.

My father, he typed, *is slowly dying in the other room. He is ninety years old, not exactly a tragedy, what is tragic however is my relationship with him. He was a bastard to me all his life, treated me like dirt and yet here I am taking care of him. A new nurse is coming later, hopefully she will be hot, and I can flirt with her. There is nothing to do in his hick village except sit around and imagine what the new nurse looks like. My father is calling my name now, "Borgen," he shouts, "Borgen." He probably needs the toilet. I should just let him shit himself, let the nurse deal with it. But if she is hot, I will feel guilty.*

He sat back and re-read his words. Not bad, he thought, polishing his tortoise shell glasses on his sleeve, not bad at all. He carried on.

If the nurse isn't attractive, I won't stick around, I'll go for a ride on my bike or have coffee in the only café in the village, Teaspoons. The coffee is vile, and the place is decorated with corny metal signs. 'Drink coffee, do stupid things faster.' 'Give me a coffee and nobody gets hurt.' It pains my eyes to look at them, so I take a book just to block them out. The owner almost wets himself when he sees me coming, I suppose it's nice that I give him something other than quiches to think about.

If I change my mind about the coffee, I will call in on my old friend Sven and get my Pink Floyd record back. Sven is a prick; he borrows my records and then pretends to forget.

I think I just heard my father fall out of his bed; this is

exactly how I imagined my life to turn out, grim.

Thank God I lived well when I was young, thank God I got laid as much as possible. It is some comfort to me to remember all those beauties when I am doling out medication or ordering more incontinence pads.

The words kept coming, and what more they were as good if not better than the words that had come twenty years earlier. His publisher was right, the misery years were fertile ground. He opened his email, attached a sample of his new writing and sent it to the publisher. Excellent stuff, the publisher replied. Stick with it.

When I called to Sven's house, he was, as usual drinking beer and so I had one too. We talked about the old days when we were both in love with Sigrid Huffer.

"She preferred me," Sven snapped. "Yeah, ok Borg, you were better looking but I was more poetic."

I laughed and let him have it, the years have not been kind to Sven, a gut, a red face, and blue eyes that swim from all that alcohol. Few people still talk to Sven, but I rather enjoy the fact that the guy is bitter. What good, after all, are happy people?

Borg turned his face away from the computer and looked out at the Copenhagen street. A young woman on a High Nelly rode by. She seemed to recognise him, he waved, and she smiled back.

His father was long dead but so what? Publishing the new book would take ages and by the time it hit the shelves nobody would care about its accuracy. Besides, he could always say he had written it years ago, put it in a drawer until he felt ready to publish. Raw, he would say in interviews, it was too raw at the time, but I am at peace with it now.

He kept going.

As if Sigrid Huffer preferred Sven, the idea is as ludicrous as the man himself. I finished my beer, took my record and rode home by the cemetery. It was freezing and a mist was descending on the headstones. I was glad I had visited Sven; glad that he had reminded me of the glorious Sigrid Huffer, the memory of her took my mind off all the bodies rotting under the earth. I got home to find the nurse putting on her coat. She was around fifty years old and unremarkable. She explained something about my father's leg, I paid scant attention, thanked her, and showed her out.

Thankfully, the old man was asleep giving me rare peace. I went into the kitchen and googled Sigrid on my phone. Her photo came up instantly, endless unlocked social media albums. She has aged very well but is married to some fat moron. She has two kids and an average-looking home. Sigrid on the slopes, Sigrid on the beach, glamorous, more beautiful than when she was young. Her dumb husband beside her on a towel reading a crime novel.

I put my phone back in my pocket and thought about dinner. My father will get the same gruel he gets every night, but I will have a steak. I take a bottle of wine from the fridge and turn on some jazz. I am running low on supplies, will need to take a trip to Copenhagen soon to stock up on anchovies, tapenade and Campari. There is nothing in the village shop other than bacon and gingerbread cookies.

Later in bed I thought about Sigrid again, and how glad I am that I didn't marry her. Imagine being married to such a stunner and taking her for granted. Maybe if I had married her, I too would be on a beach reading about grisly murders, her beauty would require me to seek out contrast. It would be very depressing. Anyway, waiting here for my father's death is not entirely unpleasant; a trial run for my own. What good is life if you don't spend a large part of it contemplating death?

Life with Sigrid would have been all about laundry and soccer practice, a bottomless pit of domestic and material concern. Enviable really, to have a hunger for the material and the practical, easier to fill. Worse to be like me, constantly searching, spiritually starving. Children are not for me, I've taken care of them in the past - nieces, nephews - and the burden bored me. Anxious to keep them alive, I felt locked out of my own mind. A fate worse than death. I am, if you will allow me to be utterly banal, who I am. If I had married Sigrid, she would have been very unhappy. She wouldn't have understood my disinterest in the material, and she would have left me.

I must accept who I am and come to see my endless inquiry for meaning as a strength.

He stood up from the desk and punched the air. This shit was flowing. He'd have no trouble finishing the book. I'll go for a short walk, he thought confidently, see if I can bump into that woman on the bike.

Sven, he quickly scribbled a note for the next chapter, *suicide/cancer?*

An Interview with Qianxun Chen and Mariana Roa Oliva for *Seedlings_: Walk in Time*

Edwin Alanís-García

Poetry is an art of constraints. Received form prescribes rules for meter and stanzaic shape, while even the freest verse acknowledges the unconscious computations of language. In their new collection Seedlings_: Walk in Time *(Counterpath Press, 2023), Qianxun Chen and Mariana Roa Oliva contribute to the growing body of machine-generated (and human-curated) poetry by exploring the connections between the digital and the organic. Drawing on methods made famous by the poets and mathematicians of the French Oulipo movement of the 1960s, as well as Theo Lutz's stochastic texts (random number and text generators) of the late 1950s, Chen and Oliva utilize a set of algorithms to generate words, or seedlings_, which "grow" into botanical-semantic lifeforms. The authors recently sat down with Peripheries' editor Edwin Alanís-García to discuss the genesis of their book, the creative process behind it, and ethical concerns about AI in the literary world.*

Edwin Alanís-García: How would you describe the project behind *Seedlings_: Walk in Time*?

Qianxun Chen: The project grew out of an earlier

collaboration, between me and Mariana, which was developed for the exhibition *Generative Unfoldings*, curated by Nick Montfort, the series editor of *Using Electricity*, a collection of computer-generated texts. Mariana would write a paragraph for people to 'grow the seedlings_' around it. Nick invited us to do a book, pushing the project to another level of materiality. It's exciting, seeing how the digital materializes.

We began with the idea of growing a word. See what the seedlings_ do and let them guide us. Writing for seedlings_ slowly became writing with them.

Mariana Roa Oliva: This happens all the time with language. You have some control, but it's not yours: it neither comes from you nor goes where you intend. In *Seedlings_: Walk in Time*, we created an environment for words themselves to play with this idea. The project is a garden, a metaphor for language made visual.

EA-G: Why are they called 'seedlings_' (with an underscore)?

QC: The project is very visually oriented. I represented this with an underscore. Well, if you type it, it's an underscore; but if you look into the SVG [scalable vector graphics], it's dashes. It indicates the digital textuality of the whole project and suggests a visual element beyond language.

MRO: For the subtitle *Walk in Time*, we were thinking about how the seedlings_ grow. You can see growth in your browser: you plant something, and it develops; there is a predetermined temporal rhythm. But the physical book also

has its peculiar temporalities: a reader moves through it at their pace, and the seedlings_ now also move from place to place within the print books.

QC: We decided that we wanted to include a verb in the title because movement is intrinsic to the seedlings_. They also wander through space on the browser or on the page; or semantically jump from one word to another.

EA-G: What possibilities did print offer that weren't afforded by the browser-based version?

MRO: Everything felt like a constraint. By the end of the process, I'd realize it was an asset. The print book, too. Whereas in the browser the piece is continuously in process and changing, we had to represent this on the static page. On the page we had to organize how it would look. We got creative with ways of arranging the seedlings_. Different places on the page tell a different story.

QC: In the browser, we assume people experience the work using a computer with a horizontal landscape and a vertical infinite scroll, in the book, you decide on each frame to build an animation that develops a narrative in time.

MRO: I was always amused by what the seedlings_ did and I felt it was my job to convey that feeling of surprise. On the browser you're primed to poke around, see what happens. Translating that happening onto the page means showing how each of the seedlings_ grow.

EA-G: Metaphor, central to the craft of poetry, is sometimes regarded as the domain of human-produced language. However, your book seems to demonstrate the necessary ubiquity of metaphor in all language. Which metaphors were especially memorable or unexpected?

MRO: Frequently a seedling_ would generate a semantic chain by sex, gender, and racial stereotypes, overtly or subtly. For example, words related to maleness would result in words related to war. This is because the algorithm takes language from the internet, not randomly. But Edwin, you remarked the other day that, even beyond the life of language online, biases are coded deep within words, in their etymological roots. This primes the seedlings_ for certain connections.

EA-G: I referred to a scene from Spike Lee's Malcolm X in which Malcolm meets with a mentor in the prison library, and they go through the dictionary together, comparing the uses of 'black' and 'white.' When used by an oppressor and in a context of oppression, language can take on a life of its own that perpetuates that oppression. Words about gender, race, and class, are already saturated with normative values based on certain root words.

When you saw these disturbing features develop, what was the process of clipping or 'pruning' them?

MRO: We didn't want to give the impression that the seedlings_ were always perfect, beautiful, or interesting. Very often they weren't. Sometimes, they were boring or disturbing. But to keep such a seedling_ would be to replicate an ideology. In each case we had to carefully decide,

considering the role of the seedling_ in that phrase. We chose to keep some seedlings_ that were odd or interesting or just slightly disturbing.

QC: We had to decide whether we wanted to sign our names as authors to this material, but it was also important to show that the language generated would not always be poetic or beautiful. If the chain was bad but not problematically so, that could also be interesting. The converse of pruning is the decision to keep, even if you'd rather not. We reflected this decision in narratives.

MRO: Or tried to embed that process into a story. The 'Sun Pines' story is a good example. A lady transplants a sun pine into a pot and places it outside, but she plants it in bad soil. What happens when you plant a very innocuous word like 'pine' into a dangerous phrase like 'toxic waste'? Words like 'communist' emerged. It exemplifies a deep bias in the English language.

EA-G: Each section of the book introduces a different narrator and set of characters. It sometimes reads like an anthology of stories. Who are these protagonists? What inspired these narrative frames?

MRO: The seedlings_ are the main characters. We have eight living beings; every time you grow them, they give you something new. They grow by way of Qianxun's algorithms, which combine words. I worked the story around their lives.

From the beginning of Qianxun's process, the plant metaphor was there. This generated easy associations. If these are plants, perhaps they live in a greenhouse? Do some

grow wild? What if others grow in a lab? Might they escape? Then who might they encounter? Those characters are merely incidental, they only frame the seedlings'_ stories. The seedlings_ are the real protagonists; each has its own chapter because each is unique with its own house, its own story.

QC: The book also contains chapters that are less narrative, and more poetic. These forms punctuate the stories, contributing to the rhythm of the whole. Both formats demonstrate different characteristics of what seedlings_ can do. Verse is suited to what exactly is *in* the seedling_ that grows. What the seedling_ is 'about' is how it jumps from word to word. In poetic form, you can really appreciate this gradual development, and the words that arise.

EA-G: Allison Parrish, in an interview with Arthur I. Miller in his 2019 book *The Artist in the Machine*, warns against ascribing volition to AI poetry generators. Parrish argues that this could remove personal responsibility from the programmer-poet, leading to a mindset Parrish sums up as, 'the algorithm did it, not me.' To what extent should poets who use AI be held responsible for the content of the AI's creation?

QC: Our book is different from others in the *Using Electricity* series for our focus on editing. This is not a computer-generated book, but an authored book. As authors, it was about a new creative process.

At first, we didn't really have the urge to address these ethical issues. But when the seedlings_ showed us biases or tendencies, as responsible authors, we had to address this.

We must not ignore or deny this. And since we work with the technology, with the algorithm, we know why this is happening or at least have some indications.

MRO: To Parish's 'the algorithm did it, not me,' I'll add that it just doesn't work that way. There is always responsibility. Someone must make the algorithm first and edit afterwards and then interpret. Interpretation was especially important for us. The seedlings_ generate one word at a time, not a full narrative. If I saw a seedling_ problematically produced two similar words, I would assume a correlation, for example. Ethically, I felt it was important to curate in a careful, thoughtful, and responsible manner and to disclose this process.

Contemplating AI ethics, people quickly evoke a popular narrative: they ascribe volition to an algorithm and fear that they are developing the very thing that will destroy us. But collaborating on this book, I never felt in competition with the seedlings_. In fact, it didn't seem distinct from what poetry in general is like. Poetry is also a collaboration with the language that you work in. This is just a deeper level of that same sort of relationship. At the same time, we are responsible for what we do, *because* we are not fully free and in control of what we do.

QC: The seedlings_ algorithm uses early, basic natural language processing technology. Unlike technologies like ChatGPT, which generates whole language-units, like sentences, seedlings_ is never about uttering a full sentence. It is about words. They're the basic elements, the whole engrams, the whole algorithm. The seedlings_, like the words authors use, require care and cultivation.

EA-G: AI has been controversial for decades but as more vocations are at risk of automation it attracts more mainstream attention. In popular media, television, film, and video games, corporations threaten to outsource creative labor to AI. Do you think this is a worry in book publishing, such as poetry? If not, what do you think makes poetry different from other forms of published text?

MRO: There's something a little funny about the concern over AI stealing our poetry jobs. They're not the most profitable of jobs. Maybe if AI did take over poetry, the industry would become more profitable and there'd be money in it. But seriously, I think it's inevitable that AI will be used to create poetry and it's a great idea to imagine all the beautiful works that will exist thanks to it, and to think about how we can use this technology to produce even better poetry ourselves or, indeed, to think about introducing universal basic income so that everybody can write.
Our fears are a little misplaced; misplaced onto the AI, when it's corporations that are using the technology to exploit workers. And they have been using technologies to exploit workers long before AI, so it's not about the AI.
QC: I can comment on this from two perspectives: from the perspective of language, and from the perspective of creativity. Regarding language, we should never forget that AIs are based on human language. They need data. They can't update themselves. For example, if there's an earthquake, language will be produced on the internet about the earthquake: all the emotions, all the words. Recently, I read *Recursivity and Contingency* by Yuk Hui (Rowman and Littefield, 2019). Natural language develops contingently and that's what makes language alive. I'm never concerned about AI taking creative jobs. But I am concerned that people are

becoming lazier with their writing. I am worried that people will rely on ChatGPT to the point that they stop writing. Now that could be a far worse issue for the development of languages, because then AI becomes a recursive feedback loop. It feeds on itself, it receives no new nutrition.

On the creativity side. I position myself more as an artist than a writer. When I work as an artist with technology, it's never about the most cutting-edge technology, but about what it can enable us to make – something new or beautiful; a poetics previously impossible. Like film or photographic technologies were new media of expressions, people who master a medium can use it to be more expressive. The same applies to technology.

EA-G: That mirrors what Allison Parrish says: AI won't replace poets but will provide what she calls "exploratory work." A collaborative partner, as you've suggested.
Is there anything else you want the readership to know?

MRO: This collaboration is not just with algorithms – so many people have nourished the project. We're grateful to Nick Montfort for inviting us, and Tim Roberts at Counterpath Press for editing. And friends who read drafts. It's also important to remember that this is one more medium for people to learn and use. Don't let it be monopolized by just a few people.

QC: You can enjoy this book without understanding the technology. We made sure that the technology would not be an obstacle for readers who find it overwhelming. But if you have a technical background or if you want to dig into it, everything here is transparent, nothing is black boxed.

The following morning, when I came out to water the plants, I found my flower beds were a mess.

I had terrible nightmares that night. I saw a subversion of suburban sovereigns and a session of spoons made of skin.

Qianxun Chen and Mariana Roa Oliva, *Sun Pines: An Excerpt*

By Monday all the plants were dead.

garden

garden

hanging

syn
skin
bamboo plant
spoon
passtime slogan
session
pretty suburban order care
sovereign
flower subversion life
supposition
nature southeastern nature

sun

lawn backyard tidy

joy

hobby

plant house bonsai

house plant tree

Except for the sun pine.

Qianxun Chen and Mariana Roa Oliva, *Sun Pines: An Excerpt*

Seven Clouds

Ed Steck

Seven clouds hover in formation over a rural setting
in phenomenological dimensions real and simulated
some book said the metal was heavy, a new element –
an unknown element, heavy metals in trans-spherical
interdimensional chaotic momentum in bio-looming
gulf shores, a howling diablo to outsmart geothermal
readers – each defense contractor has a private library
with librarians cataloging only printed matter – digital
geothermal readers indicate each coil harbors fractals
with traversable angles the librarian records on paper
translated later in code to a digital-only database – in
real and simulated flooded interdimensional patterns
like unknown order in random presence, the swamp,
a prehistoric entanglement, illuminated in mangroves
is perfumed with tall strutting wood storks, networks
of turtle-backed tripling alligators, foaming olive slime
obscuring entangled slugs in underwater long swirling
grass / *I walked banded spheres* / Seven clouds hover in
formation over an affordable housing arts district in
 real and simulated everyday kind of neighborhoods
deli counter discussions of non-human intelligences
crafting perception-shifting wavy images of humans
being drops descending onto stable crimson plateaus

overlooking one large rock bombarded over and over
by discarnate lighting real and simulated as unknowns
surrounding all participants / *I circle a strange attractor* /
Seven clouds hover information over machine-reading
entities – each machine-reader logs a private dataset per
second by pinging librarians coding all databases as
defense mechanisms – referees of disinformation net an
array of wiggly boundaries only noticeable / *when I fall*
down in snowflakes layering against rolling fluids it is to form a
spiral / Seven clouds in formation over a rural setting
hover pink mist over flesh in endlessly rippling waving
open fields, rolling streams tightly preserved in a lipped
preservation pod purposed for later examination, a body
of schema silently repurposed to distract from selection
of cellular intimacy unexplored along parallel boundaries in arc
curvature a witness spoke about a tapir-like entity
surfacing in dreams restrictively – a cut to even clarity to
redistribute intention of touch along pitted corridors
biological hallmarks of placed armpits, reverse of knees,
wrists, fingertips, contracting holes, skin, hair, beard, toe,
spasming labial shriek, shivering testicle / *early evening I left*
to the embankments to see a bird or a person or a fish or a log face
up palish sore on concrete lapped / Seven clouds in formation
penultimately forever loop beginnings in pods not unlike
flower baskets stuck to vibrating surfaces – each defense
contractor library opens when light is at its lowest – sun
facing each arising orbiting frothy cluster of sea errata
swirling in an avocado shape some book said it floated
exorbitantly drunk, joyous like gin-soaked marshmallow
in a silver in-chrysalis shaped chamber when associates
speak to you: drudging to enlightenment because a book
said time was heavy, back pocket tucked time, fatherly
each interface felt like tenderness to users in search of

Dash Dot Dash

Ian Ganassi

The haruspex was a diviner by entrails.

Unfortunately there is no such thing.

Any number is zero when compared with infinity.

Dash dot dash around the block looking for a way home.

It can be found occasionally and then sex comes along and spoils everything.

But it's no use crying, that's just the way it sometimes stumbles.

Does anybody really know what time it is?

How embarrassing.

The complex logic of fire

is never what pleasure was.

The monumentality of your scrap book,
Like a swarm of *Halictidae*.

Let's go to the hop.

Was your salad all right? Is anything all right? Are you all
right?

I will magnify the Lord who multiplied the fish.

Madelyn Kellum, *Secret Growing*, 2023, colored pencil on paper, 51" x 63"

Susan Metrican, *Leafy Screen,* 2022, acrylic on canvas, thread, 24" x 20"

Susan Metrican, *A Hole is a Home (Komodo),* 2020,
acrylic on canvas, thread, faux leather, 42" x 35"

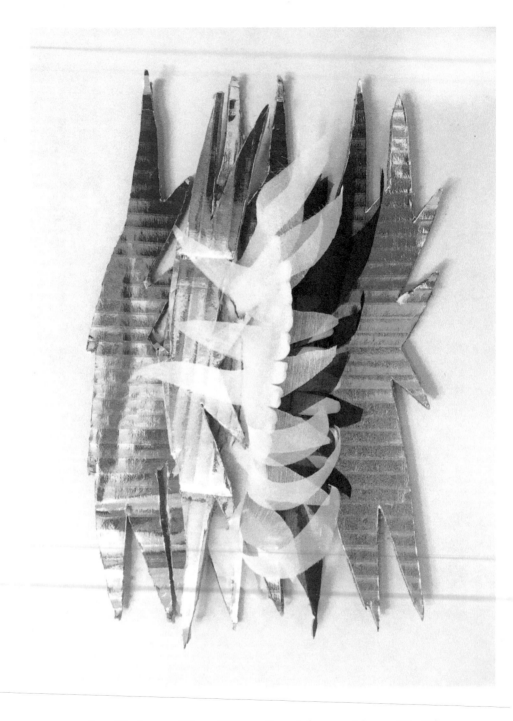

Sam Oh, *Layers of Days*, 2020, cardboard, foam, and linen, 15" x 10"

Today's Word Is Invisible:
On Peter Gizzi's *Fierce Elegy* (Wesleyan University Press, 2023)

Timothy Leo

A few years ago, Peter Gizzi penned a voice that ate the air. This "I" fashioned a life of "sky and its procedures," wanting out of the past, entranced by "pale crenellations" and flirting with "a name / for every bird in me." The voice did not falter, but the speaker fell. Eating the air "cut me, an iridescent chord / of geometric light. / I breathed deep, it lit me up, it was good." Now, with *Fierce Elegy*, Gizzi offers a hint of exhalation. Three poems in and eschewing mourning, "Revisionary" enacts both declaration and disappearance—entwining the fierce, the elegiac:

> I've decided to let my inner weather out.
> Even in the nerves flashing, some things
> are only shadow.
> What's up with that?
> My muse bruises me.
> Some days I sit hours to be relieved
> by a word.
> Today's word is invisible.

In the space between decision and shade, language haunts itself and—like any good ghost—knows there's more to loss than loss. There's of course the numbing, the twists and

shouts of anger, the thinking, the magic, the growth, the laughter, the breath, the aphasia, the smiles. "It was all so Orfeo / the other night." And as the collection elaborates, it's all so eerie how, in the incalculable distance of death, our actions remain entangled with those who've gone. *Only in connection with a body*, reads the epigraph, *does a shadow make sense.*

Nodding to Rosmarie Waldrop, Gizzi coaxes this awareness across and through each section, poem, and line. His lines play with the sheer, simple material of our days infused with the mysteries of perspective, selfhood, and even love. Everything is as real as the heft and glass of the screens we hold in our hands; we live in the "as," the "like," the similitude. The air is not indifferent. An abstraction is a hard plastic, living words carry dead meanings, and at times *Exit* may merely be a sign made of glowing letters in a beige rectangle, hanging in a hallway and pointing the way to the door.

> When 8 Ball says "ask again."
> When the day reveals
> the prismatic systems of loss,
> a blinding shimmer
> on new blacktop in a sun shower.

> ...

> When you're brought to your knees,
> sing a song of praise.
> When you're gutted,
> embrace the whorl. FTW.
> There's nothing like it.

It's evening, it's afternoon, we lose ourselves and each other "between the rug / on my floor and / the sun setting / out the window." We lose each other in childhood, in age, in delight. "Sometimes it's hard / to know the outline / of a body, there's / so many people inside." Even if solitude may be one possible illusion accessible to us, "I is [also] that wound / / with its slight aura, archival glamour, gas-lit corridors, / its famous sunsets that dayglo on water." The light here throws "rhythmic shadows, / doppler and strange. Where are you?"

every glance

some circumference

of shadow

calling into

the psyche's

paper-blue

hieratic light

cardinals flaunt

their red into

a gentle rain

soft and constant

when elsewhere

becomes

an image

a thing

to live with

a worn feeling

an old force

softening glass

Elsewhere, the lines stretch across the page and maintain their playful halting movement. "Of the Air," a voice enunciates: "Speechlessness. Long stumbling earnestness. I have never been able. Will be different. The greater part. From now on. But I shall play."

surely this is about water jetting from a spring,
a languid rafting with no particular destination

as the old arguments, humans, how they rhyme,
stutter, get lost

this is also about conversations with the dead,
the only honest definition of silence

surely you are not listening to the words I am singing

We are indeed reading. There may be silence, there may be sound. This is a song. Together, we "[c]ut a hole in the

poem to play peekaboo with the afterlife." Before considering the wound, you may find yourself "unleashed as a verb. / Free to twirl, to disco, to walk away undone." *The word "I" sits on my shoulders,* says Waldrop, *ready for carnage. A cry, which is not a description, is not an image either.*

In this, *Fierce Elegy* realizes an emptiness akin to the emptiness of air, an ever-shifting repletion teeming with energies, mass, inertia, affect, sweat evaporating in a dance. "Nearing the end, I could hear a lark. / Its trill fixing itself to my brain. / A thing become a wave." As someone once said of Woolf's body of work, these poems are weighted with delicate, physical facts. With *Fierce Elegy*, we're "counting ribs / in alabaster light." We listen "to stone translate to silence."

'Carry Me There, Bright, Burning and Alive': A Review of *Deep Are These Distances Between Us* by Susan Atefat-Peckham (CavanKerry Press, 2023)

Tawanda Mulalu

I encountered the poetry of Susan Atefat-Peckham in my first undergraduate poetry workshop through her son Darius. At that time, Darius was writing a series of call-and-response poems to his mother, who passed away in a car accident in Jordan, along with his little brother, Cyrus, when Darius was much younger. Darius is an inventive and profoundly warm poet in his own right, which is but one of the many reasons that I love him. Back then, I understood the diasporic imaginations in those poems as Darius's attempt to broach a dialogue across an impossible barrier between life and death.

I understood this attempt as wholly unique to Darius. I was wrong. Now I recognize a similar (if contextually different) diasporic imagination in Susan's poems. In her second collection, just released at the time of writing, *Deep Are These Distances Between Us*, Susan, born in the United States, traverses barriers of time and distance to remember and re-imagine her parental homeland of Iran.

The intimacy of these poems surprised me. As I carried them through New York while figuring out how to write this review—I felt desperately homesick through Susan's words.

Though Susan was writing of Iran through America, my brain, wishing for Botswana, was ignited by her poetics.

Perhaps my surprise at how deeply these poems wounded me stems from our present cultural suspicion of universalism in the arts: a suspicion well-warranted by centuries of colonial, racial and gendered historical dispossession of people and their voices. But the vision of diasporic solidarity I imagined while communing with Susan complicated that suspicion, opening towards a larger conversation whose dynamics I'm still figuring out.

Susan herself presents such a complication of diasporic solidarity (and lack thereof) between Iranians and Afghans, through the figure of Ghossam, a young boy from Afghanistan who stayed in her grandmother's home as a helper. In the poems where he appears, such as 'Ghossam Remembers His Brother', we slowly come to understand that Susan is writing from America retrospectively, and in doing so, unspools familial dynamics that would otherwise feel uninterrogated:

> He says, One day
> *I will buy a knife—no, one day,*
> *I will buy a gun and stand*
> on a car and shoot everyone.
> He says, One day I will kill
> *all Iranians. Esmat Khanoom*
> wonders which village he came
> from in Afghanistan. She knows
> this kid has no one, and feeds him
> sholeh zard, watches the tip
> of his spoon drip into the saffron
> and pistachio design, cutting
> the surface of the pudding, listens
> to him speak through the yellow
> gelatin clinging to his teeth.

Perhaps it is the distance of both time and space that allows the reader to be drawn through a window and into the speaker's family life. And it is truly rare to see intimacy of this kind mediated through such brutal, but simultaneously tender, statements of fact. The poem 'Lower Manhattan', in contrast, relies instead on a style of lyric meditation that directly addresses us. Here, the intimacy, despite the obvious distance of the 'you' (reader, known only truly to oneself) and speaker (assumedly Susan, known only truly to herself) is created via the poem's plea for us to somehow be with the speaker via the patient magic of the poem:

> This city, in the palm of my hands,
> beneath spaces of clamped fingers,
> where I carried it to France, Iran,
> Switzerland, Texas, Nebraska,
> Michigan, where I still hold it,
> the years I've left behind. How
> will I find my way home? My palms
> burn. If you are lost, look
> for my eyes, hot in your hands.
> Carry me there, bright, burning,
> and alive.

I wanted to write more about how Susan manipulates distance, especially formally on the page. What to make of the short-lines that force a constant disruption of our reading of her actual sentences?—as if the poet wishes to bide time with us readers; and of the repeated indents at the beginning of her stanzas?— as if to mark the possibility, between these quick silences, of other voices, other ideas and journeys. And I've only just barely touched on a whole host of thematic questions. I've fixated here on Susan's particular renderings

of diasporic experience, but there's also a lot she has written about the particular material conditions and cultures of her Iranian heritage that have both facilitated and disrupted her writing process; and of Susan's understanding of how that heritage has deepened her visions of her own mortality through seeing her parents age and through birthing her children.

But I wanted to speak, too, about how I've witnessed how these poems have deeply influenced Darius' own writing—yes, of course, on a personal level—but also by realizing the sheer craftiness with which he has engaged with his shifting sense of self, mediated through Persian culture and language. How he has sparked his own unique elucidations of himself through a country that he has never stepped a single foot into, but still takes wholeheartedly as a deep place from within where his poetry can speak to his mother, to himself, and to all of us, in and from America, and elsewhere. I imagine that this metaphysical correspondence between these two poets is of a literary significance that will take a longer moment than this to understand properly and sincerely—and I'm looking forward to how the study of this correspondence will tell us about what it means to love from from a distance that is nonetheless intimate.

I wanted to tell you more about all these things, but my admission to *you*, reading this review, is that I'm not a critic, just an admirer. Which is to say, one who is overwhelmed with how to speak of all of this in a sensible way besides gesturing you towards a million of these different thoughts (coincidentally, I had *just* walked by the United Nations building when I read 'Lower Manhattan' for the first time, which itself begins, 'From the United Nations / International School on FDR Drive / and 25th Street, Mother and I walked…") So let me instead leave you with some of the

lines that most moved me in *Deep Are These Distances Between Us* while walking through the city, working on this review, reading and re-reading one poem after another, and disappearing further into the generous surprises of Susan's words:

from The Meanings of Names

i.

 The boy was unlucky—
Mother says the name Massoud
means happy, fortunate, prosperous,
but Massoud drowned in liquor, died
by the shores of the Caspian, a salt
shaker in his hand…

iii.

 In Michigan
I'm choosing a name for my son.
Mother sits on the couch and says
I shouldn't think too much. Where
I am, leaves and children appear
and disappear into fog, swallowing
the lake in and out…

*

from Continuance

 '...and humid
New Jersey hours inside the house, the sun
beating the hours into the roof saying,
Today will lead to some place of repeated
comfort where even scars will brighten.'

 *

from Clean

 ...I imagine his fingers bent
beneath the threads, cherry preserve stain
in his nails, the tips meeting his thumbs,
red silent mouths, opening.
 Grandfather,
I have washed my hands, I have
washed my hands, I have washed
my hands.

 *

from Night Conversations

 Palm: How
do you beg to travel such
unknown distances?
 Star: Friend,
clap the blades of your leaves
into these black hours, for deep
are these distances between us.

Haramkhor

Rajiv Mohabir

I would myself red with flight, gloveless hand,
adventurer in the Spokane River
covered with feathers, closed to starshine—
those emerald-back feathers: to assuage my
fear of being thrown powering, powering
beneath. Have I ever had quill or spine
to draw myself into a whole or wings
to unfurl to glide against glacial melt?
I have stolen the rocks' smooth edge, sparkles
of quartz and lust, to claim a tumbled polish
as though myself a river serpent able
to fly, I feast, an Eater of Erasure,
Eater of eggshells. I write my namah
in another's thieved red, dear wing, dear window.

Benjamin Keating, *UCP 003*, 2006, cast bronze, 20" x 8" x 16"
Photograph by Robert Banat

Benjamin Keating, *Mouth open to her,* 2022, cast aluminum and tree, 7' x 4' x 3'
Photograph by Chloe Gifkins, courtesy Tripoli Gallery

A Visit to Merwin's Garden

J.P. White

On a visit to Maui, I went looking for W.S. Merwin. I knew only that he had an Hai'ku address. I made a few inquiries, but no one had heard of the poet. Near the market I found the Hai'ku Style Gallery, owned by a Frenchwoman, Claire. Surely, I thought, she must know of him. She lived in the valley next to his and she knew him just enough to say hello and talk plants. After a few minutes of island talk, I asked her for directions. "I can give you the name of his road, but you will never find him. It's not his way." Before I turned to leave, I asked her a second question. "What is he like… now?" She seemed reluctant to say more. "Very quiet. Very smart. Very kind."

"That's it?" I asked, wanting to hear more.

"Isn't that enough?" she replied.

I found the road, but I did not find W.S. Merwin. No street address. No mailbox. No signage.

I would not find where Merwin lived until after his death. My wife and I were spending the winter of 2020 in Maui. We thought we might move there, but Covid had been in full force for over a year. The remote workers of the world had descended on Maui that winter with cash in hand and real estate values jumped by 50% and nearly everything we

looked at was out of reach. When Merwin arrived in 1975, he must have found a north shore that felt almost uninhabited except for surfers looking for a sliver of cheap living.

Merwin had come to Maui to study with Zen Buddhist master Robert Aitken and had become involved in the local effort to restore the natural flow of water off Haleakala. It may be that his time in the dojo prompted him to get involved with the land as a way to focus his mind and find a way out of bleakness, a slice of which can be found on almost any page of The Lice published in 1967:

WHEN THE WAR IS OVER

When the war is over
We will be proud of course the air will be
Good for breathing at last
The water will have been improved the salmon
And the silence of heaven will migrate more perfectly
The dead will think the living are worth it we will know
Who we are
And we will all enlist again

Merwin found three acres that had been classified as "wasteland" by the bank. Land is the oldest currency in Maui and much of it, by 1975, had already been rendered infertile by cattle, sugarcane, and pineapples. In an interview, Merwin said, "The Lice was written at a time when I really felt there was no point in writing. I got to the point where I thought the future was so bleak that there was no point in writing anything at all. And so the poems kind of pushed their way upon me. I would be out growing vegetables and walking around the countryside when all of a sudden I'd find myself

writing a poem."

<center>*</center>

That 3-acre wasteland has today expanded into the 19-acre Merwan Conservancy that is one of the most diverse palm gardens in the world. In *"What is a Garden?"* Merwin reveals that he chose palm because his early attempts to grow the native koa and sandalwood failed. The depleted soil would not sustain them. But palms are woody herbs with a straw-like root system that can get established in a wide range of soils with decent drainage. The Merwin Conservancy is a verdant analogue to the fluid, unpunctuated world that Merwin first experimented with in his poetry of the early 1960's. Hidden and spacious and fiercely full of an emptiness that suited Merwin's penchant for the nameless embrace of things. Once behind the gate, the greenery and the core quiet of the Conservancy quickly takes you in and the canopy of the palms blocks out much of the sky and no sound of cars on the busy switchback road to Hana. How does a poet turn a wasteland into a palm forest? One tree at a time. Over the course of the forty-plus years he lived there, Merwin planted nearly 3,000 trees representing nearly 500 species. Not everyone approved of his vision. Claire from the art gallery told me there is a strong island opinion that only native flora should be cultivated and that what Merwin created is not in alignment with the spirit of the island. Merwin must have seen a bigger, mycelial statement: that palms from all over the world are capable, through a vast network of fungal threads, of dialogue, collaboration, connection, renewal, protection.

<center>*</center>

At a stop on a ridge where you can glimpse the ocean, our guide, Sara, offered a chant and Merwin's poem, *The Laughing Thrush*...

THE LAUGHING THRUSH

O nameless joy of the morning

tumbling upward note by note out of the night
and the hush of the dark valley
and out of whatever has not been there

song unquestioning and unbounded
yes this is the place and the one time
in the whole of before and after
with all of memory waking into it
and the lost visages that hover
around the edge of sleep
constant and clear
and the words that lately have fallen silent
to surface among the phrases of some future
if there is a future

here is where they all sing the first daylight
whether or not there is anyone listening

And then, more descent into a maze of greenery that mostly started from seeds that Merwin started planting when he first moved there.

*

I've heard it said by other poets that no other American poet led a more charmed life than W. S. Merwin. He won the Yale Prize in 1952 when he was only 25. He was a tutor for the son of Robert Graves on the island of Majorca. He had lived for years in the ruin of a farmhouse in Dordogne, France where he first established himself as a gifted translator of Spanish, French, Latin, Italian, and numerous other languages. But maybe it is that he chose to live off the grid and on the cheap his entire life, and always in places of great natural beauty, which accounts for the 'charmed' aspect of his life. I am thinking of the old French *charme*, meaning incantation and the use of magic spells, and from the Latin *carmen*: song and incantation. I can't think of another American poet, unless it would be Wendell Berry and Mary Oliver, who is as charmed and seduced by what he found in the natural world even while acknowledging the earth in all its *Sturm und Drang* and vanishing. At his best, Merwin's poetry leads one into a timeless landscape where the elements are dreaming us into song. We don't always know where we are and we are uncertain we ever want to leave. In this mythic dreamscape, threat and wonder co-exist with humility and gratitude and a recognition that the beginning of seasons, memories, reflections, and encounters are closely tied to their end. The human part of the story is subsumed by the elemental. You can smell the elements. Hear them. Feel them like a second skin. In a Merwin poem, you will find yourself a long way from any convenience, any cell phone, any gas-powered engine. The poems are almost always set outside where the memory of rooms falls away and something unexpected emerges from the ever changing rain, light and wind. His muck boots are on and he is on the trail, a dog by his side.

*

I first met Merwin just prior to his moving to Maui in 1975. In a mushroom-shaped foam house in Boulder, a party was thrown by The Naropa Institute after Merwin gave a reading. His reading style, like his poems, was one of gracious seduction. He could lead you into his dreamscape with his quiet voice encouraging you to take one step after another until there was no way out, but through. At the party Merwin hung back in a corner, not saying a word. He was 48. He had already won a Pulitzer Prize among others and was as famous as any American poet can be. I was 23 and not really certain of anything except wanting to write poems. I braved a silly question. "What is your secret?" He smiled as if to say, "And why would I share such a thing with you," then after a significant pause, he said, "I listen for a long time. Watch everything. What else can I do?"

Rumor had it he had come to Boulder, not just for a reading, but to study with Trungpa Rinpoche and something had gone off the rails between them. I had no idea he was thoroughly disenchanted with the world and was moving to Hawaii to find another way forward through the post-industrial wasteland bound by profit and war. But then the idea of returning a "wasteland" to a thing of beauty takes hold and he puts his hands to work in the ruined soil and suddenly the palm garden turns up in the poems. The dark poems found in his books *The Moving Target* and *The Lice* start to take on a different tone where rain and sun are more evenly mixed. Some modest hope returns to the land and to the voice of W. S. Merwin. Here's where he gets to on that ridge I spoke of earlier...

ANNIVERSARY ON THE ISLAND

The long waves glide in through the afternoon

while we watch from the island
from the cool shadow under the trees where the long
ridge
a fold in the skirt of the mountain
runs down to the end of the headland

day after day we wake to the island
the light rises through the drops on the leaves
and we remember like birds where we are
night after night we touch the dark island
that once we set out for

and we lie still at last with the island in our arms
hearing the leaves and the breathing shore
there are no years any more
only the one mountain
and on all sides the sea that brought us

The Rain in the Trees, 1994

Merwin found almost everything worthy of contemplation in his palm forest tucked away below a ridgeline offering a glimpse of the Pacific. Rain, leaves, beetles, wind, birds, the seasons, memory after memory, travel, recollections of violence to greenery and animals, fallen stone walls and those left standing, the sound of words, grief and gratitude entwined, the never ending communion with dogs and trees, and always that listening. All of it is available on this garden path he created. Sara stops our group at a little wooden bridge over a creek long since dried up for another Merwin poem…

ONE VALLEY

Once I thought I could find
where it began
but that never happened
though I went looking for it
time and again
cutting my way past
empty pools and dry waterfalls
where my dog ran straight up the stone
like an unmoored flame

it seemed that the beginning
could not be far then
as I went on through the trees
over the rocks toward the mountain
until I came out in the open
and saw no sign of it

where the roaring torrent
raced at one time
to carve farther down
those high walls in the stone
for the silence that I hear now
day and night on its way to the sea

The Shadow of Sirius, 2009

Another poet might have built his home on that ridge with
the peek-a-boo ocean view, but Merwin was not a water poet.
He much preferred the inner hull of the ship to the deck itself.
He wanted the depths of the Pea'hi Stream valley and did not
require the horizon line. As we made our descent, it felt like

everything we saw and heard was intentional. Everything before us was part of his plan: to make a wilderness to hold back the encroachment of the world. Sara points out the Merwin residence, but it's difficult to glimpse behind the greenery of the fronds. In Merwin's Essay, *The House and Garden: The Emergence of a Dream*, he writes of this deliberate hiding of his house....

Another influence on the setting of the house I wanted, as I thought about it, came from my reading. A few years earlier in a book by John Blofeld, I was captivated by his account of his wanderings in the mountains of China in the 1930s and earlier. He was drawn then to find what he could of the ancient Taoist and Buddhist monasteries, as they were then...

...at a turn in the path, he would be taken by surprise by the sight, just over the edge of a slope, of an earthen wall and tiled roofs just visible above it, all looking as though they had always been there and had grown out of the mountain...

What he was describing sounded to me like an ideal, and I hoped to have a house set among trees and visible only as one actually arrived there on foot.

<div align="center">*</div>

Buddhist schools vary in their interpretation of the path to liberation from *samsara* (the wandering of the world), but all schools recognize suffering as the bedrock of human existence. Merwin's poems, so often set in a green, untamed place, reflect his own cycle of suffering between healing and hurting. This place of constant growth, change and decay was the ideal creative source for an extended meditation on the "blowing out" of our afflictions through walking the earth. He found work and solace there with his house hidden behind the greenery, yet in many of his best poems, the relentless

ecological threat is never far from the heartbeat of the palms.

Merwin never sought the structure of an academic life as a way of sequestering from the world, but now, by moving to the wet, north shore of Maui, he deliberately removed conveniences and comforts and made room for an elemental language. The "wandering" of the world, the craving for the new, the hunger for more, has now been replaced with a dream-like marveling over things that had long ago taken root in the rain…

> out of the calling water
> and the black branches
> leaves no bigger than your fingertips
> were unfolding on the tree of heaven
> against the old stained wall
> their green sunlight
> that had never shone before
>
> walking together we were the first
> to see them
> and we knew them then
> all the languages were foreign and the first
> year rose

The Rain in the Trees, 1994

His choice to turn a wasteland into a garden is not a mere turning away from suffering, but a cultivation of another way of seeing and listening that will allow that pain, his own and the world's, to co-exist with a root and leaf flourishing. He sensed that the voice from the garden was needed more than ever to be a voice at his own table and the world's. Merwin's garden is not a hermitage but a source of hope, renewal and

imagination and the poet is not an isolated eccentric but a servant of the earth with his garden gloves on, always ready for work and the promise of what that work might deliver.

<p style="text-align:center">*</p>

If mindfulness and intention are the lodestones of Buddhist practice, then W.S. Merwin was an able practitioner who brought the creation of his palm forest and his poetry into a unified field that included alarm and astonishment. In Maui, I would have asked him one question: *Did you consider your poetry or your palm forest to be your central legacy?* Standing there, at his gravesite where he and wife Paula and his beloved dogs are all buried together, the answer felt apparent. The life and the art were one. Every day, with words and seeds, he went to work, looking to grow something.

PLACE

On the last day of the world
I would want to plant a tree

what for
not for the fruit

the tree that bears the fruit
is not the one that was planted

I want the tree that stands
in the earth for the first time

with the sun already
going down

and the water

touching its roots

in the earth full of the dead
and the clouds passing

one by one
over its leaves

From *Radii*

Tessa Bolsover

n. of unknown origin, ray
or beam of light, a spoke, a line
from center to circumference, ellipse
moon and earth irregular
angles, tangent spheres, divided
wings of moths, forearm bones irradiant
reaching toward an edge's soft decay

to coin as in
to name. palm divot
opal blue collected
metals in the body

 the

 center is
 the orbit
 cameras know this
as do birds. how space moves like the surface
of the sea or a riot

how contact makes radiant. unsealed evening
violeting our edges. curves alalia, clipping
silk or thud of bird. images within the eye
return at last to lengths of light

Me and My Sister in Hats at the Top of the Temple

Alex Baskin

My father took
us to Mexico I
don't remember
much I
know we climbed
Chichen Itza and
tried to count the stone
steps but couldn't

There is a photo
of me and my
sister in hats
at the top of the temple:
our little fingers hooked
into the corners of
our mouths spreading
our lips wide
like frogs jutting
our wet tongues
towards the lens
our recently-divorced
father beaming
behind the camera
I'm sure

I remember soon
after the trip a
churning feeling in
my little belly lying
awake on a mattress
on the floor at
his new *apartment*
pondering this
hazy-gray word which
seemed to mean that
my father wanted
to be apart
from my mother

That man took us
to Mexico
and poured us mango
juice for days I
know we slurped it
up like zealots high
on sugar and the chlorine
fumes from the pool
at our hotel

Yes
he would disappoint in
uncountable ways
over the years but
well there is no *but*
it's just
that both things are true:
Mexico & my father

Bob, En Français

Bin Ramke

After my mother's death my sister told me my mother's
nickname as a child was Bob. Perhaps sonically reduced
from Melba. Ba. BaBa. My mother spoke Louisiana French,
Cajun, the word a corruption of *Acadian*, from Acadia
Province, Nova Scotia.

Éclair means lightning. *Éclaircissement* is what they call
the Enlightenment which ended in 1789. An éclair is filled
with a sugary ooze and covered with chocolate. In 1755
the British drove the French Catholics out of Acadia during
the period when Beausoleil was credited with the deaths
of many British soldiers—the accounts were no doubt
exaggerated, but the suffering was not. Many Cajuns got
to Louisiana by way of what is now Haiti, where there is
still now suffering and French speaking. My mother on
the telephone was a foreignness. She had won prizes at
shorthand and told us she mentally transcribed all her
telephone conversations. In Gregg—elliptical figures and
bisecting lines. Speaking to her sisters she spoke French and
I never asked if her shorthand was French. The thread of
Ariadne twines morninggglorylike through some lifetimes
and it would be a bright glory to see whole, to feel a life in
the brain in a moment, monumental.

I think of my mother now as Bob. She left behind a thousand cookery books many with marginal notations, with newspaper recipes interleaved and with emery (corundum and magnetite) boards and the occasional kitchen match or even matchbook as book mark. Also there are hand-written recipes she sent to her children on request, for gumbo, for lemon-meringue pie (*meringue*, from French, of unknown origin, the word first appeared prior to the *Éclaircissement*).

I have a memory of my mother whipping egg whites in a bowl by hand, a frantic motion interrupted from time to time to sprinkle sugar into the foam until shiny peaks would form and hold. A hand crank rotary egg beater was patented before the start of the Civil War.

Progressive bulbar palsy damages motor neurons in the brain stem, those that involve chewing, swallowing, speaking, and that help control emotions. You may laugh or cry without meaning to or knowing why.

I once cooked for my mother, early in her illness which would leave her unable to swallow. Even then she was losing abilities, and was soon unable to speak and, like me, began to carry with her a small notebook to keep contact with the world.

> *Whatever one may say or think about suffering, it escapes knowledge to the extent that it is suffered in itself, for itself, and to the degree that knowledge remains powerless to transform it.*
> -Jean-Paul Sartre, *Search for a Method*

Clatter

What does glitter is not air. Slimmest air
among the pears, pearls of shape and shimmer:
to air the linens in summer a task assigned

the youngest son or daughter to keep them
kept. Keeping continues the dreary dream
of the idle, the lesser minding.

What is air is
How you tell the cloud from clarity
when both are blue. The pearl-shaped

pear grows thick in sunlight, licked by
wasp and weather alike. The pearl
grows without light or air or shame.

Picked. All or parts of memory remind
the hand to remain muscular. Fingers finicky
twist the pearskin parts of tree,

theft. A saint could not resist the taking.
A mind an emptiness with one or two
dried seeds, like a child's distraction.

Or a forgotten gourd in the garden.

You Had Me at *Premier Cru,*

Angie Estes

you had me on the hillside

of *Clos de la Croix de Pierre* in Burgundy

even though we have never

been there. You had me contemplating

the riddles of birds: *What looks open*

and invites you in but is something you can

never enter? You even had me laughing

at the jokes birds make, like the one

about the Northern Flicker that believes

the cup tattooed on his chest is half

full, when it's really half empty. You had me

at Andrei Rublev's grave, which no one

can find, although the bells keep

ringing anyway. Sitting next to you

on the bed before you left, you had me

sitting before the road and you had me inside

you leaving Venice, chanting with the novices

in the monastery of Grande Chartreuse: *Tu m'as*

séduit, o Seigneur, et moi, je me suis laissé

séduire, O Lord you have seduced

me, and I let myself

be seduced.

Come, No Longer Unthinkable

Jennifer Grotz

Like someone who puts out the light
the better to see into the dark, look,
I put it out.

And then the dark changes, it becomes
various things instead of one. That's
what lures me out

among the slick black trunks of pines
soft from drinking up the melted snow.
Uniform and tall as bars

the forest is the only cage I've entered to be free.
Under moonlight, ice light, the deer
nose in gold spokes of grass,

piercing the stiff snow, glossy as meringue,
with their perfect hooves. They brave
the center, unlike

the milkweed orbiting the clearing, that look
like all the different phases of the moon, I thought,

fanned out for display.

Did I think it or did I mind it? Because the mind
won't stop minding. Or the eye stop eyeing.
That's why, closer up,

the milkweed is eyeing, too: a cottony globe
in its socket looks out from the hood
of a wood-gray eyelid.

I stare—the dark requires staring to be sure—at what
it's staring down at: a large stone, and beneath that,
a patch of wet earth.

Where one can't see any further, only imagine.
Where darkness is just a purgatory
of things unseen.

I stand right there, in that particular dark.

Thoughts on Joy

Joanna Klink

Hard to stand what hasn't
worked, what hasn't
taken shape, all the unsteady
need. I walked over
a steel bridge with you,
which took a long while, feeling
only content. There were streetlights
hazing over the dusk, rain
falling through trees. I did
know that you were living
in the aftermath of great
loss. But I believed the heaviness
would soften, even if
it never ends.

There are hours when
each of us feels we have
not once been at home.
I can imagine the old roads
in Iowa, where I was born,
the woolen wet prairie heat.
Today I have nothing to
say. A new kind of ruin
entered my life
when you showed me it was
possible to never again
try to speak.

I am writing this on a Saturday.
I dislike tasks that must be
endlessly repeated, like
cleaning the sink. There
must be a few people who
delight in such things
and I've found it's possible
to learn someone else's joy
just by watching. I want
to apprentice myself to exceptional
work. I admire the grass
that persists through thick
bolts of cement, and the air
made by trees. The sleep
we crave, and require.

Don't be coy—you had convictions.
You had a fierce sense of
what you would and wouldn't
do. I asked a hundred questions
and still you couldn't explain
the hospital, the rosebush, the days,
gliding as they were or slowly flashing—
the way we hold on to each other
wanting nothing but bliss—pure,
unspoken, with no need to talk
or strive or understand,
no need for poetry—just a silence,
broad and constant, in which,
occasionally, winds shift or stars fall.

Most of the time I hardly know
what to believe in, beyond
the fragile hinge of each night,
or the secret love people
harbor for each other,
the real will to help. You were
almost there, pensive, tapping
at the screen door. Damage
is effortless. You still come and go.

You pushed off into day
and walked the long streets to work.
The light down the avenue
was beautiful, but it was also a sorrow.
Time to find you. Time to wrap you
into me and buoy you. Years have now
passed. I don't think
there's a way to account
for my graceless exit, the crushing
wall of your silence. I love mornings,
I love the whole hour after it's rained,
and how that simply
passes. Like the sky,
which neither leaves nor arrives.

Maybe you scowl, convince yourself
it was a place that didn't
exist. It existed. It was not
a distraction or passing
thought: there were blocks
in this city we walked, books
we held out to each other, long
languorous days. A ceiling fan
clicking over the bed.
There is an alphabet
where a tree is a clockhand,
a tunnel a pause,
where night feathers out
to the edge of the suburbs, beyond
the blown ditches and litter, and touches
the dawn, which is kind,
before it even begins.

Folio: Anti-letters

Scalia indicum. 5. 5.

Hepatica triloba. 12. 13.

Portulaca triloba. 5. 1.

Anti-letters
Editors' Foreword

This folio was originally inspired by the so-called "Master" Letters of Emily Dickinson: a set of three mysterious, unmailed missives to an unknown recipient, discovered posthumously among Emily Dickinson's poems. These letters were not kept with Dickinson's correspondence, which her sister Lavinia destroyed upon discovery. Theories about the identity of Dickinson's "Master"—often thought a potential lover—tend to dominate critical and popular interest surrounding these three documents. Adjacent to the search for Dickinson's addressee, Ralph William Franklin in the introduction to the facsimile edition of *The Master Letters of Emily Dickinson* (Amherst College Press, 1986) declares curtly that "Dickinson did not write letters as a fictional genre".[i] Why would Franklin open with such a defensive claim? Because someone else had just claimed the opposite.

The year prior in *My Emily Dickinson* (North Atlantic Books, 1985), Susan Howe proposed that readers, rather than invariably focusing on the possible identity of the Master letters' addressee, should instead attend closely to the letters' structure—their wording, imagery, and ideas—in relation to Dickinson's known literary influences. The language Dickinson uses in these three letters is urgent and strange. "I used to think when I died— / I could see you— so I died / as fast as I could[.]" Dickinson's voice turns as it might turn in a poem; she performs meekness, then she commands: "Say I may wait for you—"; "You make me say it over—";"you know what a leech is, don't / you—"; or below, "Listen again, Master":

You ask me what
my flowers said—
then they were
disobedient—I gave
them messages—
They said what the
lips in the West, say,
when the sun goes
down, and so says
the Dawn—
Listen again, Master—
I did not tell you that
today had been the
Sabbath Day.[ii]

As Howe controversially points out, we have no evidence that
the Master letters, written during the years when Dickinson
was "at the height of her creative drive," were ever actually
sent to a recipient. We should therefore pay primary attention
to the way in which Dickinson uses the epistolary form to
imitate or innovate, or trace similarities in tone, voice, and
image between the Master Letters and epistolary examples from
the sources Dickinson was reading. Instead of restricting
ourselves to reading the Master Letters as hysterical
outpourings of a spurned woman to her lover, Howe suggests
that we consider them first as "self-conscious exercises in
prose by one writer playing with, listening to, and learning
from others."[iii]

This folio of *Anti-letters* developed out of thinking about
Dickinson's Master Letters as creative exercises that produce
organic new forms: forms used by the artist for something
other than their originally intended function. How can other
instances of writing that we might consider "personal"—
letters, diary entries, lists, marginalia—function similarly
to the Master Letters? How, alongside a purported mundane
or private purpose, can they work as creative exercises
originally unintended for an audience?

As you might expect, most writers responded to this inquiry about their creative process with enthusiasm—and very differently from each other. Jane Miller's two pieces titled "The Elusive Pursuit of Happiness" draw their syntax from the untitled poem prior, originally a notebook list cordoned off from her poetic writing. James Davis May's "Stand" grew out of an assignment from his therapist, and Cody-Rose Clevidence worked from notes on TikTok, farming, economics, America. Countering the idea of anti-letters with "ante-letters," Jill Magi's "The Open Stone" draws on pedagogical exercises used in her classroom to explore the combined gestures of language and material in forms prior to public and typeset literature. Stacy Szymaszek's "Essay" series enters a dialogue already begun between Stephanie Young and Bernadette Mayer; Nicholas Regiacorte's call-and-response between the figures of A.M. and Sigrid originated as notes in the right margins of drafts. In conversation with Marguerite Porete, Amy Hollywood's "Love and the Heretic" reacts to and redacts stories told and not told, speech both given and withheld. Pages from Susan Howe's Concordance point also to redaction, omission, and stifled dialogue, only to develop back into speech in a sound installation with David Grubbs. Across the arc of these pieces, *Anti-letter* came to mean not only missives sent or retained, but speech, text, and language both broken off and resumed; silenced, or again begun.

The folio's title plays, of course, with the controversy surrounding Dickinson's "Master"— but it is also an homage to two other artists who feature in Howe's critical writing on language and form: Trappist monk, writer, and poet Thomas Merton, and experimental concrete-poet Robert Lax. *A Catch of Anti-letters* (Sheed & Ward, 1978) is a volume of their selected correspondence that spans a five-year period (1962-1967) during which Merton was living in Gethsemani Abbey in Kentucky, and Lax first moved as a hermit on the Greek islands of Patmos, Mytilini, and Kalymnos. These letters—only a fraction of the reams these friends wrote to one another—provide a glimpse of two more writers at play with

the epistolary genre. Consider, for instance, the following excerpt from Lax's undated message to Merton sometime in February 1996:

> cher murps,
>
> hir again is holy patmos. patmos really holy place. what i mean dear murthwog, it's what i'd call a holy place. holy, that is, not at all like the elks. & place; like the place is holy. not saying something one way or another about the people. maybe they are too, maybe they all are. but the place. flowers, rocks birds. it's more like the rocks look happy.

Or part of this list enclosed with Merton's letter to Lax ("Dear Most") on February 24, 1965[iv]:

> Book of Proverbs:
> 1. I will tell you what you can do ask me if you do not understand what I just said
> 2 One thing you can do be a manufacturer make appliances
> 3 Be a Man-u-fac-tu-rer
> 4 Be a manufac
> 5 Make appliances sell them for a high price
> 6 I will tell you about industry make appliances
> 7 Make appliances that *move*
> 8 Ask me if you do not understand what is move

Merton and Lax's anti-letters remind us that writing relies on an element of play built in from the start; of organic and irrepressible delight in the shifting function and form of language, no matter how serious its subject. For Dickinson, life, death, love, and God are all on the line in the Master Letters; yet throughout, she remains a master at play with her craft. The language she leaves us with is the material consequence of that practice.

As this folio began to take shape, we saw almost immediately that it would of necessity exceed the boundaries that we

had originally thought to put around it. What compels a reader about the Master Letters is not only their mystery, but their mutability: to each reader, these letters speak simultaneously with great insistence and great difference. In turn, this is how we hope that the pieces within this folio will speak to you, our reader. Thank you to all of the artists within for your incredible contributions, and thank you for being willing to let us look briefly behind the veil of your process.

Emma De Lisle, Associate Editor
Sam Bailey, Managing Editor

Image credits

p. 241: Seal, Dickinson Family Artifact, Houghton Library, Harvard University. Photo by Yongyu Chen.

p.242: Herbarium, Emily Dickinson, circa 1839-1846. Houghton Library, Harvard University.

p. 248-249 : Emily Dickinson letter to Master (first line "If you saw a bullet hit a bird/ No rose, yet felt myself a'bloom"), Emily Dickinson Collection, Archives and Special Collections, Amherst College.

[i] Dickinson, Emily. *The Master Letters of Emily Dickinson*. Edited by Ralph William Franklin. Amherst, Mass. : Amherst College Press, 1986, p. 5.

[ii] Ibid., p. 40, 39, 36,14-16.

[iii] Howe, Susan. *My Emily Dickinson*. North Atlantic Books, 1985, p. 25, 27.

[iv] Merton, Thomas, and Robert Lax. *A Catch of Anti-Letters*. Rowman & Littlefield, 1994, p. 73, 58.

persons who pray - Can demand

~~Father~~ "Father"! You say I do

not tell you all - Clara, confess

and denied not.

Vesuvius dont talk - Etna dont

~~...~~ Said a syllable - one of ...

a thousand years ago, and

Pompeii heard it - and hid

forever - She couldnt cook the

word in this face, afterward

I suppose - Because Pompeii

"Tell you of the vaunt" - you

know what a circle is, ~~...~~ don

you - And Clara's arm is sm...

And you have felt the hor...

havnt you - and did that

sea never come so close as

to make you dance?

I dont know what you can

do for it - thank you - Master -

Master.

If you saw a bullet
hit a Bird - and he told you
he was'nt - shot - you might weep
at his Courtesy, but you would
certainly doubt his word -

One drop more from the gash
that stains your Daisy's
bosom - then would you believe?
Thomas' faith in Anatomy, was
stronger than his faith in faith.
God made me - [Master] - I did'nt
be - myself. [He] dont know how
it was done. He built the
heart in me - Bye and bye
it outgrew me - and like
the little mother - with the
big child - I got tired
holding him - I heard of a
thing called "Redemption" - which
rested men and women -

Note

'Untitled' is a page of a notebook entry I made simply trying to escape the grammar of my recent poems. You could say it's a list. It has a sense of being broken into lines, sort of. That's usually what happens to me unconsciously, even with a shopping list or directions.

The other two are poems that developed a "syntactical style" from the first group. They are each titled "The Elusive Pursuit of Happiness." Not sure if there will be more. I have a couple in mind. They seem to range more widely than the initial homegrown list to consider issues like climate, consciousness, illness, etc. At least they might be poems, whereas the first, who knows what it is. I didn't "intend" anything by it.

Jane Miller

(Untitled)

Jane Miller

Days we would wonder could it get any hotter.
Nights could have peed our pants with friends
hard drinking. Drives we took through Texas.
The dust devils. We could just stop the car
and not go in. We could arrive early and drive
around the block. Have they moved yet? We would
stop where we liked those tamales and beer
if it hadn't burned down. Where that sunburnt
homeless woman her hair matte like a coyote's
says any money help me with her cardboard
and the cart she'd like to shove in front of cars
at the intersection with the lobster sign.
What kind of lobster would that be around here.
We could hear the freeway but it never wondered
about us nor we it. And the sewage treatment plant
coming home with the windows down no amount
of cash could re-direct. Coming in hot to make love
and seeing the power out. Times my mother wanted
my nose fixed and hair straight. Times your mother
ought rather have blunt forced you into Hollywood
than speak so poorly to you you left. Driving
a secondhand car working for tips for the Iranian.

Smoking a joint on the porch. Passing through
a desert night blindsided by a memory of snow.
Where love circles like a practice jet over the airbase.
Wondering for the hell of it as you see the exit
if that would be me oh baby that would be me.

The Elusive Pursuit of Happiness

That there's nothing to be afraid of nothing at all.
What the scientist said about the end of consciousness.
Mighty as the Incan Empire. Where I lay beside you
in that convent for the night. We could do a road trip
together. Could slight their Jesus journeying to kiss you
on both shoulders. Cherubs like rosebuds on stems.
Could visit the flower stalls and sleep all afternoon.
Get a ride to the airport. Drop the grand plan of a mountain
lake that ends in a morphine ward. Where illusion by that
proverbial thread hangs. Babies dropped at the border.
Listening to the chilling quiet in the middle of the Mozart
sonata where his mother dies. Flying out undiagnosed
as the moon rises. We could try to sit together
on the plane. Fry the guinea pig flat with a brick
or it curls up. Make millefeuille cakes and apple vinegar
as the nuns at Arequipa play three chimes to mark
the sieging of the poor. My kingdom for a thermometer.
The raw eggs fool the brandy. The thought that we could fly
out when you are better. Could pay in cash. In spirit
and corporeal form. Spells you described as white
cats on fresh snow. Infants disappeared. The painter
showing Mary at the moment she has turned from her one

life as a courtesan. Sitting weeping on a wooden stool
jewels scattered on the floor. Could pour the nectar
of the gods into a blender at home. Brakes screeching
from the desert to the coast. Could let summer. Let light.
What the gems we buy at the airport would signify.
A glow rare as green amber. Making ice all night. Thinking
what if I have to call your mother to tell her.

The Elusive Pursuit of Happiness

Nights it couldn't rain any harder. Crazy running out
stripped down and drinking wine under the gutter spouts.
The healer Asclepius sick and missing from the southern sky.
Who once brought a king's son back with bitter herbs
after he drowned gold-plated in a cask of Cretan honey.
The myth dies with the times. Electricity out. Fallen lines.
Life magnificent and raging. Native peoples intuiting
that spores of a waxy plant emit a healing ten-thousand-year-old
eucalyptus scent soaked in turpentine and clove. Musk
of medicinal dust. Of smoked duck cooked over camphor leaves
and tea. Life divine. A stink of incense cured over time to signal
rain. The shame we failed to harvest. Animals lamed. Birds
dropping from the heavens on their way to Canada. Nights
 standing
in ambrosia as the ancients forest-bathing. Nights struck dumb
being so much older than you are and staring down where
each of us would go. You inside in candlelight and my ghost face
reflected like dry ice in a lightning flash. Would go and not return.
Earth essence passing through the black washed atmosphere.
Life sacred and night blind. Waking very late as drops of nectar
spoiled by the sun. Earth not one to beg. That begged. That scent
opens across half the valley. Proof the earth we failed did love us
unconditionally. The myth dies with the times. Dies raging.
The monsoon lingers until noon.

Note

"Stand" grew out of an exercise my therapist gave me.
We were discussing recently uncovered family trauma: my
mother had been horribly abused as a child by her parents,
a revelation that left me feeling confused and paralyzed.
The people who did these awful things to her were my
grandparents, and I was completely unsure of how to react
to the news. Should I seek revenge on my mother's behalf?
If so, how? Call the police? Write my grandparents a
scathing letter and cut off all ties? I wasn't the one who
was harmed, though learning about the history and how much
my mother had to endure was certainly painful. I told my
therapist I felt like I had to do something but had no idea
what that action was. "You're a poet," she said. "You should
write a poem. That's your assignment for next time." It had
been almost a decade since I had been assigned a poem to
write, but the charge gave me some sense of purpose, some
sense of control—as though I were taking the situation onto
my turf, a place where it was subjected to the physics of
poetry.

My therapist's assignment also felt like permission to not
react right away. Auden's "Poetry makes nothing happen" has

been discussed probably as much as any line of poetry ever
written, but one way of interpreting it seems applicable
to these poems: poetry makes *nothing* happen. It's a stay,
as Frost would say, an anti-action. It can be a way of
arresting decision and consequence, suspending them at least
temporarily to make room for clarity, and if not clarity
then anti-confusion.

James Davis May

Stand

James Davis May

A man tells his therapist a story about his mother
well before she was his mother. She's five,
on a hill, and wearing corduroy overalls,
a detail he's borrowed from the one photograph
he's seen of her at that age. She's backing up
against an oak tree that dominates the hill—
that's the verb he uses, *dominates*, and he wonders why
but keeps going because that's what the therapist
has told him to do. His mother has retreated
to the hill and then to the tree because a horse
has chased her there. If she moves a foot
to the right, the horse moves a foot to its left,
"unescapable like some sort of depiction of fate,"
he wants to say but doesn't because he thinks
it sounds corny until he realizes that he has said it
and his therapist makes a noise as if to acknowledge
significance, but significance of what is unclear.
Eventually, his mother climbs the tree. From that view,
she can see her grandfather's farmhouse
and a cousin or two going on with their tasks—
maybe one is mowing the field on the other side
and another is outside the shed, tinkering

with some sort of machinery, "oblivious to her
suffering," the man tells his therapist and stops,
realizing he's inverting "Musée des Beaux Arts"
so that the suffering is in the foreground, and the bystanders,
oblivious to their role as bystanders, are distant.
It's a perspective the girl will have to get used to
when her own mother marries a man who will abuse her
until she moves out. When she tells her mother
she's not yet seven, and her mother will tell her
it's common between stepfathers and their stepdaughters
and that they cannot lose the house, they cannot
lose the house, they cannot lose it, and they never do—
even now her mother still lives in that house
with the man her children believed
was their grandfather. Believed until they were all grown
and their mother told them everything
the day she decided that she should, which is why
the man talking to his therapist is talking to his therapist,
except now he's not talking, there's a pause,
and his therapist asks what he thinks this story means—
"Why do you associate the abuse with the horse,"
are her exact words. "Her stepfather isn't in the story."
And he's not sure it's the horse exactly,
even though he sees it clearly now, breath
faintly spooling from its nostrils because the sun
has sunk behind the mountains, cooling the air.
His mother has been scared for hours, alone
but for the horse, whose eyes are so dark
they seem to lack pupils. Every few minutes
it stomps in place, its hoof hitting the ground
like a judge's gavel, and he can't forgive it,
his imagination of the remembered horse,
for leaving her alone when someone found them.

My Parents Debate the Afterlife

My mother's a child and floating
against the ceiling like a lost birthday balloon,
the bee hive's venom sizzling in her
almost an hour while she's looking down
at her body on the gurney. A doctor
readies a needle—but then my father
walks into the room where we're sitting
and says, "Oh, not this bullshit, again,"
and my mother says, "I'll come back
and haunt you," and he says, "It's bad enough
as it is." Next week, another doctor
will snake a catheter through a vein in her arm
up to her brain, where it will inject a dye
that will show, we hope, the cause
of the cerebral hemorrhage that last month
made her dizzy and blurred her vision.
There's a chance the procedure could dislodge
plaque or blood clots and cause a stroke,
so she surprised me at dinner by asking
for my signature on her living will.
After we got home, she began the story
about the bees and the other time

she almost died. But now my father tells us
that "Once you're out, you're out—that's it,"
and I know who I favor and who I fear
is right. When the heart attack nearly killed him
and his weak pulse circulated the anesthesia
before surgery, he tried to see how long
he could stay awake. They're both on the couch now,
his hand in hers. My mother says it was so happy
there until they brought her back.

Absences

1.

My friend David says you can't find God,
that you can find only where He's been—
as in the way a trembling branch confirms
almost the owl that left it
or perfume lingering in a room
that was empty until you entered it
suggests it hasn't been empty long.

How much time, though, had passed
after God left and my mother, then a child,
pushed her dresser against the door
so the man her mother married
couldn't come into the bedroom again,
as he had done many times before?

2.

Today, my wife, daughter, and I
were walking in the woods and saw
the silhouettes of turkeys sprint
across our path into the trees.

We tried to see them through the lines
the straight-backed poplars made,
but could discern only flickering movement,
not their shapes, just sunlight and shadow,
and then a change, a beam of light
suddenly gone, a logic that said
they were there, moving away from us.

3.

What if there's a power vacuum? God leaves
the way the wolves left—or, that is,
the way they were driven out, and so
the coyotes strengthened their numbers
and became the threat. I hear them at night,
that howling that's almost a squeal—so easy
to see why the Puritans imagined that noise
as a witches' meeting—and yet,
though I walk outside in the dark morning
toward their calls, I never see one
that isn't just a blur.
 But this metaphor
doesn't work: I'm wondering what happens
if God leaves us alone and someone else knocks.

4.

I had not known any of the story,
but when I visited my grandparents as a child,
the bed was the same bed. The curtains,
the same curtains. The man had repented,
apologized, said he had found God,

was baptized, became my grandfather,
and my grandmother forgave him,
didn't divorce him, didn't
do anything except blame her daughter.

My mother remembers the marks
where dresser and door met each other
as he tried again and again to get back in—
before I was born, he had sanded the door so well
that those gouges had almost disappeared.

5.

Maybe the hero returns—sure. Maybe,
in the end, the villains are slaughtered,
or better, embarrassed, shamed. Maybe
the man behind the door behind the dresser
stops. Maybe the spirit—can I say that?—
lifts from the body completely blameless.
Maybe by sundown the rafter of turkeys
makes it to safety. Maybe when the dead
are dead and finally buried, guilty
and awful as they are, and the house
is gutted and sold, maybe something good,
something almost like healing, something
not at all like redemption or grace
but at least something like an ending.

6.

A child sees an owl as it's leaving a branch—
her parents look in time
 to see her see it.

Shark in the Pool

I had found something
like a skill in the deep end,
pleasure in my breath's
ability to sustain me there
longer and longer
each time, each year,
a privacy about it, like
the imagination, a place
I couldn't stay but I could
revisit. Then my brother
yelled "Shark," and kept
yelling it, almost chirping it
into birdsong, modifying it
with "Oh, Jim, I know you
don't believe me, but
you have to—it's in there.
Please, God!" until the blue
in the underwater walls
darkened to gray shadow,
the image settling as though
someone had adjusted
a TV antenna, blur

and flash synchronizing
to body and fin, the mouth
festive as a spiked collar.
Despite what I knew
I could not not see it,
and panic-swam, the teeth,
I swear, chalkboard-screeching
across the metal ladder
my feet had just left.
Thirty years later, I catch
the shiny eight ball eyes
watching me as I finish
my last lap—can I blame
my brother for my fear?
The terror in his voice
was so convincing—as if
he didn't want this thing
he created to do exactly
what he made it for.

Note

The following two pages are taken from Susan Howe's *Concordance* (New Directions, 2020). These pages are part of an adaptation for the sound installation "Six Pages from Concordance," created for the 2022 group exhibition curated by Anthony Huberman, *Drum Listens to Heart*, at the CCA Wattis Institute for Contemporary Arts in San Francisco. The six accompanying sound excerpts are taken from Susan Howe's and David Grubbs's album *Concordance* (Blue Chopsticks, 2021).

Audio for this piece can be found on the **Peripheries** *website.*

Concordances, I may remark, are
hunting down half-remembered
worthy service. They contribute n
e history of words, and so to the
ined such assistance from them

Omitted Words

a, am, an, and, are, at, be, been, by, c
for, from, had, has, have, he, her, him,
my, no, nor, not, now, of, on, or, our,
their, them, then, there, these, they, th
we, were, what, when, where, who, wit

Note

Years ago I was invited to a conference responding to
lines from Michael Hardt and Antonio Negri: "There is
really nothing necessarily metaphysical about the Christian
and Judaic love of God: both God's love of humanity and
humanity's love of God are expressed and incarnated in the
common material project of the multitude. We need to recover
today this material and political sense of love, a love
as strong as death." I couldn't argue with them, although
I wanted to. The form of the academic lecture could not
contain the extent of my grief, rage, and love in the face
of these philosophical platitudes.

In "The Master Letters" Dickinson writes: "I used to
think when I died—/I could see you—so I died/as fast as I
could[.]" Speaking to an other whose absence is close to
absolute, Dickinson writes for herself as much as anything.
That's what I did in my anti-lecture.

I let medieval Christians and modern rock stars tell their
stories, in their own words, and I told a few of my own.
Here are two of them.

Amy Hollywood

From "Love and the Heretic: An Anti-Lecture"

Amy Hollywood

III.

Uninvited?
Isn't the mystic the one who invites God in? (into what?)
And the one whom God invites in – into his wounds, into
his Godhead?

> (What's more metaphysical than that? What's more
> political?)

"My dove in the clefts of the rock, in the crannies of the wall,
show me your face, let your voice sound in my ears."

The soul, throughout the long and ongoing history of
Christianity, buries herself in his side.

IV.

But this doesn't just *happen.*

From V.

She works for love, although no amount of work guarantees
its arrival.

From IX.

Love's "comings and goings," ecstasy and evisceration, the soul caught between the joy of Love's presence, the threat of Love's absence, held hostage to Love's unrelenting demands for fidelity.

("they gored his side with a lance")

("You wounded my heart, my sister, my bride, you wounded my heart with one of your eyes.")

What's this got to do with politics?

From IX.

So many stories.

Here's one.

It's the 13th century. A woman named Marguerite wrote a book, *The Mirror of Simple and Annihilated Souls and of Those Who Remain in the Will and Desire of Love*. (That might be the title. She might be the author.) I imagine Marguerite traveling through the cities and towns of Northern France and the Low Countries, reading the book aloud. Performing. In the book, the Soul, Love, and Reason talk about love. And tell stories.

(the multitudes)

The Mirror of Simple Souls is a love song between the Soul and Love, a theology of abandonment, a cry of despair, a

self-help book for the helplessly infatuated. And it promises freedom, freedom from Love.

To be free of love, you have to kill her.

Marguerite: "And after that I pondered and considered how it would be if he were to ask me how I should react if I knew that it could be more pleasing to him that I should love another more than Him; and then my wits failed, and I did not know what to answer, what to wish, what to say; but I said that I would reflect on the matter."

"And afterwards he asked me how I should react if it could be that he could love another more than me. And here my wits failed, and I did not know what to answer, nor what to wish, nor what to counter."

"Furthermore, he asked me what I should do and how I would react, if it could be that he could wish that someone other than himself loved me more than he did. And again my wits failed and I did not know what to reply, any more than before, but I continued to say that I would consider, and so I did, and I took counsel from him."

"And I said to him that these three matters were much more difficult than were those before. Then I asked, in great bewilderment of thought, how it could ever be that I could love another more than he, or that he could love another more than me, or that another could love me more than he did. And here my wits failed; for I was not able to reply to any of these three, or to contradict them, or counter them. And he continued to press me to reply. And then I was so much at my ease and overcome with love at being with him,

that I could not under any circumstances contain myself, or find within myself the means of doing so. I was so reined in that I could not even move at a gentle pace. No one knows what such things are if he has not experienced them. And yet I could have no peace, if he had no answer from me. And I was so overcome with love at being with him that I could offer him no easy answer; and had I not been full of love at being with him that I could offer him no easy answer; and had I not been full of love at being with him, my reply would have been curt and light. And yet reply I must, if I did not want to lose both myself and him, and because of this my heart was greatly troubled.

And now I will tell you how I answered."

And now I will tell you how I answered. And now I will tell you. And now. And now. Now.

Marguerite: "If I had all that you have, with the created nature you have given me, in such a way that I could be equal to you, Lord, except only in this matter, that I could change my will for the sake of someone else, which is what you do not do: since you would wish, with no doubt, these three things which have been so hard for me to bear and to grant, and since I knew beyond doubt that your will would wish it with no diminution of your divine goodness, I would wish it, and not ever wish anything ever again. And so, Lord, my will comes to an end in saying this; and so my will is martyred and my love is martyred; it is you who have led them to martyrdom, when they said that it had all come to nothing. Once my heart thought that I could always live in love through the longing of a good will. But now these two have been brought to their end in me, and they have brought me out of my childhood."

"there where I was before I was" there "without a why"

nothing because all, all because nothing

(I'm leaving out all of the paradoxes, the parts of the *Mirror* the philosophers would love if they ever read her. "These mystical ejaculations are neither idle gossip nor mere verbiage, in fact, they are the best things you can read.")

Because in the end, Marguerite Porete kills herself with a story.

> (And what she couldn't kill, the church did. Burned to death at the Place de Greve. Paris. June 1, 1309.)

XII.

(Why kill? Why kill love? Why kill love for love?)

(My brother was suffocating to death. There was nothing to do but kill him. The nurse gave me a look. I nodded. And then after a short time he didn't die. "Your brother has a strong heart." – "Thou hast wounded my heart my sister, my bride." – And then after a short time, and then, and then, and then And then after a short time. The nurse gave me a look. I nodded.

And then after a short time he died.

If I'd had to get a gun and shoot him, I would have done it. If I'd had to tie him to the bed, hit him with a blunt object, shove a pillow in his mouth. I would have done it. I would

have killed my love for love.

I did kill my love for love.

(Hyperbole)

(Cancer. Cancer killed my brother.)

There are two men, strangers to me, each of whom has one of his eyes. – "Thou hast wounded my heart with one of thine eyes.")

(multitudes)

Note

"Ante-letters": this is how I interpret "anti-letters,"
finding myself going toward what comes before published,
public, typeset literature, and even word processing's
typeset-looking drafts. In the history of writing and
publishing in the west—and we in relation with this lineage
do not have to go geographically elsewhere to find the
"ante-"—Tim Ingold reminds us in his book *Lines*, Chapter 2,
titled "Traces, Threads and Surfaces":

> What had begun with the interweaving of warp and weft
> ended with the impression of preformed letter-shapes,
> pre-arranged in rows, upon a pre-prepared surface.
> From that point on, the text was no longer woven
> but assembled, pieced together from discrete graphic
> elements. The transformation was complete. In the next
> chapter we shall explore some of its consequences.

This is a cliffhanger of a quote! But it relates to my
response to this folio's theme, making explicit my habit
of returning to a time and disposition where the flow of a
line of text had to do with the work of a hand, and a mind
perhaps not too sure of itself just yet. Quick jottings in

notebooks, the flow of ink, paper giving back a certain
texture and quality, a wandering and wondering. This is, for
sure, a nod to Emily Dickinson, and perhaps also to Cecilia
Vicuña, Leslie Scalapino, graffiti writers, and those whose
handwritten works resist, in the present, the completion of
the transformation Ingold describes. I write "resist," but
I think the better word for this disposition is poetry—true
poetry—Dickinson's "true poems flee—" line comes to mind.
Then, I wonder if the "slant" in her couplet "tell all the
truth/but tell it slant" is a reference to handwriting's
slant versus the upright, self-assured attitude of print.

Whether in image or text or textile, I am after a line, as
Ingold suggests, that:

 grows as it goes, and shows its growth marks if it ever
 appears to be finished;

 lets us recall reading as a practice of gathering
 and meandering, not map-deciphering as if there is a
 destination to achieve;

 regards place as enmeshment and intersection, not as a dot
 on a map with an inside and outside, citizen and non-;

 knows language to be ever-sounding and never truly
 rendered mute despite modern textual practices that are,
 actually, quite new in global history.

In my poetics I come repeatedly home to these notions via
literacy teaching and other aspects of my biography. Trying
to put my ante-letter tendencies under one banner, I might
use the word "textility." Textility, as Ingold explains,

responds to forces of so-called inert materials—ink, page,
paint, wall, thread, cloth, book—not as other but as
partner, choosing a "going along with" over the pre-formed
plan. And as Gayatri Chakravorty Spivak articulates in *A
Critique of Postcolonial Reason: Toward a History of the
Vanishing Present,* "…textility escapes the loom into the
dynamics of world trade" where the conditions of world trade
are a consequence of modernity gone violently awry, which is
to say they are also conditions of modernity completely and
perfectly achieved. An awareness of how modernity hinges on
violence depends on where and with whom you stand. Yet the
very idea of stance feels off to me as I trace "stand" back
to its origin in "sta" which gives us "stem," the name for
the main vertical stroke in typeset letters. Instead, it is
inside handwriting's ante-letter gesture, in the diagonal
and circular, where "letter" returns to its medieval root
"to let" or "slacken," where I burrow, scoping out, often in
the dark, who and what else is there.

Jill Magi

"The Open Stone": Literacy, Transcription, and Poetry by way of Paulo Freire, Akilah Oliver, and Tim Ingold

Jill Magi

Our past exceeds place line think of— land
that is— handwriting, traces the river edge or
the open stone.

12 canvases, each 18" x 24"; graphite, watercolor, acrylic; 2022-2023.

<center>*</center>

When I worked as an adult literacy teacher in the South Bronx, we called our work Freirian—meaning we came up with practices to link students' worlds with written words. It was storytelling, basically, which included telling, listening, and then writing down these told and related poems, stories, and theories.

I found these practices beautiful. We did them over and over, week after week, repeating the routine which became comfortable, reliable, and this eased everyone's anxiety. One of the main things was to help students not to feel like outsiders among a world of readers and writers. Everything began with prior knowledge, reinforcing the truism that you aren't stupid if you don't read and write—you just don't read and write.

Teaching literacy in this way brought me to writing—it set me off toward poetry. Now I see those practices coming up in the visual work I make. "The Open Stone" is a fruition of that—

<center>*</center>

Artist statement as pedagogy: I want to share what we did in the classroom.

But first, who is this "we"? We were a community of practitioners from different walks of life and we trained teachers around the country in our methods. We reflected a lot on what we did; we adjusted, made changes, read Freire together. Perhaps inevitably, we began to reflect on how tiny

our paychecks were and the struggle we faced paying household bills. One thing followed the next and there was a union attempt. To the surprise of my politically naïve self, the vote for/against a union turned out to be a tie. Management hired fancy lawyers and they targeted the most financially vulnerable among us. A tie goes to management—and after I was illegally fired for union activity, the "illegal" part having absolutely no power to restore what I thought would be my lifelong career, I got a measly settlement and was required to sign a gag order so this story is a fiction.

*

A central classroom practice was "generative word" discussions. The word would come from the class—it might be "family" or "the subway," "school" or "drugs," "the rent" or "the July 4th holiday." As teacher, I would put the word up on a piece of newsprint, and then the class would discuss while I transcribed thoughts, comments, questions, anecdotes, advice, controversies, disagreements. We would stop now and then to re-read what we were talking about.

These sheets of newsprint became the text we worked with for the week. Students would put words they thought they needed in their "personal dictionaries"—notebooks that were lexicons they could refer to in order to write stories, essays, poems relatively independently. I would circulate around the room confirming various words that were being lifted from the sheets of newsprint—the transcription now papering all the walls around us—to be placed into their dictionaries.

Students would then write on the theme as they saw fit, often beginning with "I think that—" or "I remember—" I circulated around, scribing: listening to what the student had to say and writing it out for them and then inviting them to

re-read so that they could "get" the text they had made with assistance from me. Sometimes we would make a group poem, repeating the phrase "I remember" or pushing metaphor, filling in the blanks: "My family is like a _____" where the blank couldn't be "real." All kinds of contradictions lived side by side in these group-authored poems. And of course we found out that poetry's language felt realer than the real!

A couple days later, some students would read their pieces out loud and this could lead to more discussion. The stories and thoughts written down would circulate around the class and students would sometimes write letters to each other in response to what they read.

If the students were excited about the theme and thought it was a good idea, I would type up their texts, make multiple copies, and as a class we would compile them into photocopied booklets. Everyone took one home and we left some in the classroom for future classes to read. To sum it up, we made literature together.

*

I am wandering around a big-box craft store in Rutland Vermont. About the same size as the newsprint sheets from those classrooms, I find cheap, thin, pre-stretched canvases available in bargain-priced packs of six. So I buy two packs and they seem like paper to me: a stack of not-so-special substrates that I can layer and layer without thinking too much about making a painting.

I begin, applying a dark brown, then an off-white, then other brighter pastel, then creamy white, and some grey. I sand the surfaces down and reapply paint. The canvases begin to look like concrete, or like stone. In sanding, the stretcher bars reveal their presence and I like this visual hint

of the support.

The canvases seem ready, so I go to recent notebooks sitting on my studio table. In about an hour I find a handful of interesting words and phrases. I make photos of those pages, upload them to my computer, and then crop them severely so that only single words of handwriting remain. I print these out and, using carbon paper, trace them onto the canvases.

Then, like embroidery, but a little bit quicker and easier on my hands and eyes, I carefully hand paint each word. The black paint covers well. I love its viscosity—tiny brush gestures that glide over these chalky, old-looking surfaces. The paint spreads easily like ink. The word, painted, is bold like a sign— though a little lost and lonely floating there. I have scaled up notebook jottings so that they come into public space—a kind of reversal of the literacy classroom practice. The words look a little sloppier than my teacherly handwriting, but they are about the same size as the handwriting I used year after year, week after week, in front of the class, on newsprint, in the service of students' stories and theories and poems. And also, it turns out, in the service of my own art, or me learning and relearning that art is not to own.

Together, these canvases become a kind of sentence. Actually, there are many possible sentences, combinations. There are gaps and glitches, maybe not enough verbs, so the grammar is a little odd. This is perfect for a poem—a poem I could have never imagined would exist a month ago, a year ago, or back in the 90s when I worked in the Bronx.

This project is a fiction and an archeology.

A flat stone is open, ready to receive memorial language. Eons later maybe it is found, read—a brush dusts off the dirt and the stone opens again.

The canvas substrates look old but they are not. The words look like they were written quickly—and they were,

once, later to became objects of slow deliberation under my hand. The words came from me; the words came from elsewhere. The words are meant for me and they are meant to be public. The words started out months ago as quick scribblings; they started out centuries ago when mostly war and violence forged "English."

<p style="text-align:center">*</p>

The highway underpasses where I live have an interesting story of public, private, fast, slow, creation, erasure going on. This spring I noticed big squares of grey, usually in a couple different shades, layered, painted on the seamed concrete surface. It's where the county has painted over graffiti, and it looks like these places got tagged again after the first attempt to cover up, so the town came back with a darker shade. And so on. I love these incidental compositions—big rectangular blobs with hints of marks underneath. A war between writing and erasing. Erasure always shows itself and writing always persists.

This spring I made two paintings based on this back and forth—marking and covering up. I worked across a grid of substrates, and then found that excerpting from this grid may have yielded the strongest work because its edges are so suggestive. This reminds me of how beautiful patchwork is because it allows us to see just how partial any whole truly is.

I am thinking of the late, beautiful poet Akilah Oliver and her lyric essay, "The Visible Unseen," published in *A Toast in the House of Friends*—about graffiti writing, her son, presence and absence. In an interview in BOMB magazine about the work she said:

What I love about how graf marks absence is that

a.

b.

c.

d.

I.

presence always intrudes. I'm thinking of the title of that film about Jack Johnson, this documentary, I saw it on PBS, called *Unforgivable Blackness*. Graffiti is like that, in your face, naming itself as never an "other," but always as itself. Unforgivable in that sense, you know, in that it upsets easy notions of identity, resists type, even though the form itself has been codified as if it were only representational of a particular voice–the way the "invisible" are reduced to easy categories of erasure. Anyway, this critical, creative piece is about disrupting that erasure by looking further into it.

We are/there is always two-ness in the creation of presence and absence: one adding, one taking away, one believing that more is always possible and the other believing in the possibility of a return. But one disposition seems to be an obvious "outlaw aesthetics." Even if both live inside one another and need each other, the disposition to exceed boundaries of what's possible, going where it couldn't or shouldn't, shows up, I think, as poetry.

*

In his book *Lines* anthropologist Tim Ingold discusses the relationship between handwriting and conceptualizations of place—that before the typeset word, reading was more an act of assembling, gathering. This was also true of place: before typeset language and before maps used filled-in dots of various sizes to denote a town, a place was where lines intersected. Where people moved through. They arrived; they left. Belonging was negotiated by "how long have you been here, where did you come from, and when might you leave?" rather than official citizenship: some state-constructed right

to occupy. As an intersection, a place and its people makes and remakes itself like a sequence of handwritten words.

Notebooks, filled with handwriting, as places. Continual arrival and departure, a sequence of intersections. As I read Ingold, I made notes, copied some phrases and key words, and converted typeset words into the handwriting that lead to "The Open Stone."

Note

These poems are a near call-and-response between two
speakers. One is the American Mastodon (A.M.), whom I
introduce in the collection *American Massif*, published last
year. The other is Sigrid.

I knew the person I call Sigrid for just a short time. My
memory circles a single moment sitting on a bench together,
outside of a lecture hall one morning in Iowa. Brilliant,
serious and funny, beautiful, that morning she spoke only a
few words—four that I remember clearly. When I learned of
her suicide a year ago, she'd already been dead seven years.
I can't say what my reaction was, exactly. What right did
I have? But the wrongness of the news followed me around
in more than one way. At that time, I was rereading newish
drafts of A.M. poems with growing impatience, and doubts. I
started to jot fresh notes in the right margin, but followed
it down the page sometimes, which was new. The notes argued
with a premise and veered off in ways that surprised me.
They struck me as things I imagined Sigrid would say, maybe
poems themselves.

Of course, this speaker is different from the woman that,

through only a few particulars, I remember. I could no more
attempt a biography when writing from the right margin than
I could add to the scientific knowledge of *Mammut Americanum*
when writing from the left hand. Both extinct. But the push-
and-pull between their two voices together changed how I
see the ends of a single poem. It invites a meeting, where
one speaker keeps striving to enter into this world, more
human—while the other, having escaped it, is drawn back in.

Nicholas Regiacorte

A.M.
says it sibboleth

Nicholas Regiacorte

What are you now but the world's
authority
on death or would be if
you could
talk at all only you have to
rely on me
like your dim interpreter
whose Italian's
only good enough for philosophy &
cooking but
not basic civics no plumbing no dirty
jokes always missing
the gists though I feel very strongly
you'd have
forgiven my sins by
now enough
to trust me with a big truth

Here's a little one—your last name
was the dog's
from my father's childhood their
German Shepherd who

could carry chicken eggs in his mouth without
breaking them who
pulled their go-cart up-hill and under-
stood so many
unuttered words like "rabbit shed"
or "marina" who'd
disappear and reappear exactly
where they'd
hoped but always startled to find him
bursting out of a
covey or ditch bolting straight into
the sea believing
he could fish with his mouth
opened wide.

SIGRID *of the brick wall trick*

You want to believe Houdini could dematerialize
and rematerialize when walking through
a brick wall. In spite of seeing the trap door

for yourself, in the Orpheum stage, you can't
shake the prospect as though you've invented this language
in which all walls are negotiable.

Barely human and you want to guarantee
passage to and from, to and from the other side,
without tricks, as though M– or I could reappear,

just like Christ, appearing inside locked doors
to show off his nail wounds and stay for lunch.
You check all the locks, inviting the surprise,

and I am half-tempted. But you'd have to first give up–
believe me obliterated so that the possibility grows
remote enough to dissolve entirely

in time. You'd have to plunge through despair,
before I'd consider it, but you can't do that yet, poor thing—
you think it's only life ahead of you.

A.M.
dreams himself the Common Horse

How often must I come apart exactly
like a costume-
horse the hindquarters ascending a
helical ramp to you
my forequarters stumblish winding to
the depths where

I find Sigrid five years dead dealing out cards to
GR and his whitecoats to
dear Robert dead ten years to Adelina my hog-butcher
who'd just died

Play a hand Sigrid tempts as though
I have any hands
Who would foal back into that world
anyway? she says

But have I left? Even now rejoining
myself at the table just
in time for the carbonara and you three
giddy as a full house (yes)
twirling your strands right off of these
bright tectonic plates.

SIGRID *of being repurposed*

You always think in ifs–if then if then:
IF they 3-D printed the vocal tract of Nesyamun
the 3000 y.o. Egyptian priest, attached a larynx

to shake out an audible two-second syllable, THEN
you could unmummify me—my voice.
But this–this here's no larynx. Admit *this* is not

my voice. Though you'll connect your power source
to an image of me (retrieved from a fall day
outside Van Allen, 20 years before I'll die). Flip

the switch: "Voila!" and hear it again. You hear it?
Everything's bullshit. Was there anything that wasn't?
*Bloo*d I said. There.

I'll say it again *Blood.* Does the word restore me?
have you single-handedly recomposed me from ash?
Bless your heart as my grandmother used to say

the engineer Unitarian. Bless your little
heart. 3-D printed and blown-through what would that
sound like, friend, a conch shell–or whistle?

A.M.
Safety drill in the underground laboratory

We're all bewildered by the sudden re-
appearance of
our own hands feet and each
other's faces
when torn away from our precious
detectors
in which God particles keep
evading us
like minnows in a creek our focus sound
as sleeping

 when the alarm jolts us
loose we regain our
arms navels sex organs and thighs that
build us
up human again from nothing to walk us
on real feet
toward the noise together

Il capitano times us down to the
last souls strolling
in from the remoter chambers and begins to preach
For all your nice nice

footwear he smiles hand-on-pistol hand-on-phone
For all the hard hats and
good brains you'd all have perished by now most
of you dying miserably if
unspectacularly suffocated crushed compacted to
two dimensions
good as fossilized Eh?

Don't you know it is
what we always wanted O captain what
we signed UP for
to be compressed quite as we grow
in numbers down
here except when the canal moss
appears and in
3D–a precious novelty in light
of our flatness
and too green a green the green of
fresh oregano
leaves for a dish we might have cooked in
some over-world a
dish we didn't know we still had
teeth for.

Note

the initial seed—or spark—of this project came mostly
from trying to understand TikTok's relation to farming, in
terms of economics, what Adam Smith would have thought of
as "the corn standard" like what is the price, in corn,
for a tik tok—which seems to me to be this interface
between the actual earth and the built world, like, that
we still need to eat food grown in dirt and how multi-
tiered and dimensionally leveled that growth was into like,
kids getting paid to dance on the internet, because humans
are joyful and love to dance and watch people dancing, I
guess, and / or thinking about shipping lanes, about myself
ordering like, little gadgets from halfway across the globe
made by an actual person and shipped to me on shipping
containers across the entire ocean, and the guilt and also
wonder of that. I wanted to somehow write it all down all
together. It seems to me we are in a wild time to be alive,
the streams of doom and gloom and reactivity and simplistic
thinking and also real horrors at our fingertips and looming
just so constant and also how the world is just sort of

going along like always, too, and people seem happy living
their lives, having babies, going out for dinner, dancing
on the internet, being funny, and I love that, and trying
to hold all of that all together in some more complex
constellation. So I just started taking notes and thinking
about, I don't know, America, now, through that kind of
kaleidoscope, trying to let myself put everything in it, all
together.

Cody-Rose Clevidence

From This Household of Earthly Nature

Cody-Rose Clevidence

brainstem : violence : lizard : shame
build up the shining cathedral; mote in the eye of
the eye of the storm. come cumulus, trigonometry, come
apex and cosine, come stand before me, amalgam
of organisms, shape of thought shaped, eon, reaction,
generation, futility of prayer—the hummingbird hawk moth,
the iridescent blue swallowtail, tomato horn worm, whole
 lives
lived once, in the glittering air of each empire, momentous
moment in a moment suspended, whole. I kill the giant
 horseflies, step
on the hornworms, buy insecticide to kill the aphids and
 mosquitos, the leaf-cutter bugs, and squash-borer
beetles, etc., I plant milkweed for the orange monarchs on
their great migrations, leave the fishing spiders alone, & order
lacewing larvae online. in short, I am a tiny god.

we all make our choices in the universe.

what are the conditions that bring out violence
where is the location of belonging.
what is the structure of the nature of human thought
the relationship; tools : thumbs

the astronomers say "Construction of the Lunar Gateway!"
my neighbors say: "we might not even have a country soon"
the fall of civilizations podcast narrator says "let us imagine
what it would have been like to live in this time…" the meme
on the internet says "every evening I pinch the bridge of my
nose and remind myself that millions of people led full and
satisfying lives during the collapse of the roman empire" the
youtube population data-tracker shows a glowing dot for
every one million people across the surface of the globe since
40,000 bce; it starts slow, each little glowing dot and chime, a
blip, a different blip, now here, now there, now moving north,
east, west, blip, blip, then faster, blip blip blip, spreading out
over all the continents, little starbursts of light, contagious,
blipblipblipblip, coalescing, all at once, now it crescendos,
explodes with thousands of dots and chimes all over lapping,
in bright clusters everywhere, growing brighter, gone
supernova, bursting its seams, whole continents, over all. I
think "like fish roe" my friend says "like doom pop-rocks."

go forth in amazement; this world we have made

Interstate Highway System, central air, reservoir 200 miles
from the city. taking a boat out on the reservoir on a nice day,
catching a few white bass in eden.

we will invent a photosynthetic algae-symbiont hybrid-glass
 for high-rise windows,
we will build the green spires of a future city, superhighways
 of the galaxy
3d-printed nests, 3d printed meat, artificial cherry flavor, self-
replicating intersection system chain store migration, gas
stations counting their neon numbers into the bright world,

the bright world's work, proofs of concept, how to live, societal policing, beam me—outta here—Tyson chicken houses on the small highways, middle America, "across the fruited plains" Arkansas, their huge fans whirring in the heat—the stench—Go forth ye stunted dinosaurs—into the wilderness—stacked in filthy crates stacked and strapped down on flatbed trucks on the I-40, I-70, I-90 west, dirty white feathers floating, suspended for a second or forever above the hot asphalt in the shimmering air, 2,000 head cattle died in Kansas last week from the heat, have you ever smellt a feedlot, heard the animal screams late into the night—what terror is—mammalian, lizard, deep and pure—mostly we keep these things hidden, in our country. we are human, after all, compassionate. the glossy interface, America,—panopticon and aria of the new season,—which is built on top the old season—they are growing pineapples in the glassed in dome of the Botanical Gardens in New York—the prisoners are leased out for unpaid labor—there are trees now growing on the arctic tundra— I saw that on the internet—bless the lemon seed, the indigo bunting, the cold soda in the glass case at the corner store, the mechanic who makes the car engine run, the spark-plug, the faucet, the microscope, the microchip, the lithium mine, the fried chicken sandwich, this is our one world, transformed—

From This Household of Earthly Nature

that the earth "caught life" as a planet might catch a virus
atmospheric oxygen, clear skies, blue seas…and bluer than
blue,
what eyes, could see—it will strike us down

I gather honeysuckle vines for baskets while my dogs lie
patiently in the leaves

the plans are in the works to grind up and 3D print the regolith
on the moon into a landing pad, roads, buildings. "this is how
you know they're serious" the UniverseToday newsletter says,
"when they start planning infrastructure"

"but fundamentally" Tor Norretranders writes, "the
nonconscious body is not under the control of consciousness…
The body is part of a biological metabolism with the living
system on the planet—and this participation is not subject to
the power of the consciousness. We do not have access, via
the body's own means, to changing the role each of us plays
on earth. We are part of a living system to which we are so
adapted that there is no freedom to get off."

a field is a value or set of values assigned to every point in
 space;
"it helps to think of mass as a property of objects and fields
 as a property of space" the YouTube physicist says

The Field of The World—today—60°F day after days and
days of rain, sun, steam off the creek, table, deck, dishes,
tree trunks steaming, lichen and bark, wet leaves, trash—
and all the amorous frogs belting out their hymns in grunts
and groans this warm December morning—futile in some
relation to joyful : futile in what relation to joyful

one planet : awake glow worm of my same heart in the
morning, wiggling, opening up its photosensitive cell clusters
we call eyes, the baritone toads by the green pond, one hawk
circling the many little birds, all inquisitive, sensate, seeking—

more dire than myth more sensate than science more
 forgiven than iron cobalt silk silos
lithium ion battery acid milk roots dug up out
 of the dark earth forgiven by combine and grid god
damned city of cables I love you it is the first morning
 forgiven here
give it back I said give it back

all this machinery was invented yesterday, fig-leaf, ocular
 lasso, echolocation, levers, angels, angles,
fish-hooks, interiority, cam-shaft mount brackets, fuel pumps,
 reinforced steel beams, proprioception, mirrors,
permission, love— the vision multiplies as seeds

inverse relation; seeds [to] survival viable planet
 dandelion, amaranth, rabbit, tire-factory,

raceme or spoke; spoken of how many sugars in
 the hard seed to sprout now or when
 what is saved up, spent

what hubris: "a manifestation of the universal consciousness"
shut up sweet hairless ape of my same hubris we are just
lucky to even get to chicken scratch out this tiny amount of
perception; purple finch- claw wet bark some bugs a vague
itch occasional desire a cool breeze maybe on a hot day or the
opposite love

tiny eyes, kaleidoscope; vast quanta of unsensed world, scrim
 of awareness

just right on the surface barely even metabolic
 who needs a brain, anyway
 not me

fragmented, broken cup, disturbance in the flow
entropy increases in a closed system, but! our world is an
 open system

thermodynamically speaking, says the book. so we aren't
really breaking any laws by being here. it is not even that
 improbable.

we are not even that miraculous, shining in the tiny sun that
 made us, going
about our days.

we are holes in the universe
many holes, all at once.

strands of radiation flow around us
a cascade of impulse charges the net

whatever the caloric metabolism of a given planet, desire
 exists only in the distance between want and
fulfilment, thermodynamically speaking.

the joke goes: "I was born at night,
but I wasn't born *last* night." yes,
you were. human shaped luna moth of
non-functioning logic awake
in the automated substrata of eden's weird hallways
stumbling around, fooling cash registers
with your magnificent cerulean wings

time, they say, will tell.

the meme on the internet says "everything will be okay,
eventually, in thousands of years, for rocks."

tomorrow, they say, "never comes"
"free lobsters tomorrow!"

the transistor radios of my heart just the same
shouldering their looped parallel cables into the apex of
 distance,
the transformers go marching, marching, "across
the fruitless plain" O Nebraska of America's harsh
winters, prospecting for a sense of place at the edges of the
known and unknown universe just the same.

sifting for diamonds at the "Crater of Diamonds State Park;"
just gravel and mud, dismal world stretching endless,

 furrowed into each direction,
dug by the heavy machinery's metal teeth, churned earth,
 kinship rituals of suffering together, the pouring rain,
laughing late into the night, trying our best

what a family is, in each culture. what a family is, to you.

weaving and unweaving the myth of coherence
weaving and unweaving the lineage of myth

direct current of one soul, alternating current
of many souls, go catch some beauty in the net.

go out and have some fun, poet, if you can figure out how.

THISISLANDEARTH
from The Grimace of Eden, Now

we see from the precipice: the cities rise, concrete and silica, mud and sand, wood, cloth and base metals, we see those shining metals mined out of long veins in the earth for computer screens, electrocircuits of heaven, marked with spidery lines across the rippled surface. we see a tiny dotted line for each boat on the ocean, ocean liners crashing through the great troughs in the roiling dark and stormy sea carrying stacked shipping containers, we see the pirate ships of the Aegean, each marked with their black flag and skull, the pirate ships of Senegal, we see the ironworkers of Great Zimbabwe, the diamond mines of the Kingdom of Mapungubwe, the "meadows of gold and mines of gems" writes the Arab explorer, 950CE, we see the herds of elk and the herds of cattle in their vast migrations, white or darker dots moving in unison, we see roads that map travel travelled, traffic–jams on the roseate freeway overpass of the vast megalopolis, and who works the mines for all this, sulfur, salt, gypsum, silica, diamonds, uranium, iron, lithium, lead, gold, the oil fields, who dips the fry baskets, who forms the molded plastics, each assembly line a series of tiny dots, laser cutters, hands polishing stones, hands holding up beads, hands draping cloth over a child, hands measuring a child standing against a door-jamb, year

over year, hands preparing food for a ceremony, we see the ocean waves lapping at high rocky shores and shores of white sand dazzling in the sun, the rays of the sun caught and cast back by the waves, we see, and feel the muscles around our own eyes, the gaze of someone squinting out over the water and the darting flight of shorebirds bright and dark in the air. we see the forests cleared for the new airport, the tiny yellow bulldozers pushing gravel, the red cranes hoisting steel, the straight logs stacked in neat rows then loaded on trucks and drawn away as if on invisible tracks, we see the forests burning, the swirling plumes and discs of smoke drifting over the continent in their patterns, Topeka, Azerbaijan, Jericho, the lights change in succession down Lexington Avenue, hands delivering babies, a little red dot for every person giving birth, we can see each face sweating, clenched and gasping, feel their breath, the grip of their hand on their loved ones hand, whatever is nearby to grasp, a light blue dot for each prayer like a wisp of smoke disappearing almost instantly, we see caravans of camels, the first electric lamps lighting night streets of a city, the crowd gathering for the spaceship launch, the crowd gathering in the Hippodrome, chanting, as they draw the chariots in, the deafening sound of cheering, the stadium erupts, the razorbacks won, the orchestra raises their bows in St. Petersburg as the lights dim and the crowd falls silent, the earthworks erected around the city with gears and levers and scaffolding, the thickness of the walls, the marching armies with their pendants and the dust kicked up by the horses hooves, the tanks crawling through the rubble of collapsed concrete, shouts, we see the exposed wires, a pink dot for each body buried under the building, we see the fault-lines of the continent-edges color coded according to degree of built-up pressure. we see the fires blinking on and off in the night, we smell the dripping meat and hear the

distant laughter, someone is grilling in the park for a big crowd with the boombox loud and everyone is laughing, someone is sitting around a campfire, someone is lighting a candle, sounds of lovemaking, screams, and singing, telling stories in a circle of light, by the fireplace, by the electric heater, gathered around a stove in a small kitchen as someone is cooking, people clicking off the lights in their apartments and clicking them on again, blinking in cascading patterns, we see the tunnels being built for subways, the dynamite explosions cutting lines for highways in the sides of mountains, we see the mountains rising under continental pressure, we see the timber come crashing down, carried on flatbed trucks to shipping ports, steel drawn out in strands and wrapped into cables, the hands that pick up and put down each tool, each button pressed, each lever pulled, the sirens, each explosion like a little tuft of light. we see the green swath of the Sahara give way to white sands and move north and we see the shifting dunes shift in the prevailing wind, a small line of white arrows, a small translucent green dot over each well or oasis in the desert, over every spring or seep in Oklahoma and New Mexico and the Maghreb, a square over each dammed up river-reservoir, a lightning-bolt over each hydroelectric plant on the bigger dams on the bigger rivers, their force diverted, we see a small number indicating maximum percentage of pressure, the bright lights strung out as a great electric necklace over the dark continent, the water gushing through the turbines, the fish feeding in the churning water, the people fishing from the bank, each language they speak, what bills they have to pay, each heartbreak, divorce, infidelity, birth, loss of a child, death of a parent, each friendship maintained over distance and time, each pet fed and petted, indeterminate zone of floodplain where it would flood if the dam burst, if the storm-surge rose, a red line around each section of city or town or

village that would be destroyed by flooding, a gold dot over each last breath, like glitter cast over the surface and rippling in the wind, we see the satellites below us circling and circling sending the beams of their signals like strands of light, like weaving a nest, we see zones of green rove and rove around, bloom and fade again, according to season, the moisture gather as ice crystals in the upper atmosphere and fall as rain, we calculate the velocity of each drop. I watch ants tending aphids through a Loupe magnifying glass with an LED light on my wisteria blooms, anomalously flowering this cold September. we see the fires start, little plumes of smoke go up, crawl across the surface. we hear the rush of water over each cataract, Niagara, the glaciers melt, the herds move north, the soldiers break their camps, the utensils placed in each house, washed, set out to dry, someone is singing a made-up song, someone is bathing a baby, we see the sea levels rise, there are people standing on roofs in the flooding city, they are building libraries in Alexandria, in Timbuktu, in Graceland, I'm with you, Abdul Hassan ibn Hussein ibn Ali El Mas'udi, just beyond the far lip of horizon, bathed in all the distant blue of time, we see the high-rises rise like coral encrusted on the shore, the tiny yellow cranes lifting tiny sticks, cables suspending glass, we smell the smell of something baking, of feed-lots and rice-fields, urine in public toilets, the smell of snow on the tundra, the smells raising up off each plate of food being handed to someone, we smell the salt-marsh muck and sewage-treatment plant out-flow pipe and the dry dust smell of the desert at evening when the night flowers open, we see the vultures circling in updrafts of warm wind below us, feel the air change on our faces, warmer and colder, carrying different kinds of pollen to different places, now here, now there, now the forests are moving again. the swirling clouds, the oil slicks iridesce on the sea beneath us,

the blinking lights of offshore oil rigs in the hazy morning light, the sound of clanging rigging, nets, seagulls, the smell of fish hauled in on fishing ships, shining in their millions, we see the ocean bulge at the equator with each full moon as the planet spins below us, we see the pipelines pumping thick oil under the rivers and the plains and fields, near neighborhoods where people and animals live, we see the pipelines fracture and the black sludge seep. in a room they are drawing up plans for the aqueducts, they are drawing up plans for irrigation ditches to be dug off the Nile, they are drawing up plans for a biodome, for the first pyramid, for the Empire State Building, the great Locks on the Yangtze, the Large Hadron Collider, the combustion engine, someone is filling a bird-bath, someone is feeding the zoo animals the frozen carcasses of other animals, someone is rocking back and forth in pain, someone is burying or burning or setting out the body of a loved one, people are dancing, someone is looking down a microscope at protozoa, just as we are looking down at the blue-green globe spinning silently below us, now illuminated, now in darkness, turning, blinking, emitting soft gasses into its own envelope of gas, its smells of moss and dirt and diesel, frying bacon, fresh-laid asphalt, cut grass, piles of rotting trash and burning trash and exhaust and dew on a cold morning. we blink and see again. a woman in a dark covering walks a camel across the sand. a digital advertisement blinks over the overpass. someone drops a glass of a purple juice and it spills across the floor. a kid runs on the wet sand toward the receding wave and then runs back up the beach, screaming and laughing in the glinting light as the ocean gathers itself up and crashes forward towards him again. a baby is asleep in the back of a car driving across state lines. a man is holding his passport. a man is crying. three friends are watching the sun set over a river from the fire escape of a building. four

women are digging a grave. three men are making love in a shed, their bodies tangled, "oh god, oh god" they say, in their language. someone is praying a rosary. many people are kneeling on prayer mats. the ships sail on the cross-stitch tapestry of waves, a person is undergoing surgery. a team of people are performing surgery. an apartment complex is on fire. it is just starting to rain. the tents have been set up on the opposite ridge. the tents are being set up outside the city gates. the tents are being bulldozed under the bridge. a kid is leading cattle to a new grazing place. thirteen thousand people are taking a picture of the moon. the ritual sacrifice is being led to the altar. someone is putting flowers in the hair of the dead. someone is putting flowers in the hair of a child someone is putting flowers in the hair of a bride. the fishermen are hauling in nets. the smoke-jumping firefighters are jumping from helicopters into the burning forest. the migrating birds are flying in huge flocks, people are taking pictures of them in each place as they pass and putting the pictures on the internet. a woman is writing down calculations. a person is pressing a sharpened stylus into soft clay. a baby is saying its first word, someone is designing a machine that will split an atom, someone is calculating the diameter of the globe from the shadows cast by erected obelisks as they move across the surface of the earth.

Note

I began the series "Essay" in the wake of another long poem.
Instead of experiencing my usual sense of relaxation after
finishing it, I felt I had more to say, but in a different
form. Around this time, I heard Bernadette Mayer's poem
"Essay" read by New Directions editor Barbara Epler for The
Poetry Project's memorial for Bernadette.

> I guess it's too late to live on the farm
> I guess it's too late to move to a farm
> I guess it's too late to start farming

I was floored. The way the poem registered with me felt akin
to a detective finding important evidence. Key up the mood
music and close-up shot of my face!
 I have a full-time office job on a farm where, in
addition to making a living, I experience the tension of
having a calling—being a poet has given me an identity and
a purpose--and the foreclosure, as I get to be, gratefully,
old, of fantasies I have been harboring since childhood.
I could be a farmer. Or is it too late? I started to read
Bernadette's "Essay," but could only take in a few lines at
a time. It took me days. This is sometimes the only way I

can take in a poem that is a message from another poet about how to proceed.

Meanwhile, I had started a new document with two song lyrics that I expected to be epigraphs for a new poem, but weeks passed and nothing came. I thought I might write a poem for birds.

Feed the pigeons some clay
Turn the night into day

-Blaze Foley

You got sharper eyes than me, old bird
To see a worm so far away

-Arthur Russell

I had also started a modern folk playlist, or what sounded "folk" to my ear. I had just read Lucinda Williams's memoir, *Don't Tell Anybody the Secrets I Told You*, which got me on the hunt for a sound. Karen Dalton, Connie Converse, Blaze Foley, and Judee Sill are some heroes of this growing list of highly regarded artists without much commercial success during their short lifetimes—they all died before the age of sixty. In recent "Essay" poems, I write about Sinéad O'Connor in the context of folk, a context in which she understood herself, "a protest singer."

Seeking out Bernadette's poem, I also found my friend Stephanie Young's "Essay." Stephanie works in some of Bernadette's lines while also departing into her own laments about what it is too late for.

I guess examining women's working conditions is just too difficult

I kept the pages with both "Essays" open. At some point, I titled my own document "Essay," started writing about the weather while home from work on a sick day, and ditched the epigraphs.

Writing to Stephanie about these and many more convergences, I told her how her own work, Bernadette's, and the work of these songwriters gives me what I need to keep going under the real conditions of my days.

Cows, and a particular cow, are also the heroes of my "Essay." Though I work on a dairy farm, sometimes the cows do get "shipped," which means they go to slaughter. Today, I found out that my cow is getting shipped.

Capitalism makes it seem reasonable, but how can I accept that such a bright and beautiful existence must end under very unnatural conditions? I guess it's too late for a farm to be a utopia. "Essay" poses questions that weigh heavily on my heart today: Where can all beings be themselves? What if we were loved beyond usefulness? What if the entire world were a sanctuary for the marginalized beings I so deeply grieve? I want the cow, whose name is Donna, to be able to live in her own particular way, in her case, without maternal instinct. What would that world be like, built from the particulars of all beings? It is a world the poets I love create through their thinking, which is to say, their poems, and a world I want to expand upon in this series.

SS

8/26/23

Essay
Stacy Szymaszek

The sunshine hit in such a way
meticulously tracked since the 1600s
on that May day recovering from food poisoning it was brighter
than my own flame and ushered in an awareness of eternity.
The light on my face within the Victorian house now in our care
touched in its duller burning days the faces of poets philosophers farmers actors.
I tried for weeks to say even this much
to find a tone to live in for a while

Today my colleague asked if I knew about ovenbirds a chunky warbler
 that build their nests on the ground or the cowbird
a stocky blackbird that lay their eggs in other bird's nests
 if the foster situation isn't accepted they destroy the host eggs
 so they have to re-nest giving the cowbird another
 chance to slip in an egg. I didn't know any of it
which is okay tho kind of a catalyst for noticing that I was losing
 curiosity about the outside world which is so painful
so hurtful but you can't just turn off parts of noticing selective noticing
 this has afflicted me seemingly mid-decades like an exhaustion with
a politically hyper-organized hatred toward certain beings that repeats itself and I treat it
 just like this.

 My future reader must know
 the air quality is poor today from hundreds of wildfires in Canada
but I didn't notice the haze was not a regular cloudy day or that the red sun
was actually a mirror for flames until it was pointed out then suddenly I was able
 to feel it in my lungs this founding father secret theocracy dream
 for their salvation cutting off our air "creating weird conditions"

the paper says "blame Canada" nothing
about heat-trapping gasses that make it too hot
too dry or how settlers rejected Indigenous knowledge of controlled burns
of how to coexist with fire. Soon it looked like night and briefly rained
the smell settled as if the whole valley was burning leaves
in June. The sun is doing what is has always done making its flares
and mass ejections changing in every way scientists can observe.
Last weekend friends came over and asked if they should take
off their shoes and I hemmed and hawed which they
interpreted as yes. We had never had friends over in
the two years we have been responsible for this house
I didn't know what to say. One friend mentioned the dead
hemlocks in the yard "hemlock" is more specific than "tree"
which is on my list of potential problems like if they fall will it be away
from the house? Knowing they are hemlock I can now also know
that many of them in the region are being attacked
by an invasive insect. We all put our shoes on and walked at the
bird sanctuary where our friends pointed out wild ginger

may apples and clover which I learned I could eat.
I accept that the effect of my obsession with poetry is that I don't know much
about anything else I have succeeded in making myself mostly useless
am totally amazed by people who know how to do quite usual things
there was a time when I would've named these friends
but I don't want my friends or these friends to function in an overly-
determined literary way or for you to think this is an ethic of poetry
that works through friendship. My past implicates me
in that ethic and what it accomplishes how we make each other
matter there are great poets who can't matter
because they remain useless to each other
which is the ethic of this poetry.
 The air quality is still classified as unhealthy
today, I woke up before my partner whose voice I heard calling
from upstairs "are you ok?" I said yes with an "of course" tone which
I hope also conveyed my appreciation for her care
all three of my goals are wrapped up in that moment
to get my body through its fifth decade to be a fierce and vulnerable lover

to write poems in the morning before work.

There have been times when she has woken up with me not

beside her and I was not okay tooth abscesses puking and of course COVID

my father said if you can get through your 50s you have a chance at long life

I started asking my parents about their health which my

family is rather private or stoic about

in some ways I am more like their working-class

parents who were first generation immigrants I have no desire to differentiate

from them or to make more money than I need I become less afraid of my

conditions the way my body

is going to seed the more I know about my genetics and how I am

just like my dead put to rest in the earth.

The weather app says today is sunny but it's not

the graphic is a square the color of fire

I put on a N95 mask and headed into the square thinking

about what could have been. A former student thought I was a farm

hand but I work in an office on a small dairy farm right next to the milking barn

I visit the cows to stretch my legs and rotate my neck

to address conditions brought on by decades

of sitting at a desk. One of the cows has been very vocal

the herdswoman doesn't like to be bothered so I keep

my many questions to myself and try not to assume the cow is like me

upset about the air the day-darkness even though it seems reasonable

they are very curious and emotional of course

and many things can strain them.

I sat at my desk with a pleasant fullness

from my breakfast of one duck egg brown rice and

broth a never ending effort to eat nutritiously.

My colleague suggests that our office talk about ecological

trauma but there are always capacity issues that prevent

these humane gestures from happening my boss who

already has breathing issues was sitting outside ready to hold a meeting

as would be usual on a June day till I texted him I preferred not to

and please come inside.

I have been reading what poets have thought about cows

as well as drawing cows from the farm's herd one collection

of poems has been reprinted with a different cover that depicts
a scene of industrial farming horror a brown cow's body jammed
in a bucket with its head in the corner I wrapped the book in paper so I don't
have to see it but also note that I have stood before a severed
cow head in person and found it very moving
 I understood the context and knew the old cow's name
after the winter I spent combing the herd I stopped
eating beef even cows that are grass fed and well taken care of
like these I still eat dairy despite not being at ease with
 the practice of continual impregnation the life
of bulls isn't great either the life of any living
thing in service of human consumption isn't great a free cow can live
 for decades.

 A cow that had recently given birth
came back from pasture horned by another cow
despite veterinary care she bled out. Because I work in the office
farm news reaches me second- or third-hand. I heard the cow's body
was composted so low-key made a mental note to be on the lookout

for this compost area on one of my walks.

Yesterday I saw from afar the possible silhouette of a

hoof slightly bent at the ankle within a large mound of dark soil

as I got closer I saw that it was in fact her hoof

both emerging and being subsumed many other bones

horns jaws leg bones were also visible the air quality that day

was better still overcast but not smokey and a bit

of blue sky to the east the chickens were quietly feeding on

a food compost pile with fresh heads of purple

cabbage I took photos of the hoof and slipped

a bone fragment that was on the ground next to the mound

into my pocket. When I got home I told my partner the story and asked

if she wanted to see the photos she said no which I had anticipated

Monday is the year anniversary of her father's passing

and she is tending to herself in her own

way that doesn't involve the lives of cows.

The rain hit the second I closed my car door for a fifteen minute drive

to the hospital the most ferocious rain I've ever driven through occurred

as I crossed the bridge when I arrived in Hudson the streets were dry
an hour later when I left it was sunny but then drizzled the closer
I got to the bridge. At the hospital they attached monitors to my chest
while I walked on a treadmill till my heart rate reached 165
the PA said she saw no cause for concern
my flat T waves came to life and my bp was 114/70 "you don't
see that often" well I take pills for that beautiful blood pressure.
The sun is shining today and the air quality index is 59.
Sometimes I forget to listen to music it can last for many months
this forgetting the value of simple pleasures. I hear songs I like and then look up
the singer I learn that I have an ear for probable lesbians disappointment
retreat from public life I made a playlist to hone in on this sound
I hone in on Karen Dalton and Connie Converse.
Converse disappeared in 1974 at the age of fifty drove off in her Volkswagen
after sending letters to her people saying "let me be if I can"
never to be heard from again. She recorded
her songs in her room four-track overdubbing her own voice
called herself "an overeducated peasant." Dalton an unsurpassed

song interpreter Dylan's favorite singer died from an AIDS-related illness
in a friend's mobile home near Woodstock in 1993 at the age of fifty-five
it always perplexed her friends that she only sang the songs of others
when she wrote many lyrics of her own I think this
has to do with possession some things only come through that way.
These are stories about audience about giving up hope midlife
when you know you've reached your own power
of ever being publicly appreciated on your own terms
and not through the system that produces commercial success
what does it mean to be uplifted by the idea
of an immaterial audience one that loves you after
you have left the material world
of health and money and work the heaven of
audience it can be done

but it's a lot to ask.

Converse's family thinks she drove into a body
of water she asked them to pay her health insurance only till a given
date. Dalton is very difficult to sing along with her phrasing is like

a fingerprint apparently there is no footage of Converse playing
her music there is a short documentary that plays her songs
and shows her recorded voice pulsing a sound meter.
I spent early afternoon inviting birds back to our yard when we
moved here we had an array of birds till the
starlings took over even nesting in holes in the house there was also
a mysterious songbird illness that summer so I removed the feeder and bath
and put up a plastic scare owl the neighbors with a big dog
moved so perhaps the crows will visit now I have hung
a grate of suet and made a bed of peanuts in the shell
but it may take awhile for word to get out.
I pulled some weeds and reassembled fallen bricks that form
a border around a small garden where mums
will bloom late season I remembered our friend
commenting on how being watched as you relax
isn't relaxing and I am aware that I am being
watched by the neighbor who never wears a shirt.
I've spent decades trying to figure out how to live

all I know is that figuring plus time makes a life

not that all of my sometimes contradictory wishes are met but

the friction they create isn't wearing me down

I am not able to fully retreat into whatever private circles

or ensconce myself as I see people do

the word ensconce is like entomb it is deathly

doubles down on the campaign of our obsolescence

it is very difficult to walk away from comfort it too is

a lot to ask.

Because language and time are our medium I am able

to reanimate my childhood and not get old inside I relive

the parts where I was hungry for style in both poetry and fashion and

the parts where I was hungry for love I have

a full-time job right now to pay my debt

I don't really know how to do the job but I survive

by showing up everyday as a poet. Sometimes I can't

believe how silly I am but then I remember I am very young

and have so much to learn.

Essay

In a week's time the suet was gone but no birds bathed
or I saw none bathe the squirrels carried the peanuts away
and nobody not even the squirrels are interested in the safflower seed.
I hung the suet cage from the laundry line so when the rope which I can
see from the couch moves I know a bird is feeding and I can move
to the window I also bird watch from my car while driving to and from
work birds of prey glide over the highways everyday the songs on my playlist
are full of birds "Clay Pigeons" by Blaze Foley "Sharper Eyes" by Arthur

Russell Big Thief's "Sparrow" is it me bird calling? Two squashed raccoons

have joined the procession of roadkill I had never seen a vulture

before I lived here although I probably did but didn't

notice. "They were always there, the

laziest high-flyers, bronze-winged,

the silent ones" as Lew Welch wrote

in "Song of the Turkey Vulture" a poem that invites you into a hard

place the interior of a buzzard's bullet wound imagine yourself turned into hard cheese

and then imagine the ability to fly when you can't imagine

making it to the next rest stop. Writing poems changes things living

in a tone you create in collaboration with the nonhuman

world makes change this isn't a grand proclamation this isn't history

as scandal it's just a certain temperature

repeating itself on a day in a place. I wonder if this tone is still

something people want to make. I looked out the window

and saw a Blue Jay eating the safflower.

Lew Welch left a suicide note but not his body

and Weldon Kees left no note and no body another

perspective is the forest and the ocean took care of them.
One of the first poems I loved was because of
the last rhyming couplet in a poem that is
almost a perfect sonnet but not
where Kees reveals that he has no daughter
and has never desired one the poem is called "For My Daughter"
it's taught as a contemplation of parenthood he's unable
to stop seeing the child's future death but I think he's saying there are other
forms that are more viable to prolong his
survival like a slightly off sonnet.
Yesterday we drove to a book fair at a distillery in the mountains
in a downpour it was hard to motivate ourselves to go
not knowing what to expect poets I have known over the past 20 years
some who are now mountain poets showed up a seemingly random
group but we're connected by our decisions
about how to keep on poets who in my younger days
I thought were strange as they came into their strangeness young.
Now we are all old and open

to being together as old poets wiping the slate.
On the way home my partner asked me to help her not hit any deer
in the dusky wet night and shortly after that she hit the breaks
just in time and also just missed a skunk which looked like
an ambling white stripe. I bought a book
by Mary Norbert Korte with contains her elegy for Lew
Welch she remembers the day she was told he disappeared
and recounts her vision of his face coming out of the ridges riding on
the shoulders of birds of prey and it was raining just as it was raining
yesterday in the mountains.

Essay

Listening to other musicians sing songs Karen
Dalton wrote but never recorded is a let
down for the most part except for Lucinda
Williams who also isn't afraid to get ugly
with a lyric she slurs elides omits entire syllables this is what
makes a lyric desirable and such a pure desire
is unmarketable an enemy of the state. We know what we know
and we don't have numbers. If one person can stand

being intimate with me and a few dozen closely read me

I have the self-discipline to be happy

to zero in on that while making myself huge

to the forces of pure desire.

 Sue Hanel disappeared.

 Original guitarist for

the Swans a splaying

ferocious beast les

 b

 ian it

 didn't

 work

 out art

 i

 stically

 becaus

 e she

she wouldn't repeat herself her chords

from show to show were off the face of the planet.

I learned about Sue
from a poet last week in the
mountains her partner used to be a Swan too she pointed him out
across the room. The other night I dreamed
that all of my plants turned black when in this realm exciting
things are happening to them new shoots and unfurlings of leaves
especially the heart-leafed philodendron. Yesterday was
the first day of summer I got lost in Chatham
as usual and the almost set sun seared my vision as I made a left
turn with my teeth clenched. As with many older people
I wake when the sun is 6 degrees below the horizon and I now know the name
for this time is civil dawn. It's when artificial light is no longer needed
to see I wake and the first thing I do
is remove a mask connected to a machine that ensures
my esophagus doesn't collapse in the night
by blowing air into my nostrils
then I sit up and wait for the world
to stop spinning

For a year I felt

I was dying but I was wracking up

chronic conditions common

to my family and a few of my own many of them

cite as a side-effect social isolation they are sensorial

supragastric belching rosacea

being red and piggy in public I started

telling jokes I am a BEET

POET and I just want to be RED

there are also situations created by drugs such as blood thinner

that create social apprehension my thin blood funnels

from my uterus at the rate of one super absorbent

tampon every two hours

I spent a lot of time today washing blood

off toilet seats my thighs wringing it

from fabrics resetting the clock on

true menopause. Every time I leave

the house I defy the odds and doubly

if I enjoy myself.
For a year I felt how I might
die based my body's chatter
she said for sure we would die but really
of anything. My body is a great Stoic. On the first day day of summer
a sparrow watched me eat lunch with her mouth open
I thought she was begging like a dog would
but she wasn't interested in the pumpkin
seed I gave her my colleague
who I eat lunch with said the bird wanted crumbs of bread
my colleague is observant and often brings things
to my attention like the two dead trees near the picnic
table had finally been cut down or that the raven
we were watching in the sky was
about to be
mobbed by smaller birds. I wonder how not noticing
may fit into an ethic of being useless.
If capitalism makes us unsafe I will become hyper-attentive

to my surroundings paranoid even I am tired
of that kind of noticing. I do not mind being useful
to the herd. On the third day of summer
I brushed dried shit off of the rears of a dozen
cows one of their caregivers explained
to me that the older ones lose strength in their sphincters
I firmly pat each cow on her side where she can see me and I say
their names body language tells me if I should
proceed I noticed and it was later confirmed
that Winter has a very sensitive body the care-
giver showed me how to massage the skin around the base of the tail
near the butthole to get her to relax the barn was peaceful
with their silent munching and ruminating with occasional forceful
sounds of poop and pee landing
in the trough when I left I noticed my pants
were splattered. I don't mind being useful
to readers of poetry.

Essay

Stephanie Young

after Bernadette Mayer

I guess it's too late to live on the farm

I guess it's too late to enter the darkened room in which a
single light illuminated the artist stripped from the waist
down, smeared with blood, stretched and bound to the table

I guess it's too late to inhabit a glass-fronted, white, box-like
room, dressed in white, against which the menstrual blood
was visible

I guess it's too late to start farming

I guess it's too late to start struggling to remain standing in a
transparent plastic cubicle filled with wet clay, repeatedly
slipping and falling

I guess it's too late to buy 60,000 acres in Marfa

I guess it's too late to begin appearing on the subway in
stinking clothes during rush hour with balloons attached to
her ears, nose, hair and teeth

I guess we'll never have an orgiastic Happening

I guess we're too old to carry out maintenance activities in public spaces, during public hours

I guess we couldn't afford to simulate masturbation while President Josip Broz Tito's motorcade drove by below

I guess we're not suited to "I am awake in the place where women die"

I guess we'll never have a self-inflicted wound in front of an audience now

I guess entering a sex cinema dressed in a black shirt, jeans with the crotch removed, and a machine gun slung over her shoulder is not in the cards now

I guess Clive wouldn't make a good photographic montage in which their male and female faces became almost indistinguishable

I guess I can't expect we'll ever have a selection of photographs derived from images produced by the beauty industry now

I guess I'll have to give up all my dreams of being seen, clothed and unclothed, being systematically measured by two male 'researchers' who record her measurements on a chart and compare them with a set of 'normal' measurements

I guess I'll never be waiting for my body to break down, to

We couldn't get tied together by our hair anyways though
Allen Ginsberg got one late in life

Maybe someday I'll have the foreshortened barrel of a gun
pointing toward the viewer

I guess joining our hands around the base's perimeter fence
into which they weave strands of wool is really out

Feeding the pigs and the chickens, walking between miles of
rows of crops

I guess examining women's working conditions is just too
difficult

We'll never have a, never-really-a-collective, a group of
women who came together to work on a public mural

Too much work and still to be poets

Who are the simultaneously-the-beneficiary-of-our-cultural-
heritage-and-a-victim-of-it-poets

Was there ever a poet who had a self-sufficient loss of
certainty

Flannery O'Connor raised peacocks

And Wendell Berry has raised large-scale spirals of rusted
industrial materials in incongruous natural and commercial
spaces

Faulkner may have spent three days in a gallery with a
coyote, a little

And Robert Frost asked a friend to shoot him at close range
with a .22 caliber rifle

And someone told me Samuel Beckett lay hidden under a
gallery-wide ramp, masturbating while vocalizing into a
loudspeaker his fantasies about the visitors walking above
him

Very few poets are really going to the library carrying a
concealed tape recording of loud belches

If William Carlos Williams could be a doctor and Charlie
Vermont too,
If Yves Klein could be an artist, and Jackson Pollock too,

Why not a poet who was also dying of lymphoma and
making a series of life size photographs, self-portrait
watercolors, medical object-sculptures and collages made
with the hair she lost during chemotherapy

Of course there was Brook Farm
And Virgil raised bees
Perhaps some poets of the past were overseers of the
meticulous chronicle of the feeding and
 excretory cycles of her son during
the first six months of his life
I guess poets tend to live more momentarily
Than life in her body as the object of her own sculpting
activity would allow
You could never leave the structures made of wood, rope

and concrete blocks assembled to form
 stocks and racks, to give a reading
Or to go to a lecture by Emerson in Concord
I don't want to be continuously scrubbing the flesh off of
cow bones with a cleaning brush but
 my mother was right
I should never have tried to rise out of the proletariat
Unless I can convince myself as Satan argues with Eve
That we are among a proletariat of poets of all the classes
Each ill-paid and surviving on nothing
Or on as little as one needs to survive
Steadfast as any person's glottis, photographed with a
laryngoscope, speaking the following
 words: "The power of language
continues to show its trace for a long time after silence"
 and fixed as the stars
Tenants of a vision we rent out endlessly

Essay

Bernadette Mayer

I guess it's too late to live on the farm
I guess it's too late to move to a farm
I guess it's too late to start farming
I guess it's too late to begin farming
I guess we'll never have a farm
I guess we're too old to do farming
I guess we couldn't afford to buy a farm anyway
I guess we're not suited to being farmers
I guess we'll never have a farm now
I guess farming is not in the cards now
I guess Lewis wouldn't make a good farmer
I guess I can't expect we'll ever have a farm now
I guess I'll have to give up all my dreams of being a farmer
I guess I'll never be a farmer now
We couldn't get a farm anyway though Allen Ginsberg got
 one late in life
Maybe someday I'll have a big garden
I guess farming is really out
Feeding the pigs and the chickens, walking between miles of
 rows of crops
I guess farming is just too difficult
We'll never have a farm

Too much work and still to be poets
Who are the farmer poets
Was there ever a poet who had a self-sufficient farm
Flannery O'Connor raised peacocks
And Wendell Berry has a farm
Faulkner may have farmed a little
And Robert Frost had farmland
And someone told me Samuel Beckett farmed
Very few poets are real farmers
If William Carlos Williams could be a doctor and Charlie
 Vermont too,
Why not a poet who was also a farmer
Of course there was Brook Farm
And Virgil raised bees
Perhaps some poets of the past were overseers of farmers
I guess poets tend to live more momentarily
Than life on a farm would allow
You could never leave the farm to give a reading
Or to go to a lecture by Emerson in Concord
I don't want to be a farmer but my mother was right
I should never have tried to rise out of the proletariat
Unless I can convince myself as Satan argues with Eve
That we are among a proletariat of poets of all the classes
Each ill-paid and surviving on nothing
Or on as little as one needs to survive
Steadfast as any farmer and fixed as the stars
Tenants of a vision we rent out endlessly

Acknowledgements

Rosaire Appel's pages are from her book, *Accounting for Nothing* (Press Rappel, 2022).

Edwin Alanís-García's interview with Qianxun Chen and Mariana Roa Oliva includes excerpts from their book, *Seedlings_: Walk in Time* (Counterpath Press; Denver, Colorado, 2023).

Sam Bailey and Emma De Lisle's foreword to the folio includes citations from Ralph William Franklin's introduction to *The Master Letters of Emily Dickinson* (Amherst College Press, 1986), Susan Howe's *My Emily Dickinson* (North Atlantic Books, 1985), and Thomas Merton and Robert Lax's *A Catch of Anti-letters* (Sheed & Ward, 1978).

Meghan Brady's paintings 'Moonrise' and 'Novas' were originally shown through Mrs. Gallery, NYC.

Jan Hogan's artworks were previously exhibited at Handmark Gallery.

Jennifer Grotz's poems 'Come' and 'No Longer Unthinkable' were previously published in STILL FALLING (Graywolf Press, 2023).

Excerpts from Susan Howe's *Concordance* were previously published by New Directions in 2020.

Susan Metrican's *Leafy Screen* was previously exhibited at LaiSun Keane; *A Hole is a Home* was previously exhibited at Rivalry Projects.

'Essay' by Bernadette Mayer, from A BERNADETTE MAYER READER, copyright ©1992, 1990, 1989, 1985, 1984, 1983,1982, 1978, 1976, 1975, 1971, 1968 by Bernadette Mayer. Reprinted by permission of New Directions Publishing Corp.

Sharon Olds' poem, 'Meeting a Stranger' is included in her book, *Odes* (Penguin Random House, 2016).

Lloyd Schwartz's translations of the poems by Affonso Romano de Sant'Anna previously appeared in Lloyd's book, *Little Kisses* (University of Chicago Press, 2017).

Laura Steenberge 'Jackals and Owls' is from *The Four Winds*, 2016; 'V.' is from *Lucretius, My Lucretius*, 2011. Text of V. is from *Lucretius: The Way Things Are: The De Rerum Natura of Titus Lucretius Carus*, translated by Rolfe Humphries for Indiana University Press in 1968.

Stephanie Young's 'Essay' is from her book *Ursula or University* (Krupskaya, 2013).

Contributors

Sean Cho A. is the author of "American Home" (Autumn House 2021) winner of the Autumn House Press chapbook contest. His work can be future found or ignored in *Black Warrior Review, Copper Nickel, Prairie Schooner, The Massachusetts Review,* among others. Sean is a graduate of the MFA program at The University of California Irvine and a PhD Student at the University of Cincinnati. He is the Editor in Chief of *The Account.*

Edwin Alanís-García is a writer and philosophy instructor from the Chicagoland area.

Rosaire Appel is text-image artist. She creates drawings, prints, photographs and books. This includes graphic novellas, abstract comics, asemic writing (writing with no semantic value.) Appel is working with interconnections among reading, looking and listening. She is particularly influenced by encounters with and perceptions of the urban environment that surrounds her.

Chloé Milos Azzopardi is a visual artist living on an island in the outskirts of Paris. She works on long term projects mixing photography, performance and installation. At the intersection of experimental and documentary photography, her images generate fictional worlds, whose strangeness and

sensoriality are exacerbated. Her research revolves around ecology, new technologies and the construction of post-capitalocene imaginaries. She was recently awarded the prize "New writings of environmental photography"" at La Gacilly Festival, the Lucie Foundation's Emerging Artist grant and was resident at Villa Perochon during the encounters of young international photography with Joan Fontcuberta. Her work has been published in magazines such as *The New York Times, British Journal of Photography, Fisheye or Ignant,* and was exhibited at PhMuseum, Łódź Fotofestiwal, Encontros da Imagem, Fisheye Gallery, Hidden Gallery, Noorderlicht Photo Festival, Athens Photo Festival, InCadaqués, and Krakow Photomonth.

Pedro Barbeito has exhibited internationally over the past twenty-seven years in fifteen solo exhibitions and participated in over ninety group exhibitions. He is one of the first proponents of integrating digital technologies into a painting matrix. Over his career he has been represented internationally by eight galleries: in NYC, Los Angeles, Miami, Paris, Madrid and London. Solo exhibition venues include Basilico Fine Arts in NYC; Lehmann Maupin Gallery in NYC; Aldrich Contemporary Art Museum in Ridgefield, CT; Mario Diacono Gallery in Boston; Parra Romero Gallery in Madrid; Galerie Richard in Paris; 101/Exhibit in Los Angeles; and Charest-Weinberg Gallery in Miami. His exhibits have been reviewed in *The New York Times* by Roberta Smith and Ken Johnson, in *Art in America* by Stephen Maine, in *The Village Voice* by Jerry Saltz and Kim Levin, as well as in the *New Yorker, Artpulse, Frieze, Art/Text, Art Nexus, Examiner.com,* amongst others. His work has been written about by Barry Schwabsky, Mario Diacono, Ronald Jones, Raphael Rubinstein, Monica Ramirez-Montagut and Amy Cappellazzo amongst others.

Jennifer Barber's most recent book of poetry is *The Sliding Boat Our Bodies Made*, published by the Word Works in 2022. She is co-editor, with Jessica Greenbaum and Fred Marchant, of the anthology *Tree Lines: 21st Century American Poems* (Grayson Books, 2022). Barber's poetry collection *Works on Paper* received the 2015 Tenth Gate Prize and was published by the Word Works in 2016. She lives in the Boston area.

Kenneth Baron has worked as an editor and writer at many of New York City's top publishing houses and as an Editorial Director at NBC Universal. He has created a long-running TV show for VH1, had a one-act play staged as part of a Yale-organized event, and a screenplay honored at a prestigious film festival sponsored by Showtime. Early in his career, he was at *The Paris Review*. His collection of poetry, *Semi-Sleep*, was published by New York City literary press Spuyten Duyvil. His short fiction has appeared in *Good Works Review*. He currently lives in Berlin and New York.

Alex Baskin is a graduate of Harvard Divinity School and works as a hospital chaplain. His poetry appears in *Gulf Coast*, *Lucky Jefferson*, *poetry.onl*, *Redivider*, and other journals. He has an essay in *Refuge in the Storm: Buddhist Voices in Crisis Care* (North Atlantic Books, 2023.) Originally from New Jersey, he lives in Massachusetts.

Tessa Bolsover is a poet based in Durham, NC. Her work has appeared in *The Poetry Project Newsletter*, *The Brooklyn Rail*, *DIAGRAM*, *the Slow Poetry in America Newsletter*, *The Swan*, and elsewhere. She holds an MFA from Brown University and is currently pursuing a PhD at Duke. She is also a founding editor of auric press.

Meghan Brady is a painter based in Midcoast Maine. Through painting, printmaking, and drawing-installations, Brady explores the possibilities of a wide-ranging practice. Recent shows include a solo presentation by Mrs. Gallery at NY Independent Art Fair, *Said + Done* at Mrs. Gallery in NYC, *Reversible Roles* at University of Maine Museum of Art, *Take Five* at SUNY Buffalo Anderson Gallery, NADA House Governors Island NYC and *Second Hand* at Space Gallery in Portland, Maine. She's been in residence at MacDowell, Surf Point Foundation, Hewnoaks, Ellis Beauregard Foundation, and Tiger Strikes Asteroid NYC. Brady is a graduate of Smith College and Boston University. She is represented by Mrs. Gallery in NYC.

Peter Brown's collection of short stories, *A Bright Soothing Noise* (UNT Press, 2010), won the Katherine Anne Porter Prize. His work has appeared or will appear in *Consequence*, *The North Dakota Quarterly*, *Salamander*, *The Harvard Review*, *The Mississippi Review* and elsewhere. He has published three books of poetry in translation, including a French co-translation of the collected poems of David Ferry, *Qui est là?* (Éditions la rumeur libre, 2018). A co-translation of the poems of Arthur Gold, *Une période de maladie* (Éditions Encre & lumière), appeared in France in 2022.

Victoria Chang's forthcoming book of poems, *With My Back to the World* will be published in 2024 by Farrar, Straus & Giroux. Her latest book of poetry is *The Trees Witness Everything* (Copper Canyon Press, 2022). Her nonfiction book, *Dear Memory* (Milkweed Editions), was published in 2021. *OBIT* (Copper Canyon Press, 2020), her prior book of poems received the Los Angeles Times Book Prize, the Anisfield-Wolf Book Award in Poetry, and the PEN/Voelcker

Award. She has received a Guggenheim Fellowship and the Chowdhury International Prize in Literature. She is the Bourne Chair in Poetry at Georgia Tech.

Qianxun Chen is a media artist and researcher. Her works tend to bring up the non-human perspectives of language and the poetics of the non-human through alternative use of technology. She published many digital projects online, focusing on generative poetics, the aesthetics of algorithms, and digital textuality. Her media art installations have been presented in international festivals and exhibitions, such as Ars Electronica, SAVVY Contemporary and Lab.30 Festival.

Cody-Rose Clevidence is the author of *Aux Arc / Trypt Ich* (Nightboat, 2021), *Listen My Friend, This is the Dream I Dreamed Last Night* (The Song Cave, 2021), *Flung/Throne* (Ahsahta, 2018), and *BEAST FEAST* (Ahsahta Press, 2014), as well as several chapbooks (Fonograf, flowers and cream, NION, garden door press, Auric). They live in the Arkansas Ozarks with two kind hearted and goofy dogs.

Margaux Crump is an interdisciplinary artist exploring the entanglements between ecology, folklore, and magic. She is currently investigating the phenomena of the unseen, from the microscopic to the mythic worlds that surround us. Her sculpture, photography, and ritual work has been exhibited across the United States, most notably at the Mildred Lane Kemper Art Museum, Saint Louis; Women and Their Work, Austin, TX, and DiverseWorks, Houston, TX. She is a recent recipient of the Stone & DeGuire Contemporary Art Award. Crump holds an MFA in studio art from Washington University in St. Louis.

John DeWitt is a poet, researcher, and psychologist living in Marseille. He is author of *20 20 Pretzels* (Materials, 2020) and various chapbooks, as well as a doctoral dissertation on the poet Clark Coolidge.

Kinsale Drake (Diné) is a poet, playwright, and performer based out of the Southwest. Her work has appeared or is forthcoming in *Poetry, Poets.org, Best New Poets, Poetry Northwest, MTV, Teen Vogue,* Time, and elsewhere. She recently graduated from Yale University, where she received the J. Edgar Meeker Prize, the Academy of American Poets College Prize, and the Young Native Playwrights Award. She is the winner of the 2022 Joy Harjo Poetry Prize and director of NDN Girls Book Club.

Denise Duhamel's most recent books of poetry are *Second Story* (Pittsburgh, 2021) and *Scald* (2017). *Blowout* (2013) was a finalist for the National Book Critics Circle Award. A recipient of fellowships from the Guggenheim Foundation and the National Endowment for the Arts, she is a distinguished university professor in the MFA program at Florida International University in Miami.

PM Dunne is an incarcerated author from New York. He has won numerous awards and a fellowship from PEN America. Upon his release in 2024, he plans on earning an MFA and starting and independent press for prisoners and prison abolitionists. The following works belong to his forthcoming poetry collection, *Real Time*. Read more at pen.org/prison-writing.

Dina El-Sioufi was born in Alexandria Egypt. She graduated with a Physics (BSc) and Mathematical Physics Diploma in 1987 from Kings College. While freelancing as a teacher and translator, she studied Decorative & Fine Arts at Christie's, Post-War & Contemporary Art at Sotheby's, and obtained an MA in Modern French Studies from Birkbeck College, 2000 (dissertation: Staging the Feminine in Balthus & Pierre Klossowski") She then completed an interdisciplinary-oriented PhD in French from UCL, 2006 (dissertation:" Hans Bellmer & The Experience of Violence"). El-Sioufi started painting sporadically in 2010, exhibiting in group shows between 2012-2014. Her first solo exhibition appeared at the Egyptian Embassy in Berlin, 2016. Her most recent solo exhibition was shown in 2022 at ECB Mayfair, London.

Elisha Enfield's work is concerned with the liminal, the betwixt and between. Her subjects linger at the edges of perception; we feel rather than know them to be present. In recent work, Enfield explores the divided history of burnings––from ancient funeral pyres, through witch hysteria, to modern community celebrations. Simple, joyful, yet macabre. She has been selected for the Wells Art Contemporary, awarded the Landscape Prize at the Discerning Eye and is the winner of Sky Arts Landscape Artist of the Year 2022. Her work is held in the DE Collection, National Waterways Museum and private collections internationally.

Angie Estes is the author of six books of poems, most recently *Parole*. Her previous book, *Enchantée*, won the 2015 Kingsley Tufts Poetry Prize and the Audre Lorde Prize for Lesbian Poets, and Tryst was selected as one of two finalists for the 2010 Pulitzer Prize. Her seventh book is forthcoming from Unbound Edition Press. A collection of essays devoted

to Estes's work appears in the University of Michigan Press "Under Discussion" series: T*he Allure of Grammar: The Glamour of Angie Estes's Poetry.*

Ian Ganassi's work has appeared recently or will appear soon in journals, such as *New American Writing, Survision* and *Home Planet News.* His first full length collection, Mean Numbers is available in the usual places. His new collection, *True for the Moment,* is now available online. A third collection will appear in June of next year. Selections from an ongoing collaboration with a painter can be found at www.thecorpses.com. He is a longtime resident of New Haven, Connecticut.

aracelis girmay is the author of three books of poems, most recently *the black maria* (BOA 2016). She is on the editorial board of the African Poetry Book Fund and is the Editor-at-Large of the Blessing the Boats Selections. Fall 2023, a limited edition chapbook of her new work will be published in collaboration with artist Valentina Améstica and the Center for Book Arts.

Jennifer Grotz's most recent book is *Still Falling* (Graywolf 2023). A poet and translator, she teaches at the University of Rochester and directs the Bread Loaf Writers' Conferences.

David Grubbs is Distinguished Professor of Music at Brooklyn College and The Graduate Center, CUNY. He is the author of *Good night the pleasure was ours, The Voice in the Headphones, Now that the audience is assembled,* and *Records Ruin the Landscape: John Cage, the Sixties, and Sound Recording* (all published by Duke University Press) as well as the collaborative artists' books *Simultaneous Soloists* (with Anthony McCall, Pioneer Works Press) and *Projectile* (with

Reto Geiser and John Sparagana, Drag City). As a musician Grubbs has released fourteen solo albums and appeared on more than 200 releases.

Jessie Hobeck is an emerging artist from the Eora Nation of the Gadigal People, Sydney, Australia. She is currently studying a Bachelor of Fine Arts at the University of Tasmania in Nipaluna/Hobart. During the semester breaks, Jessie works as a Teacher and Arts Therapist in Mparntwe/Alice Springs at a bi-lingual school for First Nations young people.

Jan Hogan is an artist and educator whose work focuses on the places where she finds herself living. Using the processes of drawing and printmaking she is interested in the poetics of water and geology and how they attract attachment and influence a sense of place. Her work leads her to form attachments and responsibilities to the ecology that she exists within. Jan is the coordinator of drawing and printmaking at the University of Tasmania. Her current projects are based on the Derwent Estuary in nipaluna Hobart, lutruwita Tasmania. Immersing herself and her work in the estuary Jan is learning to map herself within this geology. Her investigations shift between the multiple scales that influence a site; from handheld stones to the reef systems revealed and concealed by the tidal pull of the moon."

Amy Hollywood teaches at the Harvard Divinity School. Her most recent book, co-authored with Constance M. Furey and Sarah Hammerschlag is *Devotion: Three Inquiries on Religion, Literature, and the Political Imagination.*

Susan Howe's recent work includes *Concordance* (2020), *The Quarry: Essays* (2015), *Spontaneous Particulars: The Telepathy*

of Archives (2014), and a poetry collection, *Debths* (2017), all published by New Directions.

Brionne Janae is a poet and teaching artist living in Brooklyn. They are the author of *Blessed are the Peacemakers* (2021) which won the 2020 Cave Canem Northwestern University Press Poetry Prize, and *After Jubilee* (2017) published by Boat Press. Brionne is a 2023 NEA Creative Writing Fellow, a Hedgebrook Alum and proud Cave Canem Fellow. Their poetry has been published in *Best American Poetry 2022*, *Ploughshares*, *The American Poetry Review*, *The Academy of American Poets Poem-a-Day*, *The Sun Magazine*, *jubilat*, and *Waxwing* among others. Off the page they go by Breezy.

Vincent Katz is the author of the poetry collections *Broadway for Paul*, Swimming Home, and Southness, and the book of translations, *The Complete Elegies of Sextus Propertius*, which won the National Translation Award. His writing on contemporary art and poetry has appeared in *Art in America*, *The Brooklyn Rail*, and *The Poetry Project Newsletter*. He has curated exhibitions on Black Mountain College and Rudy Burckhardt and co-curated a retrospective of the films of Isabelle Huppert at Film Forum in New York.

Ben Keating is a poet and sculptor, born and raised in the Flatbush section of Brooklyn, NY, where he currently works.

Joanna Klink is the author of five books of poetry, most recently *The Nightfields*. She has received awards and fellowships from the American Academy of Arts and Letters, the Trust of Amy Lowell, and the Guggenheim Foundation. She teaches at the Michener Center for Writers in Austin, Texas.

Daniel Kraft is a writer, translator, and educator living in Richmond, Virginia. His poems, essays, and translations of Yiddish and Hebrew appear in a number of publications including the *Kenyon Review, Poetry Ireland Review, Image, Jewish Currents*, and *Slate*. His newsletter of Yiddish poetry in translation can be found at danielkraft.substack.com, and he is currently a Translation Fellow of the Yiddish Book Center in Amherst, Massachusetts. Daniel is also a graduate of Harvard Divinity School, and a former resident at the Center for the Study of World Religions.

Catherine Lamb is an active composer exploring the interaction of tone, summations of shapes and shadows, phenomenological expansions, the architecture of the liminal (states in between outside/inside), and the long introduction form. She currently resides in Berlin.

Timothy Leo is a member of the surgical house staff at the University of Chicago. His work may be found in *Annulet: A Journal of Poetics, Denver Quarterly, Guesthouse*, and *Narrative Magazine*.

Abigail Levine is a choreographer and writer from New York City. Rooted in dance, her work moves across media into performance, text, drawing, and sound. Levine has performed with performance artist Marina Abramovic and choreographer Yvonne Rainer and collaborated with composer Alvin Lucier. Her writing has been published in *Documents in Contemporary Art, Art21, Women & Performance, Performance Art Journal (PAJ)*, and *Interim Poetics*. Her latest performance work, *Redactions*, premiered at The Chocolate Factory Theater in 2022.

Seth Lobis teaches literature at Claremont McKenna College. His work has appeared in *The Yale Review*.

Maisie Luo makes paintings and painting animations. Her work reflects on our relationship with animals and nature in this time when capitalistic systems of consumption often exploit them to satisfy human needs and desires. Her artistic practice is inspired by Buddhist teachings of compassion, such as exchanging self with the other. Luo also writes about the moral value of attention in art making and viewing.

Jill Magi works in text, image, and textile and is the author of six books of poetry, the most recent of which is called *Speech* (Nightboat 2019). She's had solo exhibitions at Warehouse421, Southern Vermont Arts Center, Grey Noise, The Project Space at New York University Abu Dhabi, and the University at Buffalo collects her handmade books. She's been teaching all her adult life, and for the last 25 years, in colleges and universities large and small and in between.

James Davis May is the author of two poetry collections, both published by Louisiana State University Press. *Unquiet Things* appeared in 2016, and *Unusually Grand Ideas* was released in 2023. His poems and essays have appeared in *32 Poems*, *The Georgia Review*, *Literary Hub*, *New England Review*, *The Southern Review*, *The Sun*, and other journals. May has received fellowships from the Bread Loaf Writers' Conference, the National Endowment for the Arts, and the Sewanee Writers' Conference. Originally from Pittsburgh, he now lives in Macon, Georgia, where he directs the creative writing program at Mercer University.

Sam Messer has been collaborating with writers since 1983. Over the years, he has made work with Denis Johnson, Paul Auster, Jonathan Safran Foer and Sharon Olds. Messer is known for creating large bodies of works in series. His series of portraits of the self-taught painter Jon Serl can be found in the book, *One Man by Himself, portraits of Jon Serl*. The *Story of My Typewriter*, published by D.A.P. with Paul Auster's text, shows Messer's early engagement with Paul's typewriter. *Denis the Pirate*, an animated film to a story by Denis Johnson, narrated by Liev Schreiber, with music by Sarah Neufeld and Colin Stetson has been shown at festivals around the world. He has also collaborated on three exhibitions with Jonathan Safran Foer.

Susan Metrican is an artist living and working in Fairfield, IA via Boston, NYC, Toronto, and Bangkok. Metrican received an MFA from the Massachusetts College of Art and Design, her BFA from the Kansas City Art Institute, and attended Skowhegan School of Painting and Sculpture in 2014 and Shandaken: Storm King in 2022. Metrican's work has been included in solo and group exhibitions nationally; most recently at Framingham State University (MA), Headstone Gallery (NY), The Hole (NY), LaiSun Keane (MA), Rivalry Projects (NY), MassArt X SoWa (MA), Tracey Morgan Gallery (NC), LeRoy Neiman Center for Print Studies at Columbia University (NY), Maharishi University (IA), SPRING/ BREAK Art Show 2017 (NY), Able Baker Contemporary (ME), GRIN Contemporary (RI), Proof Gallery (MA), Boston Center for the Arts (MA), Field Projects (NY), Knockdown Center (NY), and Gallery Protocol (FL). Metrican has an artist edition with Drawer NYC (NY), and has been featured in ART MAZE Mag and Cream City Review. She is one of four founding members of kijidome, an experimental project

space and collaborative in Boston, MA (2013-2017). From 2014-2022, she was the Curator at the Kniznick Gallery at Brandeis University. She is currently Director of the Wege Gallery and Assistant Professor in the Art Department at Maharishi International University (IA).

Jane Miller's recent works are *Paper Banners*, poems from Copper Canyon Press, and *From the Valley of Bronze Camels: A Primer, Some Lectures*, and *A Boondoggle on Poetry*, in The University of Michigan's Poets on Poetry series.

Rajiv Mohabir is the author of four collections of poetry including *Whale Aria* (Four Way Books 2023), *Cutlish* (Four Way Books 2021) which was awarded the Eric Hoffer Medal Provocateur, longlisted for the 2022 PEN/Voelcker Prize, and was a finalist for the National Book Critics Books Award. He also authored the memoir *Antiman* (Restless Books 2021) winner of the Forward Indies Award for LGBTQ+ Nonfiction, and was a finalist for the 2022 PEN/America Open Book Award, 2021 Randy Shilts Award for Gay Nonfiction, and 2021 Lambda Literary Award for Gay Memoir/Biography. As a translator, his version of *I Even Regret Night: Holi Songs of Demerara* (Kaya 2019) won the Harold Morton Landon Translation Award from the Academy of American Poets in 2020. In the fall he will be an assistant professor of poetry at the University of Colorado Boulder. Learn more about him at www.rajivmohabir.com.

Tawanda Mulalu was born in Gaborone, Botswana, in 1997. His first book, *Please make me pretty, I don't want to die* was selected by Susan Stewart for the Princeton Series of Contemporary Poets and is listed as a best poetry book of 2022 by *The Boston Globe*, *The New York Times* and *The*

Washington Post. His chapbook *Nearness* was chosen as the winner of *The New Delta Review* 2020-21 Chapbook Contest, judged by Brandon Shimoda. Tawanda's poems appear or are forthcoming in *Brittle Paper, Lana Turner, Lolwe, The New England Review, The Paris Review, A Public Space* and elsewhere.

Catherine Noonan is from Kildare, Ireland. In 2005 she completed an M. Phil in creative writing at Trinity College Dublin. Her work has been published by The Stinging Fly Press.

Geoffrey Nutter is the author of Christopher Sunset, The Rose of January, and Giant Moth Perishes, among other books. He teaches at NYU and Queens College in New York City and runs the Wallson Glass Poetry Seminars.

Mariana Roa Oliva is a fiction and performance writer. They're interested in communication and collaboration across languages and species, natural and artificial.

Carolyn Oliver is the author of *The Alcestis Machine* (Acre Books, forthcoming 2024), *Inside the Storm I Want to Touch the Tremble* (University of Utah Press, 2022; selected for the Agha Shahid Ali Prize), and three chapbooks. Her poems appear in *Copper Nickel, Poetry Daily, Shenandoah, Passages North, Southern Indiana Review, At Length, On the Seawall,* and elsewhere. She lives in Massachusetts, where she is a 2023-2024 Artist in Residence at Mount Auburn Cemetery. (Online: carolynoliver.net).

olivier is a queer research-based artist+writer and archives worker. They speak Cantonese at home with their demonic

cat. Focusing their practice on ephemerality in archival theory, queer theory, and ufology, they work with speculative projects, artists' books, videos, performance-lectures, happenings, surveys, drawings, installations, and lead a secret mail art practice/life. olivier holds an MA in Visual and Critical Studies from the School of the Art Institute of Chicago. For the past ten years, their time-machine has been stuck in this dimension. So it goes.

Louis Harnett O'Meara is a writer from the UK.

Alice Oswald has published several collections of poetry, including *Dart, Memorial and Falling Awake*. She works as a gardener and freelance writer and lives in the U.K.

Rowan Ricardo Phillips' next book of poems, *Silver*, will be published in March 2024 by Farrar, Straus and Giroux.

Daniel John Pilkington is a poet, artist, and researcher, from Naarm/Melbourne, Australia. He teaches creative writing at the University of Melbourne and is about to complete his PhD, which is on the influence of magic in contemporary American poetry.

Bin Ramke's fourteenth book of poems, *Earth on Earth*, was published by Omnidawn in 2021. He teaches at the University of Denver where he lives and gardens with his family.

Nicholas Regiacorte is the author of American Massif, published by Tupelo Press. His poems have appeared in *Copper Nickel, New American Writing, Descant, Bennington Review, Colorado Review, Verse Daily, Dialogist* and elsewhere. Currently, he teaches at Knox College, where he directs the

program in creative writing.

Lloyd Schwartz is the Poet Laureate of Somerville, Massachusetts, Frederick S. Troy Professor of English Emeritus at UMass Boston, the longtime music and arts critic for NPR's Fresh Air and WBUR, and an editor of the poetry and prose of Elizabeth Bishop. His awards include the Pulitzer Prize for Criticism and Guggenheim Foundation, NEA, and Academy of American Poets fellowships in poetry. His poems have been chosen for the *Pushcart Prize*, *The Best American Poetry*, and *The Best of the Best American Poetry*. His latest collection is *Who's on First? New and Selected Poems* (University of Chicago Press).

Tracy K. Smith served as the 22nd Poet Laureate of the United States from 2017-19. Her most recent books are *Such Color: New and Selected Poems*, and *To Free the Captives: A Plea for the American Soul.*

Ed Steck is the author of *A Place Beyond Shame, An Interface for a Fractal Landscape, The Garden, Mountain Forge Serviceberry Systems, David Horvitz: Rarely Seen Bas Jan Ader Film*, and others. He is a recipient of grants from the Fund for Poetry, Pittsburgh Greater Arts Council, and the Pittsburgh Foundation. He lives in Pittsburgh.

Laura Steenberge is a musician living in Asheville, North Carolina. She composes chamber works for voice and performs with viola da gamba, contrabass, piano and objects. Her creative practice is informed by the study of medieval chant and music in mythology.

Cole Swensen has written 19 books of poetry, most recently *Art in Time* (Nightboat 2021). A book of nano essays on poetics, *And And And*, is coming out from Shearsman Books later this year. A former Guggenheim Fellow and recipient of the Iowa Poetry Prize, the SF State Poetry Center Book Award, the PEN USA Award in Translation, and a finalist for the National Book Award, she lives in France and the US, where she teaches at Brown University.

Stacy Szymaszek is the author of seven full-length books, most recently *The Pasolini Book* (2022) and *Famous Hermits* (2023). Her chapbook *Three Novenas* was published in 2022 by auric books. She was the director of *The Poetry Project* from 2007-2018. Since then, Szymaszek was the Hugo Visiting Writer at the University of Montana-Missoula 2018-19, Poet-in-Resident at Brown University, Visiting Poet for the Fire Island Artist Residency and the recipient of a 2019 Foundation for Contemporary Arts grant in poetry. She currently lives and works in New York's Hudson Valley.

Sage Vousé is a self-taught multimedia artist based in Brooklyn who deals in otherness, physicality, and transformation by way of ceramics and virtual environments. In sculpture, they combine experimental and flesh-like designs with profiles that evoke the classic and the antique; the decanter crumbling and covered in flowering warts, the bouquet banished to the bottom of the sea. These sculptures are captured as digital objects which form a language with which to build out immersive worlds and expand on emotive moments. They enjoy mixing textures, materials, scale and reality.

Jackie Wang is a poet, scholar, multimedia artist, and Assistant Professor of American Studies & Ethnicity at the University of

Southern California, where she researches race, surveillance technology, and the political economy of prisons and police. She is the author of *Carceral Capitalism* (Semiotext(e), 2018), the poetry collection *The Sunflower Cast a Spell to Save Us from the Void* (Nightboat Books, 2021, National Book Award Finalist), and the experimental essay collection *Alien Daughters Walk into the Sun* (Semiotext(e), 2023).

Sam Weinberg is a saxophonist, composer, and collage artist from Queens, NY.

J.P. White has published essays, articles, fiction, reviews, interviews and poetry in *The Nation, The New Republic, The Gettysburg Review, Agni Review, APR, Salamander, Catamaran, North American Review, Prairie Schooner, Shenandoah, The Georgia Review, Southern Review, The Massachusetts Review, Water-Stone, The New York Times, Willow Springs, Crazyhorse, and Poetry (Chicago)*. White's sixth book of poems, *A Tree Becomes a Room*, was the 28th winner of the White Pine Poetry Prize and is forthcoming from White Pine Press in 2023. *The Last Tale of Norah Bow*, a second novel, is forthcoming in 2024 from Regal House Publishing.

Stephanie Young's books of poetry and prose include *Pet Sounds, It's No Good Everything's Bad*, and *Ursula or University*. Her work on the history of prestige literary culture and its changing demographics can be found at *American Literary History, Public Books, ASAP/J*, and the *Post45 Data Collective*. Her writing on small press culture and social movements has appeared in *The Los Angeles Review of Books, Paideuma, The Bigness of Things: New Narrative and Visual Culture, and* the *Poetry Foundation*'s blog. Young teaches writing at Mills

College at Northeastern University.

Maria Zervos's most recent work revolves around an interdisciplinary approach to video, performance, poetry and drawing in an ongoing negotiation between "topos" and utopia. She remaps otherworldly landscapes such as the barren stretches of the Atacama Desert, the highest peak of Mount Olympus, gray zones or places off the map, such as refugee camps, in a search for personal geographies. Distinct for its allusions to passage, Zervos's work often investigates the conflation of nature and culture, aspiring to social criticism. Zervos is a Fulbright Scholar and she has taught courses on poetry and visual art at Harvard University.